lighthearted

100-DAY
DEVOTIONAL

lighthearted

100-DAY
DEVOTIONAL

—

**ONE-WORD
PROMISES TO
LIGHTEN YOUR
LOAD AND LIFT UP
YOUR HEART**

—

Susie Crosby

PUBLISHING®
BRENTWOOD, TENNESSEE

978-1-4300-8779-3

Published by B&H Publishing Group
Brentwood, Tennessee

Dewey Decimal Classification: 242.64
Subject Heading: DEVOTIONAL LITERATURE /
GOD—PROMISES / CHRISTIAN LIFE

Author is represented by the literary agency of Credo Communications
LLC, Grand Rapids, Michigan, credocommunications.net.

Cover design by Lindy Kasler. Image Pixel Stories/Stocksy.
Author Photo by Easton Lemos.

1 2 3 4 5 6 • 27 26 25 24

To my guys—Bob, Andy, and Ty.
You are three of the most amazing examples of how God keeps
his promises to me. I love you with all my heart.

To Jesus—I am in awe of your faithfulness, your kindness,
and your divine power. Thank you for inviting me into this
amazing life with you.

His divine power has given us everything
we need for a godly life
through our knowledge of him who called
us by his own glory and goodness.
Through these he has given us his very
great and precious promises,
so that through them you may participate
in the divine nature.
(2 Peter 1:3–4 NIV)

Contents

PROMISES FOR WHEN YOU FEEL *DISCOURAGED*

PROMISES FOR WHEN YOU ARE *DOUBTING*

PROMISES FOR WHEN YOU NEED *FORGIVENESS*

PROMISES FOR WHEN YOU FEEL *TEMPTED*

PROMISES FOR WHEN YOU FEEL *UNLOVABLE*

Introduction

The photograph that inspired the title of this book was taken by my grandpa at our family beach cabin. It's five-year-old me floating on an inner tube in the salt water wearing my favorite swimsuit and a pair of old canvas tennis shoes. My one-tooth-missing, sparkling-eyed smile takes me back to simpler times when I didn't have a care in the world.

I was **lighthearted**: *free from care, anxiety, or seriousness. Cheerfully optimistic and hopeful.*

Sometimes I really miss those days.

Life seems extra stressful now, with so much anxiety and negativity all around. The threats of this dangerous world seem closer, relationships are more difficult than ever, and our problems seem to come in multiples. Our tender hearts get weighed down by all the loss, fear, shame, hurt, and worry.

Wouldn't it be refreshing to be able to get on the inner tube and float for a while? To experience deep, lasting peace and real, life-giving joy in the midst of all the heaviness?

Jesus is inviting us to this.

In 2 Peter 1:3–4 (NIV), we read that his power gives us *everything we need* to live life with him. My favorite part of this passage tells us that he has given us "great and precious promises," so that we may share in his divine nature.

His great and precious promises will hold us up.

I wrote this devotional because I often need help remembering these promises. Maybe you do, too.

As you journey through this book, you will find that it is organized by the heavy emotions we experience. Each section offers several devotions based on scriptural promises to remind us of God's trustworthiness, his power, and his overwhelming compassion for his people. Each devotion

contains a **key word** that is connected to biblical truth. You will be encouraged to READ, REFLECT, and REMEMBER the promise that stands no matter what is going on around or inside of you.

You may want to read the devotions through from Day 1 to Day 100, or you may choose to turn directly to the section that promises God's help for the emotion you are currently feeling. My hope is that you will do both, so I have included a quick reference guide in the back of the book listing the promises by theme.

Even through the deepest, roughest waters of this life, our God is faithful to keep his promises to us. When difficult and overwhelming situations threaten to take us under, his words will keep us afloat.

Jesus is offering to lighten your load and lift up your heart today.

My prayer is that you will let him.

With love,
Susie

Promises for When You Feel Afraid

God Will **HOLD** on to Us

Key word **hold** *(verb)*: to bear the
pressure of; to support, to grasp

*"Do not fear, for I am with you; do not be afraid, for I
am your God. I will strengthen you; I will help you; I
will hold on to you with my righteous right hand."*
Isaiah 41:10

God knows us so well.

He knows that one of the emotions we struggle with much of the time
is fear. Sleepless nights, bouts of high anxiety, and even panic attacks are
happening more and more to the people I love.

When we are in the grip of fear, he reassures us in this promise that we
are not alone. **"I am with you,"** he says.

But what about the heaviness of dealing with long-term fear? Many of
us feel an underlying apprehension that causes us to focus on what might
go wrong or to always imagine the worst-case scenario. We live with a sense
of helplessness that never goes away. The difficulty we have in just trying to
get through a day in this unpredictable world is paralyzing.

"Do not be afraid," God tells us here. **"I am your God."**

God doesn't want us to be bound by fear. He knows how much it hurts
us and how it keeps us from experiencing the freedom and victory of his
abundant life.

And he really doesn't want us to worry.

But worry creeps into most of our hearts every day. We worry about
ourselves and about the people we love. We worry about health, safety, and
the future. We worry about things we have control over and things we don't.
We worry about things that could really happen and things that probably
never will.

Underneath it all is the terrifying question: *Can we handle what comes
next?*

What if we can't?

God promises, **"I will strengthen you."**

He will give us his energy and the stamina to keep going. He will sustain us with his power and make sure we have all the resources we need to get through the hardest things.

God promises, **"I will help you."**

He will protect us, he will bring light into a dark and confusing time, and he will give us comfort. He will help us in exactly the ways we need it, and he will never leave our side.

And then he promises this: **"I will hold on to you with my righteous right hand."**

Not only will he give us his strength and help, but he will **hold on to** us. In some translations of the Bible, the word used here is **uphold**.

Strong's Concordance defines **uphold** this way: *to sustain, to keep fast, to stay.*[1]

To sustain: When the rug has been pulled out from underneath our feet, he will support us and be our place to stand.

To keep fast: When our minds are slipping down the slope of worrying about things we can't control, he will help us focus on his truth and cover us with his peace.

To stay: When we feel surrounded and it is all too much, he will grasp our hands and pull us closer to him.

And right there in his hands, we will be able to handle whatever comes next.

Dear Jesus, thank you that you are with me when I struggle with fear. Please help me remember that my help and strength come from you. Thank you that your mighty hand is holding mine right now. Amen.

REFLECT

In your journal, write **Isaiah 41:10** in your own words.

What does this promise reveal to you about God's character?

What's one thing you can do today to better let Jesus hold you in your fearfulness?

REMEMBER

In your journal, write the keyword (or a different word) you want to focus on in this verse. How will it help you hold on to this promise?

Draw an image to remind you that God will hold on to you today.

Jesus REACHES Out His Hand to Us

Key word **reach** *(verb)*: to stretch out, extend; to touch or grasp

But when he saw the strength of the wind, he was afraid, and beginning to sink he cried out, "Lord, save me!" Immediately, Jesus reached out his hand, caught hold of him . . .
Matthew 14:30–31

Jesus had just said to his disciples, "Have courage! It is I. Don't be afraid" (v. 27). It seems like he had to say this often. So did almost every angel who greeted someone with a message from God. Hmm. Seems like those of us who live with fear and anxiety are in good company.

One of our relatable companions in this struggle is the disciple Peter.

In this story, Jesus is walking on the water through a terrible storm toward his disciples in a boat. This has all the makings of a panic situation—an unexpected, dangerous storm with a ghostlike figure approaching.

Where is he? Is that Jesus? I'm not sure.

Peter and the other disciples become convinced that it is Jesus, and he doesn't seem one bit worried about the strong winds or the crashing waves. So Peter asks Jesus to call him to walk on the water, too. When Jesus does, Peter gets out of the boat and begins to walk to Jesus. He is doing fine until he takes his eyes off Jesus and focuses on the storm.

I'm trying to be brave, but these waves are so high. And this wind is out of control! Jesus, save me!

Jesus reaches out his hand to Peter and saves him from drowning. They both get into the boat, as Jesus calms the storm *and* Peter's heart.

What just happened? That was terrifying. I actually walked on the water for a few steps. But then I didn't see Jesus anymore. I started going under, and Jesus had to catch me.

Sometimes we are so much like Peter.

A storm comes out of nowhere. The panic starts to rise. It looks and feels like we are going to be overtaken. We think we are going down. Is that Jesus coming toward us?

It is Jesus! Here he comes, reaching out his faithful, steady, loving hand. We can reach out of our fear for a moment and grab on to him. We can hold onto what we know of his faithfulness, his power, his goodness, and his truth. Even if the wind doesn't stop and the waves start to pull us under, we don't have to stay in the panic.

Jesus reaches out to catch us and save us every time. Through the voice of a friend, the perfect song, a breath of fresh air, the warmth of the sun, or one of the millions of creative ways he knows will calm us. Whether the storm is short-lived or much longer than we ever thought it could be, we are safe because he is always right there—reaching out his hand and helping us back into the boat. With him.

Dear Jesus, I'm scared and looking for you. Please help me see you coming toward me, reaching out your hand in comfort and strength. Thank you that nothing is too hard or too scary for you. Amen.

REFLECT

In your journal, write **Matthew 14:30–31** in your own words.

How would you explain this Scripture promise to a young child who is feeling *afraid*?

What is crashing around you that you can look for Jesus's hand to reach through?

REMEMBER

In your journal, write the key word (or a different word) you want to focus on in these verses. How will it help you hold on to this promise?

Draw an image to remind you that Jesus is reaching out to you.

God Is Our **REFUGE**

Key word **refuge** *(noun)*: shelter or protection from
danger or distress; haven, retreat, sanctuary

*God is our refuge and strength, a helper who
is always found in times of trouble.*
Psalm 46:1

READ

Kids have so much fun building forts out of sofa cushions and blankets. When ours were little, we would come home from date night to a living room full of every blanket in the house, cushions and pillows everywhere, and giggling boys. I remember building them when I was younger, too. Being covered and protected in these cozy shelters gave me a deep sense of security mixed with the excitement of being hidden from view.

Maybe that's what *refuge* means. Surrounded yet incredibly free at the same time.

A refuge can be as protective as the cave King David hid inside, a building downtown with a free bed on a cold night, the spare room at a friend's house, or the keep of a castle. Refuge can also be as peaceful as a bench by the water, a walk in the woods, a cup of hot tea, or a few minutes of solitude in a busy house before the day begins.

We all need a peaceful, protected spot to retreat to, a place where we can be taken care of and strengthened so we can make it through the hard stuff. But we don't live in a castle, we can't always get outside to a peaceful spot, and we are probably a bit beyond the age of making forts with the couch cushions. Places of refuge are sometimes hard to find.

But Jesus isn't. He is right here.

I love thinking of Jesus as our refuge. Our shelter, our retreat, our hiding place away from all the demands and pressures and worries of each day. This promise reminds us that he is ever present. He is everywhere we are and everywhere we're going. Just knowing that we can say his name anytime and picture him ahead of us, behind us, and all around us can give us strength and calm. Sometimes it can even give us that almost giddy, hiding-in-the-sofa-cushions feeling of freedom and fun.

Whether we are in a time of crisis or just dealing with everyday stress, let's remember that we have an arms-open, mercy-providing, fiercely protective God. He welcomes us in, wraps us up in his protective care, and breathes into us the restoration and the refreshment we so desperately need.

Dear Jesus, my heart doesn't feel secure, and I want to find my peace in you. I need to feel your strong protection and your unconditional love. Thank you for being a safe place for me no matter where I am. Amen.

REFLECT

In your journal, write **Psalm 46:1** in your own words.

Look up this verse in a few other Bible translations or paraphrases (https://www.biblehub.org and https://www.blueletterbible.org are two online resources you can use to do this). Write what you notice.

What kinds of things make you want to hide? How can this promise help you in your fear?

REMEMBER

In your journal, write the keyword (or a different word) you want to focus on in this verse. How will it help you hold on to this promise?

Draw an image to remind you that God is a refuge for us.

We Are Protected in God's
SHADOW

Key word **shadow** *(noun)*: shelter from danger
or observation, a hovering over, a shade

*The one who lives under the protection of the Most
High dwells in the shadow of the Almighty.*
Psalm 91:1

Have you ever tried to walk or stand in another person's shadow? It's a fun game for little ones, trying to stay in the shadow of someone else.

They soon figure out a couple of things:

1. Staying in the shadow means staying pretty close to the person making it.
2. Staying in the shadow is much easier when the person making it doesn't move.

What a relief that God is the one making a shadow for *us*, and he is not playing a game. He is placing a covering over us to keep us safe. As the passage continues just a few verses later, "He will cover you with his feathers; you will take refuge under his wings. His faithfulness will be a protective shield" (v. 4).

Psalm 91 is one of the most comforting passages in the Bible, and I especially love how it begins. In these first few verses, our near and unchanging God invites us to stay in his shadow and live close to him. He welcomes us into a place of safety and comfort where he will protect us completely.

A secret place in the middle of this complicated life sounds amazing to me. I think of my favorite childhood book, *The Secret Garden*, by Frances Hodgson Burnett. The main character, a recently orphaned child named Mary, struggles to make sense of her new situation. She is lost, sad, scared, and unwanted. Nothing seems comfortable or safe until she discovers a mysterious hidden garden and brings it back to life. The garden behind the secret door was her refuge, her hiding place, her shelter, and her shade.

Do you need to find a place like this like I do? A secret place to hide and rest for a bit today?

If you are hurting, hide in God's shadow. He knows what will soothe your heart. He will wrap you in his arms of comfort and dry your tears.

If you are exhausted, hide in God's shadow. He wants to restore and refresh you. He will breathe new life into you in this quiet, restful spot right next to him.

If you are afraid, hide in God's shadow. He is able to calm you. He will hold your stress and your fears as he covers you with his peace.

God knows how to heal, to fill, and to nurture us. Everything we need can be found in the shadow of his wings.

We can close our eyes and take a deep breath of Jesus. He will surround, surpass, and surprise us as we trust in his higher thoughts and ways.

Dear Jesus, thank you for your shadow. You hide
me there in your fortress. You comfort me in this
closeness to you. You protect me by spreading your
wings over me. Please take my worries and stress
and let me rest securely with you. Amen.

REFLECT

In your journal, write **Psalm 91:1** in your own words.

As you think about this promise, list some things you can be grateful for.

What fear is coming over you that you can bring under the shadow of Jesus right now?

REMEMBER

In your journal, write the keyword (or a different word) you want to focus on in this verse. How will it help you hold on to this promise?

Draw an image to remind you that God protects us in his shadow.

The SPIRIT of Fear Is Not from God

Key word **spirit** *(noun)*: the activating or essential principle influencing a person; disposition

For God has not given us a spirit of fear, but one of power, love, and sound judgment.
2 Timothy 1:7

READ

"We've got spirit, yes we do. We've got spirit, how 'bout you?"

Yes, we do.

God places inside every one of us a unique spirit, an essence all our own. I imagine him smiling in adoration as he designs each distinct combination of character, personality, temperament, and energy.

But these beautiful spirits that make us who we are sometimes get weighed down by fear. Like our bodies and our minds, they are vulnerable to the dangers and discouragements of this life.

I think of these spirits inside of us like kites.

Kites?

How long has it been since any of us has flown a kite? Maybe forever?

I remember running barefoot on the sand as a young child, holding tightly to a plastic handle with both hands, struggling and cheering as the wind lifted my bright red, diamond-shaped, twisty-tailed kite way up above me.

I also remember gazing at all the other kites flying up there—dragon kites, butterfly kites, box kites, spinning kites, kites of every size and shape and color. The sky was dancing.

But a kite can only get up—and stay up—in the air if there is a consistent, strong wind blowing. All those beautiful, interesting kites will just bump helplessly along on days when there is no wind to hold them up.

When our spirits are grounded like these kites on a windless day, we feel awfully helpless. When life overwhelms or disappoints us, we get scared, defeated, reactive, and way too focused on ourselves.

Our vibrant colors become dull and diminished. Our strength is gone and our joy is stuck.

We often forget that we have God's Spirit inside of us, too. We neglect to lean into this mighty wind of God's Spirit to lift us up and help us fly.

But when we remember and ask him, he rushes in:

His Spirit of *power*—an abundance of strength, the miraculous ability to be a part of his purpose and bravely face whatever comes.

His Spirit of *love*—the absolute assurance of his affection and devotion no matter what. The abundance of forgiveness and compassion that we can not only receive from him but generously share with everyone around us.

His Spirit of *a sound judgment*—a reasonable, disciplined, healthy, and balanced way of thinking and responding based solidly on his truth. Safe, calm, and self-controlled.

This is what Paul wanted Timothy to remember.

This is what Jesus wants us to know.

God does not give us this spirit of fear.

He gives us this: "The Spirit himself testifies together with our spirit that we are God's children" (Rom. 8:16).

He brings out the true colors and shapes of us; he puts the dancing and flying back into our hearts. No matter what we are facing, let's trust the One who loves us most to touch our spirits with his.

Dear Jesus, thank you that my relationship with you is safe and strong forever. You know every single thing that is going on in my life, and you are always in control. Please help me lean into you and trust your Spirit to lift me above my fears. Amen.

REFLECT

In your journal, write **2 Timothy 1:7** in your own words.

List some emotion words that mean the opposite of *afraid*. Circle one or two you would like to feel instead.

What fears are keeping you grounded instead of soaring right now?

REMEMBER

In your journal, write the key word (or a different word) you want to focus on in this verse. How will it help you hold on to this promise?

Draw an image to remind you that God gives us a spirit of power, love, and sound judgment.

God Is Our STRONGHOLD

Key word **stronghold** *(noun)*: a fortified place; a place of security or survival

The LORD is the stronghold of my life—whom should I dread?
Psalm 27:1

Whom should we dread?

Sometimes it is actually a person—a "whom" that we dread. A controlling or dangerous person that threatens our sense of physical or emotional safety. A human enemy. King David had several he is referring to here.

Sometimes we dread a "what." Some *thing*, a situation or possibility, scares us to death. A cancer diagnosis. The loss of a family member or friend. Failing at work. Being betrayed by someone we trust. A natural disaster. Another pandemic. The list of things we think would devastate us is real and daunting.

Ever since I became a mom, my worst fear has been that something tragic would happen to one of my boys. I often worry about their health or safety, but there have been a few significant times when the fear was strong enough to bring me to my knees.

Is something wrong with his heart? Why is he so weak?

People have died on that hike. What if he falls?

That car is coming too fast. He doesn't see it!

That kind of fear wipes out every ounce of strength I have in my body, leaving me helpless and weak. Sometimes when I feel this terrified, I have to grab onto something secure to physically hold me up. A person. A railing. A chair.

Emotionally and spiritually, I try to hold on to this promise. I learned it in the King James Version: "The LORD is the **strength** of my life."

Believing that God is the strength of my life helps me when I can't hold myself up. I picture him holding me steady and helping me stand when my legs cannot.

But a stronghold is more than something to hold onto. It is the most fortified part of a castle—the place deep inside with several layers of protection and security. Walls upon walls surround it and make it safe.

That's what God is for us.

God will make us strong in our times of fear, but he does more than that. He promises complete protection if the things we worry about actually happen. We can be sure that if the dreaded phone call comes, he's got us. He will take us right to the stronghold of his presence. He will help us and defend us as we grieve and recover. He will keep us safe.

This psalm begins with this: "The LORD is my light and my salvation—whom should I fear?"

So when we are afraid, we can remember that Jesus is our **light**. In the darkest darkness, we always have his hope.

And when we are suffering, we can remember that he is our **salvation**. Our *real* life to come, where there will be no more sadness, no pain, and no fear.

What a **strong** truth to **hold** on to.

Dear Jesus, in my weakness, you are so strong. Thank you for the way you protect me when fear threatens and terrible things happen. Please hide me and keep me safe in your stronghold today. Amen.

REFLECT

In your journal, write **Psalm 27:1** in your own words.

What does this promise reveal to you about how God works?

If your worst fear comes true, how will being in God's stronghold help you?

REMEMBER

In your journal, write the key word (or a different word) you want to focus on in this verse. How will it help you hold on to this promise?

Draw an image to remind you that God is your stronghold today.

God Is **WITH** Us

Key word **with** *(preposition)*: possessed
of, in company of; beside

"Do not fear, for I am with you."
Isaiah 43:5

God is with us.

What a powerful, incredible, difference-making truth. We know that he was with Noah, Abraham, Moses, Ruth, Joseph, Esther, David, and so many others in all the stories of faithfulness and victory in the Old Testament. And it's not hard to imagine Jesus in the New Testament times—walking and talking and eating *with* his parents, *with* his disciples, and *with* all of his early followers during his time on earth.

Yet we don't exactly know how that is supposed to look and feel for us today. What does it mean that ***God is with us and we don't have to be afraid?***

Maybe it would be easier to understand the meaning of *with* if we think about the opposite for a minute.

> ***Without:*** *the* **absence** *or* **lack** *of something or someone.*

Oh. I get that. I feel that terrible ache in my heart when some of our little kindergartners cry at school because they want their mom or dad. They are scared—sometimes to the point of absolute panic—because they are *without* the only thing they think will keep them safe. The absence, the lack of their parents' presence is terrifying for them. They feel vulnerable and alone without the protection and love that brings. They are desperate for the reassurance that they can reach up and hold a bigger, stronger, familiar hand and get what they need.

So, when they run smiling and relieved into their parents' arms at the end of the school day, that must be what it means to be ***with. Possessed of, in the company of; beside.***

We can get scared like these little ones. We often feel alone, weak, unprepared for the battles we have to fight. We panic. We miss Jesus, the

only one we know who can keep us safe. We forget that even though we can't see him, he is right beside us. ***With*** us.

We don't have to experience that awful separation anxiety. We don't ever have to be *without* him. We are not lacking or needing a single thing when we live in the company of Jesus.

Jesus really is with us. Through his Spirit who dwells within us, he is *with* our hearts, *with* our minds, *with* our bodies and souls. We are *possessed* of him. We are *in his company*. He is right *beside* us. His Spirit of understanding will guide us through illness, betrayal, loss, and struggle. His Spirit of comfort will hold us when we cry. His Spirit of power will surround us with protection when we are feeling overwhelmed. His Spirit of peace will reassure us when we feel unsettled.

What a relief to be able to live in this closeness—in the comforting, powerful, victorious presence of Jesus.

What a relief that we never have to be without him.

Dear Jesus, thank you for being with me every moment of my life. When I struggle with fear, I will remember that you are right here bringing me your strength and peace. Thank you for this deep relief. Amen.

REFLECT

In your journal, write **Isaiah 43:5** in your own words.

Do you have any questions for Jesus about this promise?

What is keeping you from experiencing the presence of Jesus with you right now?

REMEMBER

In your journal, write the key word (or a different word) you want to focus on in this verse. How will it help you hold on to this promise?

Draw an image to remind you that God is with you in whatever you face today.

Promises for When You Feel Anxious

Jesus Stands AMONG Us

Key word **among** *(preposition)*: in the midst of; in company with

Jesus came, stood among them, and said to them, "Peace be with you."
John 20:19

READ

The disciples were in trouble. We can imagine that they were beyond exhausted, heartbroken, and terrified. Jesus had been crucified, and now his body was missing. They didn't know much except that they were in real danger. They gathered behind locked doors, trying to process what had happened and figure out what to do.

And **"Jesus came, stood among them, and said 'Peace be with you.'"**

Jesus came to the place they were hiding and hurting. He came through locked doors to be in the midst of them, to be in their company. He **"stood among"** them.

And what were his words?

"Peace be with you."

Jesus knew his disciples so well.

He knew they were panicking and terribly afraid. But he also knew that fear was not the only emotion they were overwhelmed by that day. His closest friends, his once deeply loyal followers, were probably completely devastated and filled with regret. Not only had they lost their leader whom they had given their lives to for the past three years, but they had repeatedly failed him in just the past twenty-four hours. They had fallen asleep when he asked them to pray with him. They had abandoned him when he was in trouble. More than once they had denied that they knew him. And now they were unsure about everything he had ever told them.

Their anxiety must have been all-consuming.

And right in the middle of their fear and confusion, Jesus showed up. He physically came, stood among them, and gave them what they needed most.

He gave them peace.

As he stood there among them, Jesus reassured their hearts:

Their terrified hearts were relaxed for him to be among them again.
Their shame-filled hearts were relieved for him to be among them again.
Their broken hearts were healed for him to be among them again.
Their confused hearts were calmed for him to be among them again.

There was still a lot of stress ahead for them, but Jesus would meet every need. He promised.

And that is still true for us today.

All these years after he lived and died, we have different struggles from the disciples. For other reasons we feel doubt, regret, fear, grief, and uncertainty. We find ourselves in trouble because of sin and selfishness (our own and others'), and we fail to follow him perfectly. We don't understand everything the way Jesus does.

Our anxiety can be all-consuming, too.

And what does Jesus do? He comes to be with us. He gets in the middle of it with us. He doesn't promise that the hard things will go away, but he promises to meet our every need.

He comes to stand among us, too.

Dear Jesus, you understand how awful I feel when I am anxious. Thank you for your promise to come and be with me in the midst of my stress. I trust you to calm my heart with your perfect peace. Amen.

REFLECT

In your journal, write **John 20:19** in your own words.

What does this promise reveal to you about God's character?

How would it feel to see Jesus standing among you right now?

REMEMBER

In your journal, write the key word (or a different word) you want to focus on in this verse. How will it help you hold on to this promise?

Draw an image to remind you that Jesus is standing among you today.

Jesus CARES about Us

Key word **cares** *(verb)*: to feel interest or concern; look out for, mind, watch

Casting all your cares on him, because he cares about you.
1 Peter 5:7

Peter uses a fishing term when he tells us what to do with our anxiety. ***Cast*** it all on Jesus, he says. Throw that stuff out there, get rid of it, heave or hurl it away. In the same way a fisherman casts his line way out into the deep water, Peter says to cast away all the things we are worried about.

The really good news about this:

As followers of Jesus, when we cast our anxiety away, we don't just send it out into the atmosphere somewhere. When Jesus invites us to **throw it all onto him,** he truly wants to catch it.

In kindergarten P.E., kids learn about the basic skills of throwing and catching. Both the thrower and the catcher have important jobs.

The **thrower** needs to focus on their target (the catcher).

The **catcher's** job is to be "ready"—looking at the ball with hands open, expecting to catch it.

Can we picture Jesus this way? As our catching partner with his eyes focused on us and his hands open to receive all the anxieties that are overwhelming our hearts?

As I write this, I hold a bulky ball of anxiety in my hands. My worries about so many things and people have increased lately, and the weight seems extra heavy today. Jesus is reminding me that he can handle it ***all***. He can take care of them, he can take care of me, and he promises hope and good and peace.

He's nudging me to cast this all on him, but as usual I hesitate.

Is he ready to catch it?

What if he already has his hands full?

What if my throw is a bit off target?

What if I am too worn out to make the throw?

That's when I remember the even better news about this:

The reason Jesus asks us to cast our worries and cares on him is because of the devoted, wise, and unconditional compassion he feels for us. He wants to take ALL of our anxious thoughts and feelings because **he cares so much**.

He is extremely interested in us.

He is protectively looking out for us.

He is always thinking about us, watching us carefully, and deeply concerned with how our hearts are doing.

He is focused and ready even when we are not. All we have to do is keep our eyes on him and throw.

Dear Jesus, thank you for always paying attention and for being ready at all times to take what I am struggling with. You will catch my sudden passes, my slow, deliberate handoffs, and every kind of crazy throw I could possibly make. Thank you for caring so much about me. Amen.

REFLECT

In your journal, write **1 Peter 5:7** in your own words.

How would you explain this Scripture promise to a young child who is feeling *anxious*?

What cares do you need to cast on Jesus today?

REMEMBER

In your journal, write the key word (or a different word) you want to focus on in this verse. How will it help you hold on to this promise?

Draw an image to remind you that Jesus cares about you.

Jesus Is the First and the LAST

Key word **last** *(adj)*: the only remaining; supreme, ultimate, conclusive, consummate

"Don't be afraid. I am the First and the Last."
Revelation 1:17

"Don't be afraid," Jesus says.

But we *are* afraid, we anxious ones confess. It gets exhausting, doesn't it, worrying about the future? We don't know what is going to happen. We don't know what to expect. And we tend to catastrophize things, imagining the worst.

Our anxiety feeds on the unpredictability of this life. The blurring pace, the changes we don't see coming, and the constant access to every single thing that is going on make our heads spin. We sometimes feel like we know too much and not enough at the same time.

We worry about how the stories of our lives will end.

Will our loved ones be okay?

Are our finances secure?

What about our health, our jobs, our plans?

The "what if's" never stop, and Jesus knows we worry.

Here in the final book of the Bible, Jesus reveals to John incredibly mysterious and unusual things. No one has ever seen anything like this—the golden lampstands, the seven stars, one like the Son of Man with a double-edged sword in his mouth, his face shining like the sun at full strength. And that is just the first chapter.

John finds it all pretty difficult to understand, as do we. In fear, he falls to the ground at the feet of the messenger from heaven.

And Jesus places his hand on John to assure him.

> Don't be afraid. I am the First and the Last, and the Living One. I was dead, but look—I am alive forever and ever, and I hold the keys of death and Hades. (Rev. 1:17–18)

Jesus tells us he is in control of the outcome of our life and our death.

Okay, that's good to know.

Because I am one who gets really uncomfortable when the middle of the story is scary, sad, or full of conflict. I don't like that part. There are times I watch my favorite movies by fast-forwarding through the problems to get to the happy ending. Even though I know that struggle is critical to the story, watching the characters get misunderstood, hurt, and depressed takes a toll on my sensitive heart.

But maybe that's where we are in this life—in the messy middle where things don't seem that they are going to end well. Maybe this part of our story has been extra hard on our hearts.

That's when we need to remember that Jesus is the First and the Last:

> *He is the only complete One, our perfect King forever.*
> *He alone has conquered death once and for all.*
> *He is the One who makes everything—and everyone—new.*

We can look forward to the happiest of endings with him.

———————

> *Dear Jesus, sometimes I wish I could fast-forward*
> *through this part of my life. Please help me trust you*
> *with all the things that feel unresolved and scary.*
> *Thank you that your victory over death assures me*
> *that this life is not the end of my story. Amen.*

REFLECT

In your journal, write **Revelation 1:17** in your own words.

Look up this verse in a few other Bible translations or paraphrases (https://www.biblehub.org and https://www.blueletterbible.org are two online resources you can use to do this). Write what you notice.

How might you feel if you were assured that your current messy middle would end well with Jesus?

REMEMBER

In your journal, write the key word (or a different word) you want to focus on in this verse. How will it help you hold on to this promise?

Draw an image to remind you that Jesus is the First and the Last.

Jesus Gives Us His **PEACE**

Key word **peace** *(noun)*: freedom from
disquieting or oppressive thoughts or
emotions; a state of tranquility, calm

*"Peace I leave with you. My peace I give to you. I do not give to you
as the world gives. Don't let your heart be troubled or fearful."*
John 14:27

We all want the peace Jesus promises, don't we?

Especially now. We all have too much to handle on our own in this life. Overwhelming emotions and high-stress situations threaten to drain our energy and leave us empty. In our hurry to find relief, we do what I did this morning. We look for the peace the world gives—even though we know it isn't a real thing. Searching Google, shopping online, and mindlessly scrolling through social media often just makes us more anxious.

When we remember to open our Bibles to look for peace, we can read beautiful psalms, letters of encouragement, and stories about Jesus that reassure us of his love and care.

But today I found myself in Revelation. This is a book I haven't spent much time in, and it's definitely not one that I would expect to bring me peace. To be sure, there is so much hope and victory in this wrap-up of the Bible, but the descriptions of the end-time and tribulation confuse me. The letters to the seven churches make me nervous about my own rebellious ways. Visions of unusual animals and bright lights and loud noises—it all feels like too much for my anxious soul.

I imagine shrinking into the crowd before the throne of God and feeling lost, unnoticed, and terrified.

Until I read this:

> For the Lamb who is at the center of the throne
> will shepherd them;
> he will guide them to springs of the waters of life,
> and God will wipe away every tear from their eyes.
> (Rev. 7:17)

That sounds like the kind of peace we need right now.

"The Lamb . . . at the center."—Jesus represents gentleness and calm in the midst of the overwhelming majesty and awesome power of God's throne.

Won't he also come gently to us in the middle of our stress, our pain, our fears today?

"Shepherd . . . will guide them."—With wisdom and protection, Jesus will lead his sheep to what they need.

Won't he compassionately lead us to a peaceful place to calm and strengthen our souls right now?

"Springs of the waters of life."—He offers his children living water, inviting them to experiencing ever deeper the refreshment of closeness to him.

Can we let him nourish and sustain us through whatever we are facing in this moment?

"God will wipe away every tear from their eyes."—Every tear. The tears held back when it isn't okay to cry, the ones that unexpectedly spill down stinging cheeks, and the ones that soak silently into pillows in the middle of the night.

Can we picture him gently wiping our tears away and holding us close through our hardest times?

"Don't let your heart be troubled or fearful," he tells us.

He will help us now, and he will give us his peace forever.

Dear Jesus, thank you for your peace that is lasting and true, not fleeting or empty like the kind I try to find in the world. I need your perfect peace to surround and fill me as I go into this day. Amen.

REFLECT

In your journal, write **John 14:7** in your own words.

As you think about this promise, list some things you can be grateful for.

How does the image of Jesus wiping your tears away help you in your current stress?

REMEMBER

In your journal, write the key word (or a different word) you want to focus on in this verse. How will it help you hold on to this promise?

Draw an image to remind you that Jesus gives you his peace.

Jesus Is Our SHEPHERD

Key word **shepherd** *(noun)*: a person
who tends sheep; a pastor

The LORD is my shepherd; I have everything I need.
Psalm 23:1 GNT

Instead of *"I have everything I need,"* many translations of this comforting psalm say, "I shall not want."

But sometimes we **do** want.

We want things to be different. We want to feel better. We want the healing, the relationship, the results, the answer, the relief. And we often feel like these are not simply *wants* but *needs*.

David wrote this psalm as one who clearly understood sheep. A shepherd knows these vulnerable animals require constant care. They need mineral-rich pastures cleared of weeds and holes. They need a continual supply of clean water and fresh hay. They need shelter to protect them from the hot sun and bitter cold and fences to keep them from wandering away. They need care for their injuries and oil applied regularly to prevent parasites. They need a brave and alert protector willing to sacrifice sleep and risk physical harm to fight off predators.

David was a devoted shepherd who not only knew the needs of his flock but had both the strength and the desire to take care of them. So, when he wrote Psalm 23 beginning with, **"The Lord is my shepherd, I have everything I need,"** we can believe him.

Jesus, our good Shepherd, cares for us in this intimately personal, protective, and sacrificial way.

But does that mean we will never suffer? Does that mean followers of Jesus won't get hurt, feel betrayed, lose someone they love, or experience dark times?

I can't think of one friend of mine—Christian or not—who has been spared the grief and stress of this life.

So, what is the promise then?

If we belong to the fold of Jesus, can we really trust that he will give us everything we need?

In his book, *A Shepherd Looks at Psalm 23*, W. Phillip Keller (a pastor and former shepherd) answers this question by comparing his friends. Some of them (who do not know Jesus) are extremely affluent and successful by the world's standards, yet he described them as "poor in spirit, shriveled in soul, and unhappy in life."[2]

By contrast, many of his Christian friends who had "known hardship, disaster, and the struggle to stay afloat financially," he described as being "rich in spirit, generous in heart, and large of soul. They radiate a serene confidence and quiet joy that surmounts all the tragedies of their time. They are under God's care and they know it. They have entrusted themselves to Christ's control and found contentment."[3]

Serene confidence, quiet joy, contentment. Everything we truly need comes from him:

> *A safe place to settle with him, an unlimited supply of living water, restoration for our souls. Guidance in the right direction, real comfort and companionship in the scariest, darkest times, provision—abundance—even in the midst of stress. The soothing protection and healing of his Spirit, overflowing grace, goodness and compassion no matter what happens, and the hope of life forever with him.*

> *Dear Jesus, you are my good shepherd. You are always watching over me and faithfully attending to every single one of my needs. Thank you for sacrificing your life for mine and making me yours. Amen.*

REFLECT

In your journal, write **Psalm 23:1** in your own words.

List some emotion words that mean the opposite of *anxious*. Circle one or two you would like to feel instead.

What wants and needs can you bring under Jesus's care today?

REMEMBER

In your journal, write the key word (or a different word) you want to focus on in this verse. How will it help you hold on to this promise?

Draw an image to remind you that Jesus provides for all of your needs.

Jesus SINGS over Us

Key word **sings** *(verb)*: producing
musical or harmonious sounds

The LORD your God is among you, a warrior who saves.
He will rejoice over you with gladness. He will be quiet
in his love. He will delight in you with singing.
Zephaniah 3:17

One of the most stressful places to be is in a hospital. Not only is it scary and uncomfortable for the patients, but also for those of us who love them. We wait and worry there. We imagine the worst. We feel helpless, alone, and lost. Sometimes we feel hungry, tired, cold, or worried that our phone battery will run out and we will lose connection with our regular life.

We wonder if we already have.

Hospitals are serious, sometimes life-altering places to have to be. I've spent more time than I'd like to think about waiting in hospital rooms and emergency departments. I've sat with my parents, my sister, my husband, and my sons at several different hospitals over the years, and even though it was mostly hard and awful, one of them has a special place in my heart.

Tacoma General is my favorite hospital because of a song.

Occasionally, a short and sweet melody chimes through the speakers in that stark, old ceiling. "Twinkle, Twinkle Little Star" gently interrupts every anxious mind and heart and signals the miracle of a baby's birth. We silently celebrate the new little life that has come into our world. Nurses, doctors, staff, patients, and visitors—we all recognize the simple tune. And together we draw a much-needed breath of joy and calm.

If a few notes of a children's song can bring a moment of peace to a busy hospital, how much more will a God song calm our stressed-out hearts?

This promise is about more than a comforting tune during a stressful time. God tells us so much about *how* he loves us here:

He tells us **he is among us**—right beside us as we struggle with anxiety and fear.

He tells us that **he is a warrior**—strong and valiant and actively fighting on our behalf.

He tells us that **his love is quiet and calming when we need it to be.** Like in the hospital. Or in the middle of a really tough day. Or when we are overthinking everything. Or when the little ones all need our attention at the same time.

And he tells us that **he rejoices over us.** That **he delights in being with us.** So much that it makes his heart sing.

Can we picture that?

Jesus coming close and covering us with his tender, strong love.

Jesus singing gently over us and valiantly fighting for us at the same time.

Jesus helping us to take a deep breath of peace in the most stressful times.

Let's listen for his comforting song.

Dear Jesus, I smile when I imagine you singing over me. Please calm all these anxious thoughts in my heart and help me feel your strong presence. Thank you for loving me so powerfully and quietly at the same time. Amen.

REFLECT

In your journal, write **Zephaniah 3:17** in your own words.

What does this promise reveal to you about how God works?

What song helps calm you? Can you imagine Jesus singing it over you?

REMEMBER

Write the key word (or a different word) you want to focus on in this verse. How will it help you hold on to this promise?

Draw an image to remind you that God is singing over you today.

The Peace of God
SURPASSES Understanding

Key word **surpass** *(verb)*: to transcend the reach, capacity, or powers of; to go beyond, exceed

And the peace of God, which surpasses all understanding, will guard your hearts and minds in Christ Jesus.
Philippians 4:7

READ

Anxiety does strange and awful things to our bodies. I can't exactly understand or explain how they are affected by the increase in cortisol and adrenaline, but I know that most of the time it doesn't feel good. Stress causes some of us headaches or other physical pain. Some of us struggle with heart palpitations and increased blood pressure when we get anxious. Others find themselves with irritating skin reactions like hives or blotches.

In my family, anxiety presents itself mostly in the gut. Our medicine cabinet is full of Tums, Prilosec, Pepto Bismol, and other digestive relief products. It takes lifestyle change, rest, and time to remedy the effects of stress on our systems.

And what about our minds? Sometimes I feel like my brain has been shocked by an anxiety attack, and I lose my power to think clearly or calm myself down.

I'm writing this after suffering one of those attacks this morning because we all need to know this promise is true.

"The peace of God, which surpasses all understanding, will guard your hearts and minds in Christ Jesus."

It came to mind as I boarded a plane by myself in the middle of a family emergency. I felt physically dizzy and weak, my stomach was churning, and I was on the verge of tears. I tried to calm myself down, I tried to find comfort in the kind texts from friends, and I desperately tried to pray. Nothing was really working.

This verse came to my mind, as it often does when I ask Jesus to give me his peace. I tried to imagine what it means to have his kind of peace—the peace that surpasses all understanding.

The Greek word used here for *surpass* is ***hyperecho***, which is defined as *superior, higher, better,* and *supreme.*

Where do we find this kind of peace? Does "higher and better" mean God's peace is somewhere way up above our anxiety?

I'm pretty sure that's not what it means. Here I was, thirty thousand feet in the air asking for this kind of peace, and my problems were right there with me. I could still feel all the stress.

And then I felt something new.

A breath of calm seemed to flow inside and outside of me at the same time. It wasn't coming from a specific direction, and I couldn't distinguish where I felt it in my body. The only way to describe it was that something good was happening. My body relaxed. My mind felt clear.

For a beautiful few moments, my heart felt the presence of Jesus. I was overcome with the absolute assurance that he was right there with me. The peace that seemed impossible to find or understand found me.

His peace can transcend our situation, our location, our bodies, our minds, and our emotions. He can permeate our whole being with his exceedingly above and beyond, incomprehensible peace.

Dear Jesus, you know how anxious I feel, and the way it affects me. Thank you for having the power to transcend my mind and my body and bring me calm. Help me feel your surpassing peace. Amen.

REFLECT

In your journal, write **Philippians 4:7** in your own words.

Do you have any questions for Jesus about this promise?

What do you need the peace of Jesus to surpass today?

REMEMBER

In your journal, write the key word (or a different word) you want to focus on in this verse. How will it help you hold on to this promise?

Draw an image to remind you that God's peace can surpass your understanding.

Promises

for When

You Feel

Ashamed

We Can APPROACH God's Throne with Boldness

Key word **approach** *(verb)*: to move closer to; to come near

Therefore, let us approach the throne of grace with boldness, so that we may receive mercy and find grace to help us in time of need.
Hebrews 4:16

READ

For those of us who fear the disapproval of others, *approaching* can be really difficult.

Approaching a friend with a problem. Approaching a boss with a request. Approaching a teenage child with a disappointment. Approaching a partner with a confession.

I picture myself going to the person with a heavy bag of guilty feelings and hoping they will take it from me.

But that isn't how it usually works, is it?

The way it usually works is that human responses can range from hurtful and angry to politely tolerant or even kind, but we just don't know what to expect going in.

Except when we go in to see Allyson. Allyson is the office manager at the school where I teach. She has the most demanding and pressure-filled job of anyone in the entire building, yet she never seems overwhelmed or stressed out. She constantly gets interrupted by people needing her to take care of their problems and figure out complicated details. She has so much to do, yet she welcomes each and every person with warmth and a willingness to help.

The smile in her eyes is genuine.

No matter what we bring to her, we don't feel nervous or unsure about approaching Allyson. Yet she is human. She has Jesus in her heart, but she has her limits (even if we haven't ever seen her reach them). And it is possible that her grace-filled spirit could be overcome by frustration or exhaustion at some point. And it is even a tiny bit possible, for those of us who worry about rejection or dismissal, that we could approach her at one of these rare times and experience that.

But with Jesus, we never, ever have to worry about our approach. We can count on him 100 percent of the time to welcome us to his throne as his forgiven and beloved children.

His throne of what? Not his throne of condemnation, or blame, or retribution, but his throne of *grace*.

Because of grace, we can be brave as we approach him with our bags of guilt.

We don't have to be afraid of getting in trouble. Or making him mad. Or getting sent away.

We can come to him no matter what we have done, no matter what we need, no matter how we feel, and be assured that he will receive us with open arms. His powerful victory over sin and death can give us the courage we need to come right up close to him. He has so much for us there.

Written in this promise are two things we need the most: mercy and grace.

> **Mercy**—*We come to his throne with sinful hearts, and he does not give us the punishment we deserve.*
> **Grace**—*We come to his throne with desperate hearts, and he gives us gifts beyond measure that we could never earn.*

Let's approach him with humility and boldness today.

> *Dear Jesus, I come to you humbly confident of your merciful welcome. Please increase my boldness and help me trust you completely with all my fears and failures. Thank you for promising that everything I need can be found at your throne of grace. Amen.*

REFLECT

In your journal, write **Hebrews 4:16** in your own words.

What does this promise reveal to you about God's character?

How would you describe the way you approach Jesus?

REMEMBER

In your journal, write the key word (or a different word) you want to focus on in this verse. How will it help you hold on to this promise?

Draw an image to remind you that you can approach God's throne with boldness.

Jesus Does Not CONDEMN Us

Key word **condemn** *(verb)*: to declare to be wrong, guilty, reprehensible; to blame or sentence

"Neither do I condemn you," said Jesus. "Go, and from now on do not sin anymore."
John 8:11

READ

"Neither do I condemn you."

What life-changing words Jesus says here.

He says them to someone we only get to read a few sentences about in the book of John:

The woman caught in adultery. The adulterous woman.

We don't get to know her name or anything else about her life. The only thing we get to know about this woman is her shame.

In this short Bible passage, we learn that she has been caught in bed with someone she is not married to, dragged into the temple, and thrown down in front of Jesus and a crowd of people. The Pharisees questioned Jesus, determined to trap him. Should she be put to death? Would he follow the Mosaic laws or the Roman rule?

Jesus was in what seemed to be a lose-lose situation.

So was the woman caught in adultery.

And sometimes so are we.

When shame surrounds us and we feel like there is no way out, we can almost imagine what it must have been like for this woman in this literal circle of accusing voices.

Whether she felt like she deserved it or not, she was about to be condemned to a horrific and agonizing death by stoning. The rocks were hard and sharp, and the men were ready to throw them.

But Jesus had a better plan. He always does.

He stooped down. He put himself on the same level as this woman. He acknowledged her, protected her, and graciously gave her a moment of dignity.

He surprised everyone. Whatever Jesus wrote in the sand struck the heart of each person there. One by one, the accusers dropped their stones and walked away.

He saved her from punishment. Jesus forgave her in this moment for all of her sin—the adultery and everything else. He spared her life and told her he did not condemn her.

He set her on a new path. He gave her a fresh start. "Go now and leave your life of sin" (NIV).

Any one of us could be this woman in this story standing in our shame. We cringe in fear and embarrassment picturing ourselves in the center of public accusation. Or we create our own ring of judgment and self-criticism to continually beat ourselves up.

But Jesus comes to us in our circles of shame, too. And what does he do?

He stoops down to show us that he is still with us.

He surprises us with good that we could never have imagined.

He saves us from the punishment we deserve.

He sets us on a new path and continues to lead us in a life of redemption with him.

Jesus tells us he does not condemn us.

Let's drop the rocks and trust his heart.

Dear Jesus, you did not come to judge me but to save me with your love. Thank you for your complete forgiveness for every single sin I have ever committed. I trust you to break up my circle of shame and draw me closer to you. Amen.

REFLECT

In your journal, write **John 8:11** in your own words.

How would you explain this Scripture promise to a young child who is feeling *ashamed*?

What rocks of condemnation can you bring to Jesus right now? (Imagine each rock having a condemning phrase written on it. What do the phrases say?)

REMEMBER

In your journal, write the key word (or a different word) you want to focus on in this verse. How will it help you hold on to this promise?

Draw an image to remind you that Jesus does not condemn you.

Jesus Gives Us a DOUBLE Portion

Key word **double** *(adjective)*: being twice as great
or as many; of extra size, strength, or value

*Instead of your shame you will receive a double portion, and instead of
disgrace you will rejoice in your inheritance. And so you will inherit
a double potion in your land, and everlasting joy will be yours.*
Isaiah 61:7 NIV

READ

Shame is a heavy thing to hold. We easily pick it up throughout our lives but seem to have a hard time setting it down. For me, shame that comes from others feels heavy enough, but the weight of shame that comes from my own heart is crushing.

I pray and ask Jesus to forgive me, yet I walk around with this load of self-criticism and unforgiveness that I feel like I deserve to carry.

I wonder if you do that, too?

Why? If we believe Jesus took our shame to the cross and forgave us for every single thing we have ever done, why do we do this?

Do we mistakenly think that if we continue to beat ourselves up about old sins, regrets, and mistakes, we might be able to "work off our debts" a bit?

Or do we have the impression that if he sees us struggling along with these heavy shame burdens, it will make us more "forgivable"?

Isaiah 61 reminds us that neither of those things is true. He doesn't need our help with shame holding. Or grace giving.

I smile, especially as I read verse 7, because the idea of a double portion reminds me of going out for ice cream when I was a kid. A stellar report card or good-citizen award at school occasionally meant that our family would take a trip to the local Baskin-Robbins. One scoop was the usual reward, but once in a while we would be treated to two.

A DOUBLE scoop.

TWO flavor choices.

TWICE as much ice cream.

It was the best reward.

And here in this promise, God turns the whole idea of having to earn that double-scoop upside down. We are aware that our shameful condition, our disgraceful behavior does not warrant a trip to the ice-cream shop, but God takes us anyway. By giving us a double portion when we have done so much wrong and so little right, he reassures us that we are his deeply loved and valued children. No matter what we have done wrong, no matter how bad we feel, and no matter how hard we work to do better, his unconditional love for us cannot increase or decrease.

We just can't earn it.

He wants so much for us to live like we believe this. His favor is a free gift, guaranteed with no strings attached. He promises that if we will give him all the weight of our shame, he will replace it with complete freedom, deep relief, and surprising joy.

Let's hold our double scoop of grace with both hands today.

Dear Jesus, I don't deserve this double portion of grace, yet you freely give it to me. Please help me stop carrying around my shame and trust you to take it. Thank you for the everlasting inheritance of joy that comes from belonging to you. Amen.

REFLECT

In your journal, write **Isaiah 61:7** in your own words.

Look up this verse in a few other Bible translations or paraphrases (https://www.biblehub.org and https://www.blueletterbible.org are two online resources you can use to do this). Write what you notice.

What specific point of shame can you trade for a double portion of Jesus's grace right now?

REMEMBER

In your journal, write the key word (or a different word) you want to focus on in this verse. How will it help you hold on to this promise?

Draw an image to remind you that God gives you double today.

God Is **FOR** Us

Key word **for** (preposition): on behalf
of; in favor of, representing

If God is for us, who is against us? He did not even
spare his own Son but gave him up for us all. How
will he not also with him grant us everything?
Romans 8:31–32

READ

Sad things, scary things, and hard-to-understand things are happening to so many people I know. Life seems so hard—especially lately. Everybody seems to be stressed and struggling. We all need someone who truly understands what is really going on in our lives, our families, our bodies, and our hearts. We need someone who can help us hold the heaviness that feels like too much.

We need to know that someone is in our corner.

This promise assures us that we have God in ours. When we feel like the almost-beaten fighter who stumbles back to his corner man for relief, we can count on him to take care of us. He is in our lonely corners, our terrified corners, our disappointed corners, our guilt-ridden corners, and our painful corners. He knows exactly what we need. He wants to restore us, to heal us, to give us his strength and peace.

But sometimes we question: *Why am I going through this? Is God punishing me? How can he be "for me" when I fail to live the way he wants me to?* The extra-hard thing about some of the corners we find ourselves in is that they are complicated with shame. Lies from the enemy tell us this is what we deserve or that God doesn't care about what is happening to us. When we do this, when we join our opponents and start beating ourselves up from the inside, we are in grave danger of losing the fight. And that is exactly when and where we need to hold onto this promise from God. We need to believe that *he is for us*.

He chose us before we did anything good, bad, right, or wrong.

He knew that we would have trouble in this world and that we would go our own way.

He did not even spare his own Son but gave him up for us all.

When God gave us Jesus, he showed us that he was committed to us. The ultimate sacrifice. A gift we could never earn or possibly repay. If he has already given us his only Son to die for us, can't we be sure that he will give us all the other things we need?

"How will he not also with him grant us everything?"

Strength. Help. Courage. Freedom. Redemption. Peace. Hope. And so much more.

His Spirit reminds us of the truth that we are completely forgiven and safe with him. We don't have to keep punishing ourselves.

God is in our corner, but he is also in the ring with us. He is not simply watching us struggle, occasionally handing us water or patching up a cut. He is right beside us and fighting for us day and night. No one and nothing—not even our shame—can knock us out when we have God on our side.

He is for us.

Dear Jesus, you are my Protector and my Savior. I kneel here in my corner and surrender everything to you today. Thank you for fighting for me. Amen.

REFLECT

In your journal, write **Romans 8:31–32** in your own words.

As you think about this promise, list some things you can be grateful for.

What battles are you facing today that could be opportunities for Jesus to fight for you?

REMEMBER

In your journal, write the key word (or a different word) you want to focus on in these verses. How will it help you hold on to this promise?

Draw an image to remind you that God is for you.

God's Heart Is GREATER than Ours

Key word **greater** *(adj)*: of an extent, amount, or intensity considerably above the normal or average; more, higher

This is how we will know that we belong to the truth and will reassure our hearts before him whenever our hearts condemn us; for God is greater than our hearts, and he knows all things.
1 John 3:19–20

A good percentage of a kindergarten school day is spent working on letters, sounds, sight words, numbers, art, music, and movement activities. And, of course, social skills. "Hands to yourself," "Put a bubble in your mouth" (when it's time to be quiet), "Where should you be?" and "Wait your turn," are repeated constantly.

Most of the time, kids respond with the appropriate choices.

My heart breaks, though, for the ones who seem to be crushed by even gentle correction. I relate to these sensitive souls who become inconsolably sad to have done something wrong.

"It's okay," I tell them quietly. "I'm not mad. You're not in trouble. We all make mistakes." All the things I needed to hear when I was young. But sometimes the tears keep flowing and the shoulders keep shaking. One little guy actually started hitting himself in the head with both fists in frustration and shame.

Some of us get stuck in the overwhelming feelings of self-condemnation and shame, don't we? It's hard to move on.

Maybe a hug, maybe a distraction, maybe something funny will help. I will always keep trying to calm an upset child.

But shame can be terribly stubborn, can't it? It likes to linger much longer than it should and make things worse than they are. It can take forever to get over some things.

This promise is especially meaningful to people like me whose inner critic is loud and relentless and likes to stick around.

"Whenever our hearts condemn us." Most of the time, over and over, long after we have confessed and been forgiven. Yes, all those times we still feel guilty and wrong and limited by past mistakes.

"We belong to the truth." Jesus died on the cross to pay for the sins of everyone in the world. That includes us. Every single sin we have confessed and repented of has been removed as far away as the east is from the west. He tells us that we are his righteous, completely forgiven children.

"God . . . knows all things." There is nothing we can keep secret from God. He knows every detail of our past, present, and future. His perspective is so much higher and wider than ours, and he knows us better than we know ourselves.

"God is greater than our hearts." The heart of our God is overflowing with grace. Even if we still feel like we need to beat ourselves up, we can cling to his words. He views us through the lens of Christ's perfect record. He sees us through his merciful eyes of love.

Charles Spurgeon said, "Sometimes our heart condemns us, but, in doing so, it gives a wrong verdict, and then we have the satisfaction of being able to take the case into a higher court, for 'God is greater than our heart, and knoweth all things.'"[4]

He's not mad. And we are not in trouble.

Let's trust his heart that is so much greater than ours.

Dear Jesus, you know my heart. I confess my
sins and ask you to take all my shame. Please
help me trust your heart more than I trust mine.
Thank you for your truth and grace. Amen.

REFLECT

In your journal, write **1 John 3:20** in your own words.

List some emotion words that mean the opposite of *ashamed*. Circle one or two you would like to feel instead.

What shaming thoughts can you bring to a "higher court" and let God preside over?

REMEMBER

In your journal, write the key word (or a different word) you want to focus on in these verses. How will it help you hold on to this promise?

Draw an image to remind you that God's heart is greater than yours.

God's Mercies Are NEW Every Morning

Key word **new** *(adj)*: made or become fresh; not known or experienced before

Because of the LORD's faithful love we do not perish, for his mercies never end. They are new every morning; great is your faithfulness! Lamentations 3:22–23

READ

Mercies. Gifts of kindness, gentleness, and compassion *toward someone who is undeserving of them.* This "someone" is us. We need God's mercy so much. We are sinful and selfish, and we mess up a lot. It's easy to slip into a place of self-condemnation and discouragement when we forget about God's tender heart. We get critical of ourselves and others in this fallen world as we try to live like Jesus wants us to.

But this verse reminds us that even though none of us deserve them, he has *new ones for us* every morning. So, how do we really experience them? *What are these new mercies?*

I'm sure we could never list all the ways he shows us mercy. But it helps to think of some:

> *New forgiveness* for every single sin. Every morning, God washes us clean like they never happened.
> *New patience* with us. He keeps working on our hearts, no matter how many times he has to teach us and gently remind us of things.
> *New closeness* to him. He draws near to us and comforts us with his presence when we feel scared, sad, alone, or discouraged.
> *New sympathy* for all of our struggles, temptations, doubts, and fears. He doesn't get tired of our stuff.
> *New invitations.* He welcomes us to come talk to him, to bring everything to him, to simply be with him.

New reminders of his goodness to us. If we take a moment and look around, we can breathe in his creative, generous beauty.

New boosts of strength and hope when our hearts are heavy, especially then.

New joy. The deep kind that only he can give no matter what we are going through.

I smile when I think of this and make my morning coffee. New coffee. No way would I want to drink yesterday's sludge. At 5:00 a.m. (when I can't quite form a complete thought yet), I grind fresh beans and add crisp, cool water to the coffee maker. When it's done brewing and I pour that steaming, comforting stream into my coffee cup, the warmth and richness of the first sip sparks my brain and energizes my body. Like my mug full of deliciousness, every morning we get his new mercy as something we have not known or experienced before. This promise tells us we can count on it. He is already up and at it (of course, he never sleeps)—washing out the old yuck and giving us a brand-new start.

We can wake up to this. We can open our eyes to his kind and loving heart that stands ready and waiting to free us, forgive us, and renew us with his amazing grace.

His faithfulness to us is so great.

Dear Jesus, I do not deserve your mercies, but I humbly receive them. Thank you for your steadfast love, your faithfulness, and your tenderness toward me this and every morning. Amen.

REFLECT

In your journal, write **Lamentations 3:22–23** in your own words.

What does this promise reveal to you about how God works?

What new mercies are you receiving from God this morning?

REMEMBER

In your journal, write the key word (or a different word) you want to focus on in these verses. How will it help you hold on to this promise?

Draw an image to remind you that his mercies are new every morning.

Promises for When You Feel

Discouraged

Jesus Came to Give Us Life in
ABUNDANCE

Key word **abundance** *(noun)*: a considerable amount;
a supply more than sufficient to meet one's needs

*A thief comes only to steal and kill and destroy. I have come
so that they may have life and have it in abundance.*
John 10:10

READ

Jesus was talking to some confused people here. People not too different from us—trying to do the right things, listening to those in authority, and occasionally wondering if something might be missing.

They had spent their whole lives learning and following the rules and traditions of their religious leaders. Wasn't that what they were supposed to do? But everything they thought they knew was being challenged now. The Pharisees were accusing Jesus and hyperfocusing on the laws, and he was talking about sheep and gates, calling himself their "good shepherd." They didn't know who or what to believe.

And sometimes we don't either. Even though we know Jesus died and rose again to free us from sin, we get caught up in this old way of thinking. It is so easy to get misled by the voices of others defining "good" Christian behavior. Too often, I find myself checking old boxes of do's and don'ts. Am I doing everything perfectly? Am I acceptable to my church?

Why does this feel so empty sometimes?

Maybe we need to pay attention to what Jesus said here: "A thief comes only to steal and kill and destroy."

Was he calling the religious leaders thieves? Some of them, yes, he was.

Because some of these Pharisees were not interested in helping God's people. They were focused on the laws—all 613 of them—and punishing those who broke them. Behavior was more important to them than the hearts of the people in their care. They were stealing their joy, killing their hope, and destroying their faith.

And Jesus, with his shepherd's heart, was determined to help his people understand.

"I have come so that they may have life and have it in abundance."

Jesus didn't want them to feel like something was missing anymore. He was with them now, bringing abundant life. Not abundant rules. Not abundant punishment, oppression, or fear. He had everything his sheep could possibly need and more.

He promises this life of abundance is for us, too. Even when it's confusing. Even when people disappoint us or we disappoint them. Even when we feel like we don't deserve it. Even if we have broken 613 laws.

Abundance—a considerable amount. A supply ***more than sufficient*** to meet our needs.

He gives us more than enough freedom.

He gives us more than enough grace.

He gives us more than enough of his presence and power to help us live the life he designed for us—fulfilled and redeemed in his unconditional love.

Even if we feel we have reached the limits of God's patience or forgiveness, he is never going to run out.

Our good Shepherd promises to always have more than we need.

*Dear Jesus, you are my good Shepherd, and I want
to follow you alone. Please help me break free
from the expectations of others and those I put on
myself. Thank you that you came to give me this
life of abundance and freedom in you. Amen.*

REFLECT

In your journal, write **John 10:10** in your own words.

What does this promise reveal to you about God's character?

What are you discouraged about that you can bring to Jesus right now?

REMEMBER

In your journal, write the key word (or a different word) you want to focus on in this verse. How will it help you hold on to this promise?

Draw an image to remind you that Jesus came to give you life in abundance.

God Will Deliver Us AGAIN

Key word **again** *(adverb)*: another time, once more, anew

We have put our hope in him that he will deliver us again.
2 Corinthians 1:10

Something really bad must have happened. Several years into Paul's missionary work, he faced affliction like never before. He had already been through multiple shipwrecks, temporary blindness, beatings, misunderstandings, and imprisonment. You'd think after all of that, he'd enter into some sort of recovery season in his ministry. Yet in 2 Corinthians 1:8, Paul wrote to the Corinthians that he (and Timothy) had been "completely overwhelmed—beyond our strength—so that we even despaired of life itself." They had apparently suffered something extremely traumatic.

Illness? Wild animal attacks? Conflict? It's not clear exactly what the trouble was, but it must have been much worse than the usual everyday stuff.

Many of us feel like this right now. We have had trouble in our past, and we expect there will be more to come. And we are going through unbelievably hard stuff at this very moment. This promise is for all of us who find ourselves in that place.

It is a promise of God's faithfulness.

"He has delivered us from such a terrible death, and he will deliver us. We have put our hope in him that he will deliver us again."

Paul encourages us to never give up. He reminds us that God is in control of the past, present, and future. He has rescued us before, he is rescuing us now, and he will rescue us in the difficult times ahead. He will do it as often as we need him to.

He never tires of it *or of us.*

Sometimes I worry that we might be using up our punch cards with God. Like we might run out of deliverance if we ask too many times. But this promise reassures us that God's love and protection for us has no limits. It will never run out, and it will always be abundantly available for whatever we are struggling with.

When the secret sin takes us down again.
When the weakness leaves us unable to function.
When we start to believe the lies of the enemy.
When we can't climb out of our deep depression.
When we react in ways we regret.
When our feelings overshadow the truth.

He comes to save us every time we ask him.
Another time. Once more. Anew.

We can ask Jesus for help without doubt and without self-condemnation. We can say it with all confidence and hope in our endlessly patient Father. Because he is not one bit surprised or irritated that we are asking him again. And he is already on his way.

God will come and get us whenever we ask, wherever we are, no matter how many times we have asked for help before. We can trust him to deliver us—again and again and again.

Dear Jesus, please come and rescue me. I am in trouble
again, and I need your help. Thank you that your
faithfulness to me will never run out. Amen.

REFLECT

In your journal, write
2 Corinthians 1:10 in your own
words.

How would you explain this
Scripture promise to a young
child who is feeling discouraged?

What do you need to be delivered
from again today?

REMEMBER

In your journal, write the key word
(or a different word) you want to
focus on in this verse. How will it
help you hold on to this promise?

Draw an image to remind you
that God will deliver you again.

Jesus Is the **BREAD** of Life

Key word **bread** *(noun)*: baked and
leavened food; sustenance

*"I am the bread of life," Jesus told them. "No one who
comes to me will ever be hungry, and no one who
believes in me will ever be thirsty again."*
John 6:35

I wish I knew the name of the sweet bakery lady who kept me alive during my college years.

I'm half joking, but I really do wish I could thank her. Every morning, my friends and I would buy her bread-of-the-day at the SPU deli. It was one of the only things we could afford that would fill us up—especially the challah. On Fridays, we would buy a perfectly squishable golden loaf of it to eat throughout the weekend. It didn't matter if we missed the cafeteria hours; our delicious challah bread would get us through.

I still love bread. All kinds. Flat, raised, boiled, baked, fried . . . even gluten-free when I'm with my wheat-sensitive friends.

Because bread sustains us. For a while.

And then pretty soon, we want and need more.

In this chapter of John, Jesus was talking to people who wanted and needed more, too. His miraculous feeding of the five thousand had drawn them to him, and Jesus knew why they had come.

> "Truly I tell you, you are looking for me, not because you
> saw the signs, but because you ate the loaves and were
> filled." (John 6:26)

This is how we think it works. We know what we want and need, and we come to Jesus for it. It is really hard to understand when something we have been asking and believing him for doesn't happen. Our hearts legitimately hurt. Why would he say no? Why is this so hard? Why won't this happen for me?

When the people he had given fish and loaves to were already hungry again, Jesus didn't repeat the big picnic miracle. These people who came to see more signs and get free food got something they were not expecting, something they didn't know they needed. The promise he made to them here was not that he would *give* them bread but that he would *be* their Bread.

We can imagine they were pretty confused and disappointed. Of course, this was hard to understand. But now we know how amazing this promise was and is. Instead of giving them what they thought they wanted and needed, Jesus was offering them himself.

So in the depths of our disappointment, maybe we can remember this. Jesus knows what we want ***and*** what we need, and sometimes those are not the same. Yet he always offers us himself.

In her Bible study *Finding I Am*, Lysa TerKeurst says, "There is a difference in coming to Jesus for bread and because He is Bread."[5]

No matter what we get or don't get in this life, we will have all that we need because we will have all of Jesus. He promises to satisfy our deepest needs, to overflow our empty places, and to sustain us forever.

He is our Bread of life every day.

Dear Jesus, when my heart is heavy with disappointment,
I want to trust you as my Bread of life. Please fill
me up with more of you. Thank you that you are
good and for giving me everything I need. Amen.

REFLECT

In your journal, write **John 6:35** in your own words.

Look up this verse in a few other Bible translations or paraphrases (https://www.biblehub.org and https://www.blueletterbible.org are two online resources you can use to do this). Write what you notice.

What kind of bread do you need from Jesus right now?

REMEMBER

In your journal, write the key word (or a different word) you want to focus on in this verse. How will it help you hold on to this promise?

Draw an image to remind you that Jesus is the bread of your life.

God Works All Things Together for
GOOD

Key word **good** *(adjective)*: desirable,
beneficial, worthy, beautiful

We know that all things work together for the good of those
who love God, who are called according to his purpose.
Romans 8:28

I am a "glass-half-full" kind of person. I get teased sometimes for being annoyingly optimistic. I can't help it. I love to look for the good. But it doesn't always help. Living in this broken world means we are going to experience some things that are hard for our hearts to take.

I think about my friend from work who is undergoing aggressive treatment for breast cancer as she struggles to have enough energy for her three young boys. I worry about another friend who cares for her dear mom as dementia robs her of her independence, strength, and peace. And I hurt for my dad who sits alone in his empty house counting the days (years) he has made it through without my mom.

The glass looks a lot more like empty to me in these things. If God said he would work everything together for good, why isn't he? This promise can sting sometimes. Especially when grief is raw. When loss is devastating. When tragedy strikes and it is impossible to imagine anything good coming from things so bad.

We might not want to hear this promise at times like this. But we need to believe it deep in our hearts and souls.

We need to believe God is in control and he is good.

We need to believe God can redeem every hard thing.

We need to believe this life is not all there is.

And we need to believe God will never leave us alone.

It's about so much more than positive thinking or looking on the bright side.

It's about his faithfulness to us.

We can trust him to do what we cannot.
We can trust him to shine his light in the darkness.
We can trust him to heal our broken hearts.
And we can trust him to see us through to the end.
He promises us this.

I love to picture him weaving together the threads of our lives into the most beautiful tapestry we have ever seen. He includes them all. Our broken threads. Our threads that are unraveling. Our threads that were cut too short. Our threads that don't seem to belong.

We only get to look at the back of it right now, and we might not see the finished product until we get to heaven. But we can hold on to the truth that he is constantly, lovingly, faithfully working **all things** together for good. Including the hard things. And it is going to be beautiful.

He will give us new understanding, healed relationships, unexpected breakthroughs, and a deeper closeness to him. He is working even when we don't understand it. He is loving even when we don't feel it. He is bringing good even when we don't see it.

In all things.

Dear Jesus, you are in control. I want to believe you
are good even when I can't see it yet. Please help me
rest in the truth that you love me completely and you
are working all things together for good. Amen.

REFLECT

In your journal, write **Romans 8:28** in your own words.

As you think about this promise, list some things you can be grateful for.

Imagine the hard things in your life as threads in a beautiful weaving. How can this help you trust God to bring good?

REMEMBER

In your journal, write the key word (or a different word) you want to focus on in this verse. How will it help you hold on to this promise?

Draw an image to remind you that God is working all things together for good.

God's Ways Are **HIGHER** Than Ours

Key word **higher** *(adjective)*: advanced in complexity, development, or elaboration

"For as heaven is higher than earth, so my ways are higher than your ways, and my thoughts than your thoughts."
Isaiah 55:9

READ

Our ways. Our thoughts. What we can see and touch. What we've experienced and how we feel.

Most of us make sense of life on these terms. God created us this way. He made us visual, tactile, emotional, *human.* We exist in limited time and space, on a planet that has days and nights, water and land, seasons and weather and gravity.

And it seems that is how we understand God, too.

We each have a unique image of Jesus based on our experiences, our knowledge, and our relationships. We read about God as a loving Father, a King, a righteous Judge, a Shepherd, a humble Baby, a Carpenter, a fiery Spirit, a Teacher, a loyal Friend, and a risen Savior. We picture him in heaven, in a church, or maybe out in nature. And we try to fit him into our own little individual boxes shaped inside these parameters.

But Jesus wants to remind us that while the images painted in our Bibles are true of him (and are written for our good to help us understand what he's like), they cannot possibly contain all that he is. He operates on much different terms than we do. The limits we live within do not apply to him.

I used to read this verse and imagine God so high above this earth that he was a bit removed from what was going on in my life. Higher thoughts and ways—*does that mean he is out of reach? Uninterested? Unavailable?*

Maybe the way-up-in-the-sky box I imagine him in is too far away for him to notice that I'm struggling here. That I'm disappointed—crushed, actually. I thought I was going in the right direction. I really wanted this to work. I keep trying. Nothing is happening the way I'd hoped and planned.

One particularly disappointing time, I was encouraged by a timely devotion to simply open my hands. To physically open my hands, close my eyes, and just be with the Lord in my sadness. This act of trust was a turning point for me. I learned that day that he wants us to bring our disappointment to him. If we will open our hands to what he wants to do instead, we will find the opposite of an uncaring, out-of-reach God. His thoughts and ways don't separate him from us. They surround and surpass and surprise us. He is before us and behind us, inside of us, and all around us. He sees, knows, creates, heals, and redeems in ways we can't even imagine. His higher ways are working toward a greater good that we may not understand until we get to ask him about it in heaven.

When we doubt because we cannot see, *we can remember that he sees and knows every detail about every single thing*.

When we don't understand why, *we can trust the One who does*.

When we face endings, obstacles, and disappointments, *we can open our hands to our miracle-working, mountain-moving, mysteriously good God*.

He is always up to something. And it's probably not going to fit in any kind of box.

Dear Jesus, thank you for being everywhere, for knowing everything, and for reigning over every person and force in the universe. Thank you that your higher thoughts and ways bring you closer to me than I can understand. Please help me trust you with my discouragement today. Amen.

REFLECT

In your journal, write **Isaiah 55:9** in your own words.

List some emotion words that mean the opposite of *discouraged*. Circle one or two that you would like to feel instead.

What kind of box are you trying to fit God into as you experience this discouragement?

REMEMBER

In your journal, write the key word (or a different word) you want to focus on in this verse. How will it help you hold on to this promise?

Draw an image to remind you that God's ways are higher than yours.

Jesus Stays the SAME

Key word **same** *(pronoun)*: being one without addition, change, or discontinuance

Jesus Christ is the same yesterday, today, and forever.
Hebrews 13:8

Have you been disheartened lately?

Has something or *someone* changed in a way you were not expecting?

As we continue to navigate the uncertainty and loss brought on by a global pandemic and a divisive political climate, I think we all can answer yes to this question. More than ever, we are desperate for something or *someone* we can count on to stay the same.

This promise reassures us that we have a God who doesn't change.

I have a special place I love to go to be reminded of God's changelessness. Cannon Beach on the Oregon coast is a rugged, expansive stretch of sand and waves with an enormous landmark at the edge of the water. Haystack Rock can be seen from far away on the beach and from the houses on the hills above.

I can remember being there during so many different times in my life.

Times as a child playing with my siblings in the shadow of the rock without a care in the world.

Times as a self-absorbed teenager not necessarily appreciating the view of the rock one bit.

Times my husband and I took our young boys to explore the rock at low tide, marveling at the marine animals in the tide pools and the seabirds that call it home.

Times I have been calmed by looking at the rock through tears of anxiety, frustration, or loss.

The last time we walked (slower than usual) to the rock for a precious photo with Mom.

In all my years of vacationing there, Haystack has been a constant. Its impressive size and unique shape never appears to change, yet I know that this enormous rock is continually being forged and eroded by the crashing waves.

Even this rock that has been such a marker in my life does not stay exactly the same.

But Jesus does.

I've run to him as a carefree kid in Vacation Bible School singing about the joy, joy, joy, joy down in my heart.

I've embraced then rejected him as a struggling teenager wanting to go my own way.

I've avoided him as a young adult consumed with selfish ambition.

I've reached for him as an overwhelmed new mom wanting to do everything right.

I've hidden in his arms, trusting him to hold me through storms of anxiety and grief.

I've marveled at him as he answers my prayers, surprises me with goodness and friends, and continuously gives me opportunities to know him better.

We don't stay the same yesterday, today, or tomorrow.

Nothing and no one on this earth stays the same yesterday, today, or tomorrow.

But this promise reminds us that we are always, *always* loved, protected, and redeemed by the One who does.

Dear Jesus, you are the only absolutely sure thing in my life. When my feelings are all over the place and I feel unsettled, help me to remember that you never change. Thank you that your character, your truth, and your devotion to me stay the same no matter what. Amen.

REFLECT

In your journal, write **Hebrews 13:8** in your own words.

What does this promise reveal to you about how God works?

What characteristics of Jesus do you need to know will stay the same?

REMEMBER

In your journal, write the key word (or a different word) you want to focus on in this verse. How will it help you hold on to this promise?

Draw an image to remind you that Jesus is the same yesterday, today, and forever.

Promises for When You Are

Doubting

Jesus Is with Us ALWAYS

Key word **always** *(adverb)*: at all times, invariably; forever

When they saw him, they worshiped, but some doubted. Jesus came near and said to them, "All authority has been given to me in heaven and on earth. Go, therefore, and make disciples of all nations. . . . And remember, I am with you always, to the end of the age."
Matthew 28:17–20

Jesus spoke these words to his eleven remaining disciples shortly before he ascended to heaven. He wanted them to go, make disciples, baptize, and teach everyone about all they had learned from him. He told them he would always be with them, even though they wouldn't be able to see him anymore.

This passage, also known as the Great Commission, is one that has inspired thousands upon thousands of sermons and missions. I feel like I have heard it in every church I have ever attended; and when I saw it on the screen again recently, I was secretly a little disappointed.

I already know this, I thought.

I know I am supposed to go where you send me, Lord.

I know you want me to teach people about you wherever and whenever I can.

And I know that you will be with me as I go.

Our pastor set the scene for us on the mountain where Jesus had told the disciples to meet him, and this is what he read:

When they saw him, they worshiped, **but some doubted**.

Wait. I hadn't noticed that part of the story before.

He came near to the worshippers *and to the doubters*.

He gave his authority to the worshippers *and to the doubters*.

He promised to be with them always—the worshippers *and the doubters*.

Some of the disciples were probably both.

I can so relate to this. I love to worship, to sing, to write praise-filled words to Jesus thanking him for who he is and for all he has done for me.

65

Yet I can be deep in the middle of any of these things and catch myself starting to doubt.

Is Jesus actually listening to me right now?

Does he even care about this?

Does he really answer my prayers, or is there a different explanation for what is happening?

Am I being foolish to put my faith in him?

It happens to all of us sometimes. Doubt sneaks into our hearts and minds more often than we would like to admit. It's hard to imagine, but the same thing was happening to some of his disciples. After three years of living with and learning from him. After witnessing his miracles firsthand. After eating the Last Supper with him. After touching the holes in his hands and side after he died and rose again.

After all this, as he was about to ascend to his heavenly throne, they worshipped, but some doubted.

Of course, Jesus knew. And instead of turning away from them or dismissing them in frustration, he came closer. Jesus came **near to them** in their worship *and* in their doubt. He turned toward them, not away from them. He continued to trust them with the future of his ministry. And he promised to be with them always.

And whether we are the ones worshipping, the ones doubting, or both, he will do the same for us.

Dear Jesus, sometimes I doubt you, and I am so sorry.
Thank you for coming near instead of leaving me
in my questioning and confusion. Please help me
experience your closeness with me always. Amen.

REFLECT

In your journal, write **Matthew 28:17–20** in your own words.

What does this promise reveal to you about God's character?

What do you find encouraging about Jesus's response to the disciples who doubted?

REMEMBER

In your journal, write the key word (or a different word) you want to focus on in these verses. How will it help you hold on to this promise?

Draw an image to remind you that Jesus is always with you, even when you are struggling with doubt.

We Can **BELIEVE** Jesus

Key word **believe** *(verb)*: to regard as right or true; to have a firm or wholehearted conviction, trust

Because you have seen me, you have believed. Blessed
are those who have not seen and yet believe.
John 20:29

I really want to believe Jesus. And I bet you do, too.

But we haven't seen him, and occasionally we start to question. Is Christianity just like any other religion? Is Jesus really who he says he is? How can we be sure?

Sometimes I think it is easier to **believe *IN* Jesus** than to actually **believe *HIM*.**

I was a young Christian when I went through my first spiritual "dry spell." I was volunteering at an outreach camp where everyone seemed to be experiencing God in exciting and tangible ways—except for me. All of us had come to Malibu because of our love for Jesus and our desire to serve him. We sang and studied and talked about Jesus as we worked. I couldn't understand it. Here I was in this amazing Christian environment, yet I could not feel his presence at all. I prayed and cried and waited, but for days and days nothing changed.

Was he really a God who wanted a relationship with me? Or was it all just wishful thinking?

It took time to feel God's presence again. More time than I would have liked. Time walking quietly along the path next to the deep blue inlet, time sitting on a rock looking high up at the snow-tipped mountains, time reading my Bible and writing in my journal, and time whispering prayers of frustration as I lay awake in my bunk. I realize now it was just the right amount of time for him to strengthen my faith in a significant way. He taught me through this that he is constant and faithful, even when my thoughts and feelings are not.

When it is hard to believe Jesus, he understands. But he wants us to keep trying, keep trusting no matter what we see or hear or feel. When his

time on the earth was done, he gave us his Spirit to help us in our times of doubt. He knew we would need it.

> "And I will ask the Father, and he will give you another Counselor to be with you forever. He is the Spirit of truth." (John 14:16–17)

His Spirit helps us find him in his WORDS.

When Jesus seems far away, we can open our Bibles and find his truth. He will help us understand more and more as we spend time meditating on a verse, a story, or a chapter.

His Spirit helps us find him in his WORKS.

When we start to doubt his presence, we can look around. His creative and redemptive power is everywhere. We can find him in a twinkling star on a dark night, in the precious sound of a baby's laugh, in the refreshment of a cool breeze on a hot day, and in every morning sunrise. We can remember and celebrate what he has done in our lives and in the lives of those we love.

Dear Jesus, thank you for never leaving me alone. Your presence surrounds me whether I feel it or not, and your Spirit reminds me of your words and your works. Please help me believe you with all my heart. Amen.

REFLECT

In your journal, write **John 20:29** in your own words.

How might you explain this Scripture promise to a child who is *doubting*?

What words and works of Jesus can help you believe him today?

REMEMBER

In your journal, write the key word (or a different word) you want to focus on in these verses. How will it help you hold on to this promise?

Draw an image to remind you that you can believe Jesus.

God Shows Us CLEARLY Who He Is

Key word **clearly** *(adverb)*: without any question; assuredly, certainly, definitely

*For his invisible attributes, that is, his eternal power
and divine nature, have been clearly seen since the
creation of the world, being understood through what he
has made. As a result, people are without excuse.*
Romans 1:20

READ

Late again, and these excuses run through my mind: *I couldn't find my keys.
I had to stop for gas. I hit every red light.*

Maybe *true* but not necessarily *good* excuses. None of these make up
for missing part of a meeting, making someone wait, or not showing up at
all. And none of them would have made me late if I had gotten up earlier,
been a bit more organized, or left on time.

Excuses become part of our pressure-filled days. We don't want to be
at fault, to be blamed when most of the time we are doing the best we can.
I laugh with my friends as we playfully exaggerate and find ways to justify
our less-than-responsible choices.

But it's not funny when we make excuses for not trusting God with
our whole hearts. Why do we hesitate to bring everything to Jesus? Why
do we fail to show up at all sometimes? Maybe our questions start to over-
shadow our faith sometimes.

My go-to question: ***Does he care enough to help even me?*** Here are a
few of the excuses I use when I don't feel like the answer is yes.

*My problems seem small compared to the chaos going on in the world.
I haven't gone to church in a while; he might be disappointed in me.
He didn't answer the way I wanted him to last time I asked for help.
I can't seem to see him or hear him clearly right now.*

Clearly, he cares more than we can ever imagine.

We can find so many examples in the Bible—especially in the Gospels—that describe how much he cared about all people regardless of their status. I think of how he loved his imperfect disciples, how he welcomed people to eat with him that no one else would, how he cried with his friends who were grieving.

Clearly, God will help us every time we ask.

The Bible is full of stories of how God helped his people and answered their prayers in miraculous and surprising ways. He was always faithful to bring strength to battles, healing and comfort in sickness, peace in times of fear, and wisdom in times of confusion. When Jesus died and rose again to save everyone who would ever believe in him, he sent his Holy Spirit to continue this helping work.

But even if we didn't have these hundreds of stories and promises in our Bibles, we would still have every reason to trust him. All we have to do is look around. Everything God created is a miracle. When we experience the magnificence of the mountains, the intricate detail of a butterfly's wing, the brilliant colors of a sunrise, or the juicy sweetness of a fresh-picked strawberry, we can't help but believe God is all-powerful, wildly creative, and incredibly good.

Dear Jesus, please forgive me for my lack of trust and my excuses. I want to believe that you care deeply about me and that you are faithful to help with whatever I need. Please open my eyes to see your power and creativity more clearly today. Amen.

REFLECT

In your journal, write **Romans 1:20** in your own words.

Look up this verse in a few other Bible translations or paraphrases (https://www.biblehub.org and https://www.blueletterbible.org are two online resources you can use to do this). Write what you notice.

What is Jesus showing you clearly about himself right now?

REMEMBER

In your journal, write the key word (or a different word) you want to focus on in this verse. How will it help you hold on to this promise?

Draw an image to remind you that Jesus shows you clearly who he is.

We Can ENTRUST Ourselves to Jesus

Key word **entrust** *(verb):* to give to someone or something for safekeeping, to commit, to hand over

So then, let those who suffer according to God's will entrust themselves to a faithful Creator while doing what is good.
1 Peter 4:19

READ

There is a lot in this verse that I don't completely understand. "Suffer according to God's will" is a tough line for me. Suffering and God's will can be hard concepts to reconcile sometimes.

I realize Peter was writing to new Christians who were being disparaged and even persecuted for choosing to follow and obey Jesus. Even though most of us reading this don't have to worry about imprisonment or death threats, we still might experience times of being misunderstood or criticized for our faith.

It has been happening to me recently, and I'm hurt and confused about it. I don't know if I am "suffering according to God's will," but my heart needs to know I can trust him with what I'm feeling.

I am trying to "entrust [myself] to a faithful Creator while doing what is good." Several translations of the Bible use the word **commit** in place of **entrust** here. Looking into the original Greek word *paratithēmi* helps us understand why:

> The ancient Greek word translated "commit" is a technical one, used for leaving money on deposit with a trusted friend. Such a trust was regarded as one of the most sacred things in life, and the friend was bound by honor to return the money intact.[6]

I guess we do that with our financial institutions, don't we? We deposit our checks or cash, and we trust them to hold our money for us. Most of the time, that feels completely safe. We don't have to keep taking it out to count it, and we don't have to call every day to make sure it is there. We entrust.

We commit our money to the bank or credit union we have chosen, and we go on with our lives.

But can we do that with our very selves, body and soul? Can we trust Jesus enough to deposit all of who we are with him?

He promises that we can. He wants us to hand it all over—the anger, the fear, and the doubt. He knows what we are going through. And he tells us we can trust him with everything. We don't need to keep recounting all the hard things we're experiencing or checking with Jesus to make sure he is keeping our stuff safe. We can commit all of it into his hands.

When we are criticized for our faith, when we get ridiculed or rejected, we can remember this. We can keep believing that the God who loves and protects us can be trusted to hold it all.

We can entrust our whole selves completely to him.

Dear Jesus, please help me in this struggle to understand.
I place my confused and hurting heart into your care.
Thank you that I can entrust everything to you. Amen.

REFLECT

In your journal, write **1 Peter 4:19** in your own words.

As you think about this promise, list some things you can be grateful for.

If God had an actual vault, what things would you put in there for safekeeping?

REMEMBER

In your journal, write the key word (or a different word) you want to focus on in this verse. How will it help you hold on to this promise?

Draw an image to remind you that you can entrust your whole self to Jesus.

We Will Know FULLY

Key word **fully** *(adverb):* completely,
totally; to the fullest extent

For now we see only a reflection as in a mirror, but then face to face.
Now I know in part, but then I will know fully, as I am fully known.
1 Corinthians 13:12

The bathroom mirror was all steamed up, and I couldn't see my face. I needed a little spot to quickly dry my hair and put on a bit of makeup, but wiping it off with a washcloth didn't really help. I could faintly see my reflection but not very well. I needed this evaporation process to hurry up and clear so I could see.

This sounds like our faith sometimes. We know God is there, but we can't see him clearly. We don't understand what he is doing, we can't recognize his features, and our view of him is incomplete. We start to doubt.

We want him to hurry up and show us all the things we can't see.

And that's when we need this promise.

The Corinthians that Paul was writing this to needed this promise, too. They were divided and confused about many issues facing the early church. They were dealing with differences in leadership and interpreting messages in conflicting ways.

They needed some clarity.

Paul had spent quite a bit of time in the city of Corinth. It was famous for its mirrors made of bronze, which at best provided people with indirect and dark reflections of themselves.[7]

In his letter to them, he explained the gifts of God in the church and emphasized love above all. He used the mirror example to help them understand that some things about God will not be completely revealed until we see him face-to-face.

Some of the ways God works aren't going to be easy to make sense of.

So, in our rush to draw clear lines of distinction about God's character, we sometimes get frustrated. We don't understand why he does certain things and not others. We don't see him as clearly as we want to. We can't

wrap our minds around his absolute righteousness, his redemptive power, his infinite creativity, or his unconditional love.

We will though. Paul tells us that we will understand fully when we see Jesus face-to-face. Until then, we will keep trying to see the reflection of God in all the gifts he gives us.

> *He gives us his words to remind us of his truth.*
> *He gives us experiences that change the trajectory of our lives.*
> *He gives us people to lead us and help us.*
> *He gives us music, books, artwork, and all of nature that reveal more to us about who he is.*
> *He gives his Spirit to lead us into a deeper faith in him.*

We won't have to worry about dark or steamed-up mirrors. We will finally get to know him as he has always known us.

Completely. Totally. Fully.

Dear Jesus, please help me trust you when you are hard to see. I want to know you fully like you know me. Thank you that someday I will see you face-to-face. Amen.

REFLECT

In your journal, write **1 Corinthians 13:12** in your own words.

List some emotion words that mean the opposite of *doubt*. Circle one or two that you would like to feel instead.

What do you look forward to knowing fully when you see Jesus?

REMEMBER

In your journal, write the key word (or a different word) that you want to focus on in this verse. How will it help you hold on to this promise?

Draw an image to remind you that you will know Jesus fully one day.

What Is **UNSEEN** Is Eternal

Key word **unseen** *(adjective):* not able
to be seen; imperceptible

*So we do not focus on what is seen, but on what is unseen. For
what is seen is temporary, but what is unseen is eternal.*
2 Corinthians 4:18

Books are one of my absolute favorite things. I love to read all kinds, but if I could only choose one genre, it would definitely be children's picture books. An engaging story with brilliant artwork can inspire me forever. Visual art is not my strength (I'm not kidding when I say that my kindergarten students draw better than I do), so I'm especially impressed by illustrators who can capture the essence of the text and make it come alive.

When I'm reading a mystery or a memoir, I tend to have a hard time. No matter how skillfully the written words describe the setting and characters, I'm sure the pictures I make in my mind aren't even close to what the author envisioned. Maybe that doesn't really matter, but pictures in novels would help the artistically challenged like me.

Regardless of our artistic abilities, many of us are visual learners. We need demonstrations, photos, or drawings to help us understand things better. Things make more sense to us when we experience them through our eyes.

Maybe that is why some of the ways that God works in our lives are hard to figure out. Like a complicated book or presentation without illustrations, we just don't *see* it:

What is he doing?

How is he working?

What is the purpose of this struggle?

So many chapters of our lives require us to remember this promise:

What is seen is temporary, but what is unseen is eternal.

Paul said this when he was being imprisoned, rejected, and beaten. What was visible to him and to the new believers was painful and discouraging. But Paul knew God was up to so much more than he could see.

And he wanted us to know that the same God who was working behind the scenes in Paul's life would be working behind the scenes in ours someday.

We may or may not see the healing that happens when we pray for someone.
We rarely get to see the angels he surrounds us with for protection.
We don't always get to see the growth or the fruit we work and hope for.
We occasionally see some good that comes out of a tragedy, but most of the time we are left wondering why he allowed it to happen.

The things we see and the things we imagine don't always tell the whole story.

How amazing it is that the Author of life is our Father, our friend, our helper, and our Savior. We can hold onto his words when life is hard to understand:

His love never fails.
He is with us forever.
He is always good.

Someday we will get to know the whole story. When we sit with him in heaven, he will tell us and show us how he worked all things together into a masterpiece of beauty, restoration, wholeness, and love.

Let's trust the One behind the scenes.

Dear Jesus, you are the beginning and the end of everything. Please help me trust that you are always faithful and working for good. Thank you for writing such a beautiful story with my life. Amen.

REFLECT

In your journal, write **2 Corinthians 4:18** in your own words.

What does this promise reveal to you about how God works?

Are there some unseen things you can trust Jesus with right now?

REMEMBER

Write the key word (or a different word) you want to focus on in this verse. How will it help you hold on to this promise?

Draw an image to remind you that we can't always see what God is up to behind the scenes.

Promises for When You Need

Forgiveness

Jesus Presents Us without
BLEMISH

Key word **blemish** *(noun):* a noticeable
imperfection, flaw, fault

*Now to him who is able to protect you from stumbling
and to make you stand in the presence of his glory,
without blemish and with great joy.*
Jude 24

READ

Many of us were raised with a lot of love and a generous amount of guilt. If we didn't know how or what to feel, guilt was the default emotion. We got used to feeling guilty about having things others didn't have, guilt about eating fattening food, guilt about being too much and not enough at the same time.

I still feel guilty about almost everything. The word *should* seeps in as I leave work wishing I had done something better, when I shorten my exercise routine or skip it altogether, and when I hear about someone suffering in ways I am not. Everything must be my fault somehow.

Well, not *everything*. I recognize that now, and I catch myself using the word *should* more than is healthy. But certainly, I am responsible for my actual sins. The ways I have hurt people and hurt Jesus make me sick and sad. *I am to blame* for real things like gossiping, idolizing things other than God, being jealous, and so much more.

It is a fact, *not a feeling*, that we all make sinful choices and deserve God's condemnation. And that is why we all so desperately need to receive the forgiveness Jesus offers us.

This promise comes at the end of a short letter written by Jude, one of Jesus's half brothers. There was nothing Jesus didn't know about Jude. He knew the good things he did, the bad things he did, and everything in between. In spite of (or possibly *because* of) being known so completely by his older brother, Jude closes by reminding us that Jesus is able to:

- **Keep us "from stumbling"**—*Even though we will still make sinful choices in our lives, our "stumbles" won't be permanent.*
- **Present us "without blemish" before God**—*Blameless, without fault, having not one mark of sin on us.*
- **"With great joy"**—*Not with great responsibility, not with great fear, and definitely not with great guilt.*

Can we imagine that for a minute?

Every day of our lives, we can hold the hand of Jesus. He knows our weaknesses and temptations, and he wants to help us. He will keep picking us up, brushing us off, and reminding us of all we have to look forward to. And one day, he will walk us right up to our Father in heaven.

I don't know how we are *supposed* to feel at that moment.

For many of us, guilt might be the emotion we default to.

All the selfish choices we made.
All the times we didn't represent him well.
All the ways we hurt God and hurt people.

But it will all disappear in an instant. No matter how many flaws we see in ourselves, Jesus will have already wiped them all away. He promises to help us stand, to present us without imperfection—blameless and without fault.

All we will know is joy.

———————

Dear Jesus, thank you that you present us
without blemish. Your death on the cross covered
the entire cost of our every sin and stumble. We
humbly look forward to standing forgiven before
our Father in heaven with you. Amen.

REFLECT

In your journal, write **Jude 24** in your own words.

What does this promise reveal to you about God's character?

What blemishes can you let Jesus wipe away right now?

REMEMBER

In your journal, write the key word (or a different word) you want to focus on in this verse. How will it help you hold on to this promise?

Draw an image to remind you that Jesus promises to present you without blemish.

We Are JUSTIFIED through Jesus

Key word **justified** *(adjective):* to be rendered as just or innocent; to be righteous

Everyone who believes is justified through him.
Acts 13:39

Justified.

This was a new word for me as a young believer, and it came with a clever explanation. To be justified, according to our youth pastor, meant that Jesus saw me *"just as if I'd"* never sinned.

This new word proved to be easy to remember but difficult to believe. Even though I was trying to be a "good Christian," I was well aware of some commandments I had not kept and some rules I kept breaking.

How could God possibly see me *"just as if I'd"* never sinned?

In this chapter of Acts, Paul was speaking at a Sabbath meeting. He told the story of God's plan for his Jewish people—recounting the exodus, the wilderness, and the promised land. He continued on with how God worked through King David, the role of John the Baptist, and then he brought up Jesus.

Jesus, he told them, is the Son of God. He is the long-awaited Messiah, the fulfillment of God's promise to his children. Paul concluded by emphasizing the significance of Jesus's death, his resurrection, and eternal life. He wanted to make clear that forgiveness for sins is available—*promised, even*—only because of what Jesus did.

"Everyone who believes is **justified** through him from everything that you could not be justified from through the law of Moses."

I imagine these rule-followers were more than a little bit uncomfortable. This message challenged their whole belief system. Their careful law abiding, and their long lists of do's and don'ts was never going to be enough.

Some of the people in the meeting that day were so relieved and excited about this news.

But others felt threatened. The way they had learned how to show themselves as worthy followers was no longer valid. This was hard to process and very unsettling.

It still unsettles us sometimes. The rules—even when we break them—give us a false sense of security. We need courageous faith and a surrendered heart to stop trying to *earn* forgiveness.

But we don't have to be afraid.

God sent Jesus to release us from the fear and oppression of living under the law. It helped me to learn that in addition to the definition above, *justified* also means *free*.[8]

To be *justified* through Jesus means we get to live in grace rather than in fear.

To be *justified* through Jesus means he took the punishment we deserve.

To be *justified* through Jesus means we can never mess up too badly to belong to him.

Because we stand on Christ's perfect record instead of our record, God sees us "just as if we'd" never sinned.

Dear God, thank you for giving me your Son's perfect record to stand on instead of trusting in my own record. You evaluate me on the basis of Christ's righteousness, and because of that, I believe and rejoice that you see me as your innocent child. Help me remember that I cannot earn my salvation or your love. Thank you that I am justified completely through Jesus. Amen.

REFLECT

In your journal, write **Acts 13:39** in your own words.

How might you explain this Scripture promise to a child who is needing **forgiveness**?

What does it mean to you to be justified by Jesus?

REMEMBER

In your journal, write the key word (or a different word) you want to focus on in this verse. How will it help you hold on to this promise?

Draw an image to remind you that you are justified through Jesus.

God REMOVES Our
Transgressions Far from Us

Key word **remove** *(verb):* to take away from
a place or position; to get rid of

As far as the east is from the west, so far has he
removed our transgressions from us.
Psalm 103:12

READ

As far as the east is from the west seems really far. I try to comprehend the distance, but my brain gets tired.

So I think about where we live in relation to our friends and family. My husband and I grew up on opposite sides of Washington state, me on the west side near Seattle and Bob on the east side in Spokane. It is a six-hour drive to get from our house now (west side) to his identical twin brother's house (east side). A mountain pass divides us, like a line drawn right down the middle of two very different worlds.

The two brothers who look exactly alike and enjoy many of the same things try to visit each other a few times a year. It's funny and obvious when they do, though, that they have surprisingly opposite perspectives on many things. Bob, like the majority of people living on the west side of the mountains, lives in the city, has more moderate-liberal political views, and is a huge supporter of the University of Washington Huskies. His brother Pat, like most of the people in eastern Washington, lives in the country, tends to vote more conservatively, and is a die-hard fan of the Washington State University Cougars.

These good-natured, fun-loving brothers get along great, but once a year their relationship gets tested by the Apple Cup—the rivalry football game between the Huskies and the Cougars. The teams take turns hosting, and every November the fans from the visiting team drive over the snowy mountain pass to the home team's stadium to watch the dogs and cats fight for the trophy.

That drive across the state feels long to me even when the weather is clear. Long enough that if God told me I could leave my sins in one place and drive six hours over the mountains, I think I would feel pretty far removed from them.

Is that what he means—my transgressions are as far away "as the east is from the west"?

I'm pretty sure he takes them a lot farther than that.

This promise assures us that God takes them so far from us that the distance is impossible to comprehend. There cannot be a meeting point between us and our sin because east and west keep going in opposite directions forever.

So that scarlet letter of shame we feel we need to wear? God removes it.

The heavy backpack of guilt we struggle to walk around with? God removes it.

The chains of regret that hold us back? God removes them, too.

The things in our past that like to keep hanging around can't—*unless we let them.* God wants to take them once and for all and send them in the opposite direction forever.

Let's trust him to get rid of them all.

———————

Dear Jesus, you are the reason I don't have to wear
my sin anymore. Thank you for removing my
transgressions completely. Please help me remember they
are as far away as the east is from the west. Amen.

REFLECT

In your journal, write **Psalm 103:12** in your own words.

Look up this verse in a few other Bible translations or paraphrases (https://www.biblehub.org and https://www.blueletterbible.org are two online resources you can use to do this). Write what you notice.

What do your sins feel like to you? A label? A weight? A chain? What would it be like if you could let Jesus remove them far from you?

REMEMBER

In your journal, write the key word (or a different word) you want to focus on in this verse. How will it help you hold on to this promise?

Draw an image to remind you that your sins are removed as far as the east is from the west.

Jesus Came to **SAVE** Us

Key word **save** *(verb):* to rescue or deliver
from danger or harm; guard, deliver

*For God did not send his Son into the world to condemn
the world, but to save the world through him.*
John 3:17

Most of us know the verse that comes just before this one:

> *For God loved the world in this way: He gave his one and
> only Son, so that everyone who believes in him will not perish
> but have eternal life.*

It is easy to take John 3:16 for granted when we mindlessly recite it. But the truth of this well-known verse is staggering. What God did by sending Jesus to us made all the difference in the world. God sent his only Son to live as a human on the earth with us. And then he sacrificed him, letting him die on a cross to save us. The thing we get confused about sometimes, though, is *why he did that. Why did he send Jesus to be with us? Why does he want to be involved in our lives? What does he want from us?*

We might assume he sent him to judge and correct us. We might picture him checking up on us and shaking his head in disappointment. We might feel like we need to hide, to keep quiet, to be on our best behavior when we think of God coming close.

We might not be able to comprehend that his sole motivation was . . . *is* . . . love.

We really don't deserve it.

Even with the sticky situations we get ourselves into?

Even with the stress we bring on ourselves?

Even with the things we can't forgive ourselves for?

Even when we are doubting him, ignoring him, and acting like we don't deserve him, **he came to help us**. It's a promise.

He knows our weak places, our temptations, our brokenness.

He knows exactly how the enemy connives and lurks and hates us.

He knows where every path we take will end up.

And he gives *helpless us* his overcoming power.

And he gives *sinful us* his forgiveness and redemption.

And he gives *desperate us* the grace and hope of life with him.

God doesn't hold a grudge. He doesn't treat us the way we might expect. He knows even better than we do the guilt and stress and addictions and distractions that threaten to destroy our hearts and our lives, and he came to deliver us from them.

Instead of pointing an accusing finger, God opens wide his arms in love. Instead of frowning at us in frustration, God's eyes smile into ours with grace and delight. Instead of leaving us alone when we hide away from him, he finds us and he frees us and gives us what we need.

That's the God who came to save us.

Dear Jesus, sometimes my heart forgets why you came. Thank you for your grace that is more powerful than my shame. Please help me always remember that you came to save me. Amen.

REFLECT

In your journal, write **John 3:17** in your own words.

As you think about this promise, list some things you can be grateful for.

What holds you back from trusting that Jesus came to save you, not to condemn you?

REMEMBER

In your journal, write the key word (or a different word) you want to focus on in this verse. How will it help you hold on to this promise?

Draw an image to remind you that Jesus came to save you.

God SETTLES the Matter of Our Sin

Key word **settle** *(verb):* to fix or resolve conclusively; to secure permanently

"Come, let's settle this," says the LORD. "Though your sins are scarlet, they will be as white as snow; though they are crimson red, they will be like wool."
Isaiah 1:18

Dark red becoming white as wool, bright as snow. It seems impossible, doesn't it? Those of us who have tried to get red ink stains out of white fabric know it doesn't usually work well. Some residual color, no matter how faint, indicates that something was there. And *red* paint? Definitely known as the hardest color to paint over. We have to apply several coats of any other color before the red stops showing through.

Maybe that is why God uses the color red to help us understand what he does when he forgives us. The stain of our sin is significant. The effects are deep and lasting.

We deserve to be separated from God. He is holy and our sin is repulsive. We do things we know we shouldn't, and we don't do things we should. We say things we wish we hadn't, and we don't say things we wish we had. Our thoughts, our motives, and our choices are often not what God requires of his people.

If we were on trial for all of our sins, the courtroom would be heavy with the evidence of our guilt and the fear of our sentencing. We shouldn't have been trusted with the red markers, but somehow we got hold of them. And we keep making a terrible mess.

Yet God doesn't give up on us. He sees the stains we've left all over his perfect design, and he comes with miraculous cleansing power. He gets rid of every bit of our stubborn, impossible red. Our stubborn, impossible sin. Our constant tendency to live our own way in rebellion and selfishness. We can't get rid of it on our own.

With his redeeming love, he washes away our sin completely and purifies our hearts. In this promise, he gives us the images of white wool and snow to help us picture this dramatic transformation.

Red—the color of passion and intensity becomes ***white***—the bright reflection of all the colors that represent purity and virtue.

Ugly becomes beautiful.

Dirty becomes clean.

Ruined becomes restored.

God does this when he settles it.

He settles the grievous, debilitating matter of our sin. The most important matter of our hearts is resolved, fixed, and permanently secured. ***Settle*** means to reason together, to correct, to decide, and to be right.[9]

God requires and desires for us to be holy and forgiven. Let's trust him to settle it once and for all.

Dear Jesus, thank you for dying to forgive me. You know all my crimson and scarlet, and only you can turn them white. Please help me remember that you have already settled the matter of my sin. Amen.

REFLECT

In your journal, write **Isaiah 1:18** in your own words.

List some emotion words that mean the opposite of *guilty* or *in need of forgiveness*. Circle one or two you would like to feel instead.

What sin(s) do you need Jesus to settle today? Are there any you feel are too red to become white?

REMEMBER

In your journal, write the key word (or a different word) you want to focus on in this verse. How will it help you hold on to this promise?

Draw an image to remind you that God has settled the matter of your sin.

God HURLS Our Iniquities into the Sea

Key word **hurl** *(verb)*: to throw forcefully;
to send with great vigor

*You will again have compassion on us; you will tread our sins
underfoot and hurl all our iniquities into the depths of the sea.*
Micah 7:19 NIV

The weight of my iniquities is heavy. My selfish thoughts and choices. My hurtful words and actions. My idolizing of anyone and anything but Jesus. I confess my sins to God in prayer and try to trust that he forgives me completely. I think I have given them completely to him, but have I?

This is how it goes sometimes:

> *I shouldn't have been part of that gossipy conversation. I'm sorry, Jesus. I know that hurts you, and I don't want to do that again. I'll just tuck that into my backpack of guilt, to remind me not to repeat that sin. That unkind judgment I made about someone? I still feel really bad about that. I better put that one in there, too. Those times I didn't exactly tell the truth? I confess them, Lord. I should probably hold onto those for a while longer. "Thank you for forgiving me," I say to him as I head into my day carrying my heavy load of shame.*

And all day long I'm wearing what feels like a backpack full of rocks.

God's Word tells us that Jesus's sacrifice on the cross paid the ultimate price for all the sins of the world. Because of his death and resurrection, our transgressions are completely forgiven, cleared from God's sight or consideration.

We know this. We believe this. But sometimes we still try to hold on to our sins. Even though they are unbearably heavy, we keep stuffing them into our backpacks. We can't forget what we have done, so how can he?

That's why we need this verse in Micah. God gives us a promise with a visual here that will help us trust his forgiveness. First, he reminds us of

his compassion for us. He loves us so much, and he doesn't want us to have to bear the burden of our iniquities any longer. Then he promises to take our sins and stomp on them, then hurl them into the depths of the sea. He will take our backpacks of guilt and launch them like a discus thrower way, way out into the ocean.

I can't help but smile with relief when I picture him doing this. Standing on the shore or the pier with us, Jesus winds up and throws our backpacks farther than we can see. As they sail out of sight, our sins and guilt are headed for the farthest and deepest parts of the ocean. He hurls all of them so far away from us that there is no way we can get them back. Why would we ever want to, anyway?

Jesus gave his life to do this for us. Only he has the power to get rid of our iniquities forever. Let's lay our backpacks at his feet once and for all.

———————

Dear Jesus, you took the sin of the whole world upon you. Thank you for forgiving me and promising that you will remember my sins no more. Help me trust you to hurl them all away. Amen.

REFLECT

In your journal, write **Micah 7:19** in your own words.

What does this promise reveal to you about how God works?

What are some iniquities you might be carrying around in a backpack?

REMEMBER

In your journal, write the key word (or a different word) you want to focus on in this verse. How will it help you hold on to this promise?

Draw an image to remind you that God hurls your sins into the depths of the sea.

Jesus Is Our ADVOCATE

Key word **advocate** *(noun):* one who pleads the
cause of another; representative, supporter

*But if anyone does sin, we have an advocate with
the Father—Jesus Christ the righteous one. He
himself is the atoning sacrifice for our sins.*
1 John 2:1–2

The job description is lengthy and broad. The role of an advocate requires knowledge and skills in assessment, communication, counseling, teaching, crisis intervention, and law. And those are just the basics. So much is involved in trying to help someone who can't help themselves. A toddler being abused. An elderly widow being neglected or taken advantage of. A desperate teen. A young man who lives in his broken-down car, unable to work due to an injury.

My brother is a social worker who sees people in these heartbreaking situations almost every day. Life is brutal for so many of them, especially those who struggle with debilitating mental or physical symptoms and have little or no help. Some people are in such a tough place they don't even know what they need, much less how to get it.

Advocates become their help; they are the connection between these hurting people and the resources available.

A *good* advocate will get the client what he or she needs. A safe place to stay, medical treatment, meals, counseling, legal representation, and more.

A *really good* advocate will do all of that **plus**. The **plus** is the personal touch—remembering to bring a bottle of their favorite flavored water, sitting to listen a few extra minutes, fighting for the best resources even when it means more work. These really good advocates make sure to leave their clients feeling dignified, known, and hopeful.

An *unbelievably good* advocate will do all of that **plus** something unimaginable. He or she will actually trade places with their client. This advocate will become sick, mistreated, or alone so the client can experience healing and comfort. This advocate will volunteer to become cold, poor, or

homeless to allow the client to have warmth and food. This advocate will even enter the foster system, go to jail, or undergo treatment in place of their client.

Of course, I'm being unrealistic. An advocate would never be expected or even allowed to do those things. Not a human advocate anyway.

But we have Jesus.

And it is a good thing we do because our desperate spiritual condition can only be taken care of by him. He provides for our every need. He fills our cracked hearts with his constant attention and unmeasured compassion. And what is really hard to comprehend is that he did the trading-places thing. The unbelievably good thing that no advocate would ever be able to do. Even before we knew we needed him to, he got on a cross in our place and paid the ultimate price for our sins. As our atoning sacrifice, he stands with us before the Father and gives us everything we need to be forgiven and free.

What a privilege to be clients of the greatest advocate of all.

Dear Jesus, you traded places with me when I needed your help. Thank you for advocating for me in the presence of our Father. I trust you to take care of me forever. Amen.

REFLECT

In your journal, write **1 John 2:1–2** in your own words.

Do you have any questions for Jesus about this promise?

How do you imagine Jesus is advocating for you right now?

REMEMBER

In your journal, write the key word (or a different word) that you want to focus on in these verses. How will it help you hold on to this promise?

Draw an image to remind you that Jesus is your advocate.

Promises
for When
You Feel

Heartbroken

Jesus BANDAGES Our Wounds

Key word **bandages** *(verb):* to bind, dress, or cover with a bandage

He heals the brokenhearted and bandages their wounds.
Psalm 147:3

READ

Band-Aids are in high demand at a kindergarten school. Little ones come up to teachers and show us the tiniest of scrapes and scratches in hopes of getting one. As soon as we put a bandage on one finger, three or four more kids are waiting for one, too. Sometimes we need a magnifying glass to see where they want us to put it.

But it's not always about the Band-Aid, is it? We often find them abandoned on the floor just a few minutes later. For these kids that aren't really bleeding, what they want more than a sticky strip of gauze is to feel **better**. To be noticed, special, and cared for in the middle of a busy school day.

We can give them this comfort pretty quickly and easily and get back to the lesson, but we can't heal their bodies or their hearts.

Only Jesus can do that. Only he can make kids and adults truly feel better.

He came to all of us to comfort **and** heal our broken hearts. He came to bandage every single wound—the big, gaping ones and the almost invisible ones. The ones that sting badly and the ones we can't even feel. The ones we just got and the ones we've had for most of our lives.

He knows what to do for every kind of injury.

Charles Spurgeon, a famous English preacher during the nineteenth century, gives us some reasons Jesus is so good at healing **the brokenhearted**:

- Jesus is prepared for this work, having His own heart broken.
- Jesus is experienced in this work, having healed broken hearts for two thousand years.

- Jesus is willing to take the worst patients and has never yet lost one.
- Jesus heals broken hearts with medicine He himself provides.[10]

When we come to Jesus with our hurting places, we don't have to wait in line or hope he will deem our pain worthy of his time. He is never in a hurry, and he doesn't just stick a bandage on us as a quick cover-up.

Jesus is the great Physician. He is the best kind of healer we could ever hope for. He knows our pain firsthand. He will take the time to thoroughly examine us, to listen to our every concern and question, and to give us what we need to make us well.

He comes to us bringing healing in his hands and the perfect bandage for our every wound.

He promises to make us better.

Dear Jesus, you are the only one who can make me feel better. Thank you for your promise to bandage my wounds with your loving care. Please help me trust you with every hurting place in my heart. Amen.

REFLECT

In your journal, write **Psalm 147:3** in your own words.

What does this promise reveal to you about God's character?

What are some hurting places you need Jesus to bandage today?

REMEMBER

In your journal, write the key word (or a different word) you want to focus on in this verse. How will it help you hold on to this promise?

Draw an image to remind you that Jesus bandages your wounds.

God Gives Us COMFORT

Key word **comfort** *(noun):* strengthening aid,
a feeling of ease from grief or trouble

Blessed be the God and Father of our Lord Jesus Christ,
the Father of mercies and the God of all comfort.
2 Corinthians 1:3

On the floor. Curled up in a ball. Crying nonstop or absolutely numb. We have all found ourselves here, haven't we? And we know our hearts will likely get broken again as we continue to live in this hurting world.

In our sadness, someone will try to make us feel better. "God will comfort you," they might say, offering words of sympathy and concern.

But the words seem to ring hollow when our hearts hurt this much. The idea of comfort feels like nothing more than a light blanket on a bitter cold night. Thin and weak and not enough.

Here in his second letter to the Corinthians, Paul praises God for being the God of all comfort.

*Of all the things Paul knew about God—his power, his wisdom, his life-changing truth—why does the apostle emphasize **comfort**?*

God's comfort must have been what kept Paul going. He had been in prison, persecuted and beaten, and was struggling with a weakness (a thorn in the flesh) that tormented him (2 Cor. 12:7–9). For God to be his source of comfort had to mean more than simply receiving a pat on the head and some nice-sounding words. God's comfort must have been his hope, his strength, and his reason to live.

The Greek word for comfort *paraklesis* helps us understand a bit more about what Paul was experiencing. It comes from *parakaleo*, which means *to call near* and *to give exhortation.*[11]

He calls us near. Jesus comes closer than ever in the hardest times. He yearns for us to draw near to him, too, and put our breaking hearts into his healing hands.

He exhorts us. Jesus knows what we need. He encourages us with his loving strength and help for each moment. He helps us up and walks us forward in his perfect timing.

Paul helps us understand that the comfort God gives is gentle, but it isn't weak. I learned this when I lost my mom. The heartbreak was deep and every kind of painful. It was hard to pray in my usual ways. It was hard to tell people. It was even hard to go to the grocery store.

Everything is hard when you are curled up in a ball on the floor.

But in all the hours, days, weeks, and years after losing her, God has been right here with me. Closer than I could have ever imagined. More powerful than I had ever dared to believe. Strengthening me and guiding me to people that taught me more about him. Healing my heart in surprising and renewing ways.

Instead of simply covering our pain with a light blanket and moving on, God stays. When we are hurting, he surrounds us completely. His comfort is like being zipped into the warmest, coziest, thickest pajamas as we cry on the floor, as we get up, and as we walk through the heartbreak into healing.

Let's trust him to comfort our broken hearts today.

Dear Jesus, please bring me real comfort right now. I need your gentle whisper and your strong hand to help me through this pain and grief. Thank you for being the God of ALL comfort and for covering me today. Amen.

REFLECT

In your journal, write **2 Corinthians 1:3** in your own words.

How might you explain this Scripture promise to a child who is feeling **heartbroken**?

What heartbreak can you bring to Jesus right now?

REMEMBER

In your journal, write the key word (or a different word) you want to focus on in this verse. How will it help you hold on to this promise?

Draw an image to remind you that God is comforting you today.

God Saves the CRUSHED in Spirit

Key word **crushed** *(adj):* compressed or squeezed forcefully; feeling overwhelmingly disappointed

The LORD is near the brokenhearted; he saves those crushed in spirit.
Psalm 34:18

READ

Tragedy strikes us hard.

Recently, a sweet friend of mine named Aly—a devoted single mom of a teenage son named Koby—got the call every parent dreads. *"There's been an accident,"* the doctor said. ***"Emergency surgery . . . critical condition . . . coma."*** The terrifying words tumbled over her.

We cried and prayed with her. How could she lose her only child, the most important person in her world?

Miraculously, Koby survived. After two weeks in intensive care, he was moved to a children's rehabilitation hospital. We are all so grateful and relieved. But his traumatic brain injury has left him with more than a huge scar on his head. His road to recovery is going to be long and difficult. Things that used to be easy for him are not. Things he knew how to do for himself now have to be relearned with therapists and caregivers.

And Aly. Her heart is overwhelmed as she watches him struggle. Will he get to finish high school? Will he ever play baseball again? Will he be able to drive, work, live independently someday? Will he overcome the depression that is sinking in as he begins to realize what happened to him?

The weight of it could crush her.

This promise helps me imagine God taking care of Aly. He knows her pain, and he comes close. He's right there in the chair next to Koby's bed. He's with her in the car as she drives back and forth to the hospital. He's comforting her when she wakes up panicking about what's next. And he's walking beside her as she takes each step of this unfamiliar and difficult path.

He is saving her from the crushing.

He saves *all of us* from the crushing. Tragic and traumatic things happen, both to us and to people we care about. Our hearts get broken, and we find ourselves feeling vulnerable, regretful, and weak. Our spirits are contrite as we come to God about it.

The Hebrew word for this is **daka***.[12] It means "crumbled, beat to pieces, destroyed." That's what we are in danger of when our hearts are being broken and our spirits are being crushed.

I imagine our tender souls slipping into a rockcrusher. Rockcrushers are huge, violent machines that have enough power to reduce large boulders into gravel. Words associated with how they work give us an idea of what happens inside: *sharp, jarring, impact, shaking, beaters, breakers,* and *compression.*[13]

That's why being crushed is so scary.

> *Will a tragedy consume us to the point of no return?*
> *Will our joy for life be reduced to a fraction of what it used to be?*
> *Will depression grind us into someone who has lost all hope?*

We need Jesus to get us out of there, and that's exactly what he promises to do. He will rescue us with his mighty, resolute, fiercely loving hand, reaching deep into the jaws of the rockcrushing machine and pulling us back to him.

He will put our souls back together and heal our hearts.

> *Dear Jesus, you know how my heart breaks, and you come close. Right now, I need you to save me from this crushing I feel. Thank you for being here to rescue me. Amen.*

REFLECT

In your journal, write **Psalm 34:18** in your own words.

Look up this verse in a few other Bible translations or paraphrases (https://www.biblehub.org and https://www.blueletterbible.org are two online resources you can use to do this). Write what you notice.

What crushing blow do you need Jesus to save you from, or bring you through, right now?

REMEMBER

Write the key word (or a different word) you want to focus on in this verse. How will it help you hold on to this promise?

Draw an image to remind you that God saves you when your soul is crushed.

Jesus Is LIGHT in Our Darkness

Key word: **light** *(noun):* something that makes vision possible; illumination, beacon

The people walking in darkness have seen a great light; a light has dawned on those living in the land of darkness.
Isaiah 9:2

It's starting again.

I see the first signs of Christmas and feel the shadows creep over my heart.

"It's the most wonderful time of the year," the song reminds me.

But it doesn't feel wonderful to me. As soon as the carols begin to pump through the speakers and everything in the stores turns red and green, I involuntarily brace for the season ahead. I feel guilty admitting this, but my first thought is that I just want it to be over.

I haven't always felt like this. Christmas used to be so special and fun when Mom was alive. The excitement she had was contagious, and her smile lit up the room as she handed out each heartfelt gift. The grandkids got their most thoughtful present last—a handwritten poem written about each one. We miss her so much.

Grief is especially tough at Christmas. So is being sick, out of work, in debt, in pain, addicted, fighting, or separated from loved ones. Everything hard seems extra hard at this time of the year. The pressure is on to feel the happiness that seems expected to magically arrive the day after Halloween.

My memories drift back to the Christmas Eve service at our church that began every year with the words: *"The people walking in darkness have seen a great light."*

I can still hear our pastor's booming voice proclaiming the news. Even though I didn't really understand what he meant, it sounded exciting. Decorated trees and houses, candles in the windows, angels appearing, and wise men following the star. The lights were shining bright in my little world.

I guess I didn't realize then we all were included in that group. *We* were all walking in great darkness, and *we* are all the people the light is dawning on. Jesus came into the dark world more than two thousand years ago, and he still meets us in our darkness today.

> In him was life, and that life was the light of men. That light shines in the darkness, and yet the darkness did not overcome it. (John 1:4–5)

Every Christmas we have reasons to celebrate, to gather and give, to experience feelings of gratefulness and deep joy for the gift of God's only Son. But even in the times when we don't "feel" especially happy or excited, when our hearts are broken and our world feels dark, we can look for his light.

Because of the first Christmas, the Light of the world is always here, guiding us through his word, shining through his people, and warming our hearts with his comforting presence.

The darkness cannot overcome it.

*Dear Jesus, thank you for coming to be with me
in my darkest times. You help me see through
the shadows no matter how I feel. Thank
you for your everlasting light. Amen.*

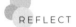

REFLECT

In your journal write **Isaiah 9:2** in your own words.

As you think about this promise, list some things you can be grateful for.

What dark places do you want Jesus to light up for you?

REMEMBER

In your journal write the key word (or a different word) you want to focus on in this verse. How will it help you hold on to this promise?

Draw an image to remind you that Jesus is the light.

God RECORDS Our Misery

Key word **records** *(verb):* to put something
on a list; to note, register, or mark

You have taken account of my miseries; Put my tears
in Your bottle. Are they not in Your book?
Psalm 56:8 NASB

Sometimes we think we will never stop crying. Other times, a single tear
spills out and trickles down our cheek.

The sadness in our heart overflows.

It overflows when we lose someone we love. When we are betrayed
by someone we trust. When we feel rejected, left out, or misunderstood.
It overflows when we have to say goodbye, when we receive bad news, and
when God doesn't seem to answer our prayers.

In the book of 1 Samuel, Hannah was crying because she wanted
a child. Month after month, year after year, God had not answered her
prayer to become pregnant. Her husband's other wife had several children
and constantly, cruelly taunted her. Sometimes Hannah couldn't even eat
because of her despair. Why wouldn't God give her a baby when her desire
to be a mother was so strong?

> Deeply hurt, Hannah prayed to the LORD and wept with
> many tears. (1 Sam. 1:10)

God eventually answered her prayer for children. Hannah dedicated
her first son, Samuel, to serve God for his whole life, and he grew up to be
a great judge and prophet of Israel. God had given her what she prayed so
many years for.

But what if he hadn't?

Would she have continued to bring her pain to God, trusting his good-
ness and love for her?

Could she have trusted his compassion whether she received the
answer she hoped for or not?

Can we?

This promise tells us that we can. It tells us that God's heart is big enough and tender enough to hold all of our misery, our longings, and our tears.

David wrote this poetic psalm after he had been seized by the Philistines. He asked God to be gracious to him in his fear. He wrote that he was being trampled, and he seems to mean both physically *and* emotionally.

I think Hannah must have felt that way, too. But Hannah, like David, had faith that God knew. They both deeply trusted their seeing, caring God. They believed God was keeping track of every hurtful thing that was happening to them. Writing them down, marking them in his book of important things.

They trusted that even in the hardest, saddest times, God was on their side.

And he is on ours, too. Even when he doesn't answer our prayers the way we hoped. Even when we feel like our enemies have the advantage over us. Even when our hearts feel trampled.

This promise can bring deep comfort if we let it. God records our pain because he cares so much about us. Even when we don't understand why we have to go through it, he knows and feels every twinge of misery we do. He will tenderly hold his bottle to our cheeks when we cry, catching each precious tear we shed.

He promises that it all matters *because we matter* to him.

*Dear Jesus, you see and care about everything that
happens to me. Thank you for loving me so much and
for keeping track of my tears. Please help me trust your
goodness even when my heart is breaking. Amen.*

REFLECT

In your journal write **Psalm 56:8** in your own words.

List some emotion words that mean the opposite of heartbroken. Circle one or two you would like to feel instead.

Can you imagine Jesus carefully catching your tears in his bottle?

REMEMBER

In your journal write the key word (or a different word) you want to focus on in this verse. How will it help you hold on to this promise?

Draw an image to remind you that God records your misery.

Jesus WEEPS with Us

Key word **weep** *(verb):* to shed tears, to cry silently

Jesus wept.
John 11:35

READ

This is the famous verse. The shortest one in the Bible. The one that connects us to Jesus through the extremely painful emotion of sadness.

He felt heartbreak. He knew deep loss. He experienced the raw ache of grief. He shed real tears. To read that Jesus wept surprises some of us.

We find this promise tucked inside the middle of a miracle story. Jesus's friend Lazarus had become sick and died, and his sisters were grieving. Before Jesus went to them, he knew God was going to be glorified by raising Lazarus back to life. He told his disciples in verse 11, "Our friend Lazarus has fallen asleep, but I'm on my way to wake him up."

Jesus knew that healing and resurrection were coming. He knew the weeping sisters were about to be overwhelmed with joy to see their brother walk out of that tomb. And yet, as their friend and teacher, he took time to be with them in their grief. Their friend and teacher had stopped to share in their pain, and he had started to cry.

Even though Jesus knew that in a matter of minutes he was going to raise their dead brother back to life, he didn't rush ahead or dismiss their feelings.

It surprises us, and it helps us so much to know that he understands when our hearts break. We cried so many tears when we lost our mom. Losing someone close to us hurts for a long time.

Even though we knew she was going to be relieved of her sickness and pain,

even though she was going to be with Jesus,

even though we have the hope of spending eternity in heaven with her, we were devastated.

Jesus understood our pain. He didn't rush us through our grief or dismiss our feelings. Instead, he came closer to us that night in the agony of losing her. He felt our sadness, too, as we said goodbye until heaven. He

tended our hearts as we started to navigate life without her. And he faithfully, compassionately sits with us when the tears still come.

This verse promises us that Jesus cares enough to cry. We can be comforted to know that he is familiar with grief, and we can be strengthened to know that he has the power to resurrect us all. He can bring life from death, good from evil, beauty from ashes, and joy from mourning. But in the painful in-between, we can trust him simply to be with us and let us share our grieving hearts. He's got tears in his eyes, too.

Dear Jesus, thank you for crying. It comforts
me to know that you care so much about my
sadness. Please help me feel your compassion and
understanding when my heart breaks. Amen.

REFLECT

In your journal, write **John 11:35** in your own words.

Do you have any questions for Jesus about this promise?

What can you let Jesus weep with you over today?

REMEMBER

In your journal, write the key word (or a different word) you want to focus on in this verse. How will it help you hold on to this promise?

Draw an image to remind you that Jesus weeps with you.

Promises for When You Feel

You Feel

Hopeless

God Is ABLE to Do More Than We Ask

Key word **able** *(adj)*: having sufficient power, skill, or resources to do something; qualified

Now to him who is able to do above and beyond all that we ask or think according to the power that works in us.
Ephesians 3:20

I have a friend who sets her phone alarm for 3:20 every afternoon because of this promise. Ephesians 3:20 brings a burst of hope into her day no matter what she is in the middle of doing. It can do this for us, too.

It can remind us that God is working in ways we can't always see or understand. It can remind us that the cries of our hearts are heard by someone who is *able* to answer them in ways we can't even dream of.

Above and beyond. Some other translations of this verse use words like:

> *immeasurably more* (NIV)
> *superabundantly more* (AMP)
> *exceeding abundantly above* (KJV)

And in the Message translation:

> *God can do anything, you know—far more than you could ever imagine or guess or request in your wildest dreams!*

It sounds so amazing, doesn't it? I really do believe he is able to answer my prayers in astounding ways. Yet sometimes I pray like he needs my help. In my finite mind, I come up with ideas and plans for how he might want to accomplish something. Sometimes I even get creative and try to suggest a few different ways he could work things out.

I'm sure he appreciates my efforts. But over and over he surprises me with how *able* he is to work things out. He is all-sufficient, all-powerful, all-knowing, and not limited in any way.

Years ago, I was struggling with some severe anxiety. I was cautiously exploring the idea of going to counseling, but the first two therapists I

called were definitely not a good fit, and I was discouraged. I prayed, *God, if you want me to see a counselor, please help me find one.* And then I forgot about it for a while.

Until one morning when I was on my way to school approaching my usual Starbucks. For some reason, I decided I didn't really need another coffee, and I just kept driving. My mind started to wander, and I somehow missed the turnoff to my school. The next opportunity to turn around took me into a parking lot with a different Starbucks.

Hmm. Maybe I did need another coffee. God's plan was taking shape. As I stood in line, a notice on the bulletin board caught my eye. All the things I wanted help with—grief, anxiety, and more with were listed on this flyer for a Christian counselor with a practice nearby. I took her card along with my coffee, and my life will never be the same.

In a crazy, unexpected way, God led me to the therapist I needed. As we worked together, God kept growing me, healing me, and revealing more of his goodness to me. Her wisdom, compassion, and words of truth were gifts from him that have turned out to be immeasurably more than what I thought I was praying for.

He loves to go above and beyond for us.

Dear Jesus, thank you for going above and beyond
for me. You are able to do so much more than I could
ever dream of. Please give me the faith to believe that
you will exceed my wildest imagination. Amen.

REFLECT

In your journal, write **Ephesians 3:20** in your own words.

What does this promise reveal to you about God's character?

Imagine God going above and beyond to answer your prayer. What might that look like for you?

REMEMBER

In your journal, write the key word (or a different word) you want to focus on in this verse. How will it help you hold on to this promise?

Draw an image to remind you that God is able to do above and beyond what you can ask or think.

Jesus Is Our ANCHOR

Key word **anchor** *(noun)*: something that serves
to hold an object firmly; a reliable support

We have this hope as an anchor for the soul, firm and secure.
Hebrews 6:19

READ

When our boys were growing up, we used to spend a week every summer at a waterfront cabin on an island in Puget Sound. They loved exploring the tide pools on the rocky beach, fishing from the county dock, running down to buy candy at the tiny general store, and roasting marshmallows over the beach fires at night.

All day long, boats of every kind would go back and forth in front of our little place on the shore. Ferries, fishing boats, fancy yachts, colorful kayaks, and all kinds of sailboats. Every night, when the boat traffic stopped, one beautiful sailboat would be anchored directly in front of the cabin. Its twinkling lights were the last thing I would see before I got into bed, and its bright sails would catch my eye first when I looked out at the water each morning.

It gave me so much peace to see that sailboat. I could count on it being there—freely floating but always staying right around the same spot. It moved a little bit with the tides and the wind, but it was never in danger of drifting away.

It wasn't in danger of drifting away because it was anchored. It was attached to a heavy object that held it securely to the seafloor. The sailboat was safe yet free because it was firmly connected to something solid and strong.

And so are we.

This promise tells us that Jesus is our anchor. Because of what he has done for us, we can have this kind of solid, unbreakable hope. We can live like that sailboat. When we are connected to Jesus, we are totally safe and completely free at the same time.

Even when the tides of this world are pulling too hard on our hearts, we can trust our Anchor.

Even when waves of stress and negativity are knocking us around, we can trust our Anchor.

Even when terrible storms beat down on us and do damage to parts of us, we can trust our Anchor.

Even when we feel like we are drifting too far for help, we can trust our Anchor.

The rest of this verse and the one that follows tells us more about why we can trust Jesus to be our anchor:

> This hope . . . It enters the inner sanctuary behind the curtain. Jesus has entered there on our behalf as a forerunner, because he has become a high priest forever according to the order of Melchizedek. (Heb. 6:19–20)

Jesus is our great high priest. He has gone to the Father on our behalf and made a way for us to follow him. He lived and died and rose again so that we could experience the joy that comes from being held by him forever.

We can trust him because of who he is.

That is the hope I want to hold onto.

Dear Jesus, you are the Anchor for my weathered soul. Thank you for being my great high priest and giving me so much hope. Please help me live in your safety and freedom today. Amen.

REFLECT

In your journal, write **Hebrews 6:19** in your own words.

How might you explain this Scripture promise to a child who is feeling *hopeless*?

What storm do you need Jesus to be your anchor in right now?

REMEMBER

In your journal, write the key word (or a different word) you want to focus on in this verse. How will it help you hold on to this promise?

Draw an image to remind you that Jesus is your anchor of hope.

We Will See God's
GOODNESS

Key word **goodness** *(noun)*: praiseworthy
character; virtue, kindness, benevolence

I am certain that I will see the LORD's
goodness in the land of the living.
Psalm 27:13

God's goodness.

The Hebrew word for *good* means "good in the widest sense." Beauty, welfare, and joy to the strongest degree.[14]

Can we believe we will see God's kind of goodness in this life?

Sometimes it's easy. We see it in a breathtaking sunrise, in the new-fallen snow, and in the first buds of spring. We hear it in a baby's laugh, in the just-right song for the moment, and in the opening of the garage door signifying someone we were praying for made it home. We taste it as we sit down to a meal after a long day—even if it we got it from the drive-through on the way home.

But other times, we feel like we might never see it again.

Long stretches of illness and pain. Financial struggles that just seem to be getting worse. Faithful prayers that seem to go unanswered.

Where is your goodness in this time of life, God?

I try to find it on my daily walk. It's not hard when I'm on a trail in the woods or on the beach path near my home. His creativity and power are so evident in nature, and seeing his beauty gives me hope.

But my workday walk is an ugly one. The only route I have time for during my short lunch is through a noisy and busy industrial park. Airplanes constantly take off and land on the adjacent runway, and garbage trucks rumble past me on their way to the landfill.

One bleak January day, I really wanted to see God's goodness. I was looking hard along this walk for something pretty, peaceful, or inspiring.

Nothing. Not one flower poking through the gray sidewalk, not one spot of blue sky, not one person passing by with a smile.

"Where is it, God?" I asked. *"Where is your goodness?"*

I went back to work without an answer. I hadn't *seen* anything good. But as the afternoon went on, I noticed how good I *felt*. Getting outside and moving my body had refreshed and energized me. My mind was clear and my muscles felt strong. The goodness of the walk was showing up inside me in ways I couldn't see or even comprehend.

Good in the widest sense. Beauty, welfare, and joy to the strongest degree.

This promise might mean much more than I thought.

As we learn to trust God's good heart, we will start to discover just how constant his favor and kindness are to us. We will learn that we can experience his goodness even when things don't look like we want them to, even when we don't understand why something is happening, even when we don't *feel* good.

His goodness will show up in deeper, wider, and different ways than we can ever imagine.

We will see.

———————

Dear Jesus, thank you for your goodness to me.
I want to see more and more of you and your
goodness in my life. Please help me trust you no
matter what I can or cannot see. Amen.

REFLECT

In your journal, write **Psalm 27:13** in your own words.

Look up this verse in a few other Bible translations or paraphrases (https://www.biblehub.org and https://www.blueletterbible.org are two online resources you can use to do this). Write what you notice.

Where do you hope to be surprised by God's goodness today?

REMEMBER

In your journal, write the key word (or a different word) you want to focus on in this verse. How will it help you hold on to this promise?

Draw an image to remind you that God will show you his goodness.

God Will RESCUE Us

Key word **rescue** *(verb)*: to free from confinement, danger, or evil; to recover

Then they cried out to the LORD in their trouble;
he rescued them from their distress.
Psalm 107:6

We all need to be rescued sometimes.

We don't mean to get ourselves in over our heads, but we find ourselves there. Even the most cautious of us can find ourselves in all kinds of distress—emotional, financial, relational, mental, and physical.

This promise will always remind me of the time Bob and I nearly drowned in Hawaii.

I was sure it was my fault. I wanted to swim one last time before we flew home. Until that day, I had been having so much fun bodysurfing in the waves while he contentedly watched me from under the palm tree. Even though it was a bit overcast and less inviting, this afternoon was our last opportunity to feel the soothing Hawaiian water. Always a good sport, he agreed to go with me.

Something was different—I could tell right away. After a couple of waves had crashed over our heads, my feet couldn't touch the bottom anymore. The beach looked faraway. I turned to tell Bob I was getting scared, and that's when I realized how far out he was and how exhausted he had become.

The look on his face sent a lightning bolt of fear through my entire body. The waves were getting bigger and rougher; and as we both struggled to stay afloat, he was drifting farther and farther away from me and out to sea.

"I'm not going to make it," he said. His voice was weak and resigned, and I knew he meant it.

Panicky thoughts raced through my mind:

I should try to get to him and hold him up, but I don't have
the strength. We will both drown.

I should try to swim to shore and get help, but he won't last that long.
Is this how our life is going to end?
How had we gotten into such a desperate situation?

I had no idea what to do. I had only seconds to make the hardest decision of my life.

Suddenly, a burst of strength came from somewhere deep inside of me. With an energy and volume that I didn't know I had, I yelled, **"HELP! HELP!"** toward the shore. There were no lifeguards at this spot, and I couldn't see the beach, but maybe someone would call 911?

That's when God sent Jeff.

He appeared out of nowhere, grabbed hold of Bob, and swam us at an angle out of the rip current and back to shore. This strong, experienced swimmer ran into danger, risking his life to save ours. God knew we were going to need him that day.

There is more to the story, but the thing I keep thinking about is how helpless we were and how powerfully God took charge. From now on, when I don't know how to get myself out of a situation, I will remember that **he does**.

He is good at rescuing us at exactly the right time.

Dear Jesus, thank you for always listening, watching, and being ready to rescue me. I believe you will never ignore my cries for help. Please help me trust you in desperate situations and also in my everyday struggles. Amen.

REFLECT

In your journal, write **Psalm 107:6** in your own words.

As you think about this promise, list some things you can be grateful for.

How does it help you to know that Jesus is always ready to rescue you?

REMEMBER

In your journal, write the key word (or a different word) you want to focus on in this verse. How will it help you hold on to this promise?

Draw an image to remind you that God will rescue you.

God's Word SHINES in Our Dark Places

Key word **shines** *(verb)*: to emit rays of light, to be conspicuously evident or clear

We also have the prophetic word strongly confirmed, and you will do well to pay attention to it, as to a lamp shining in a dark place, until the day dawns and the morning star rises in your hearts.
2 Peter 1:19

READ

Sometimes our dark places are not just places. The darkness has moved inside of us, and we feel like our hearts have turned off. Nothing feels right or good. Everything seems so much harder.

When we lose power at our house, I get so disoriented. What used to be familiar is not, and my steps are tentative rather than sure. Noises scare me, but so does the quiet.

It's such a relief to find a flashlight or a candle. Even a little flicker of light helps in so many ways.

The light reminds me of what is around me. It helps me find my way. And it gives me a sense of calm.

When our hearts feel like dark places, we need this promise. We need to know that Jesus sees us stumbling around in the dark and that he brings us truth and hope.

Peter wrote about this truth and hope after experiencing something incredible with Jesus, James, and John.

Mark 9:2–4, 7 describes what they saw and heard:

> He was transfigured in front of them, and his clothes became dazzling—extremely white as no launderer on earth could whiten them. Elijah appeared to them with Moses, and they were talking with Jesus. . . .
>
> A cloud appeared, overshadowing them, and a voice came from the cloud: "This is my beloved Son; listen to him!"

So, when Peter talks about light, I want to pay attention. That's what he is encouraging us to do in this verse—to pay attention to the truth about Jesus.

When Jesus was walking on this earth, every prophecy about him was being fulfilled. But for many in the early church, this wasn't clear yet. They were still trying to make sense of who Jesus was and all that had happened. I imagine that some of them were feeling spiritually in the "dark."

Peter reminded them of what the prophets foretold about Jesus. Their words were written to illuminate Christ—to show who he is and what he came to do. In this time of confusion, they could go back to these Scriptures that Peter said were being "strongly confirmed" (2 Pet. 1:19). Other translations use words like "*made* more sure" (NASB), and "completely reliable" (NIV). Even Jesus himself said that the Scriptures testified about him (John 5:39).

Today we can find lists of hundreds of Old Testament prophecies that have come true about him.[15] So, when things are dark and confusing, we can focus on the truth about Jesus, the Light of the world.

He is around us.

He will help us find our way.

And he will give us a sense of calm.

Because Jesus is the beloved Son of God and our promised Savior, we can have light even in our darkest places.

Dear Jesus, you are the long-awaited Messiah, the Light of the world. I want to trust you with my heavy heart today. Thank you for your clarity, your truth, and the hope of your presence. Amen.

REFLECT

In your journal, write **2 Peter 1:19** in your own words.

List some emotion words that mean the opposite of hopeless. Circle one or two that you would like to feel instead.

Where do you need God's light to shine today?

REMEMBER

In your journal, write the key word (or a different word) you want to focus on in this verse. How will it help you hold on to this promise?

Draw an image to remind you that God wants to shine his light in our darkest places.

God Can Work WONDERS

Key word **wonder** *(noun)*: a cause of astonishment
or admiration; a miracle, a surprise

You are the God who works wonders.
Psalm 77:14

READ

Psalm 77 doesn't hold back. Real feelings and hard questions are directed to God, some of them almost coming across as disrespectful:

> *God, I don't understand. Why haven't you answered my prayer?*
> *I don't feel like praying or going to church or anything right now.*
> *Are your miracles just for other people? What about me?*

Is it okay to talk to him like this?

This psalm of grief and struggle reassures us that it is. Even if we don't say these things, God knows when we feel and think them. He is not offended or threatened by our honest cries as we open our hurting hearts to him.

But the psalmist shows us how to walk through the hopelessness to the other side. We can learn from him here.

He starts by pouring out his feelings and asking his questions, and then halfway through the psalm, he switches it up. He begins to ***praise*** and ***remember***. Even though he is consumed with grief, he focuses his mind on ***who God is*** and ***what he has done***. He describes the miraculous way God rescued the Israelites and led them out of Egypt. In verses 13–14, he says this:

> God, your way is holy.
> What god is great like God?
> You are the God who works wonders.

God is holy. God is great. God can work wonders.

Oh, that's right.

Recently I spent some time looking back through twenty years of prayer journals. Page after page, notebook after notebook brought tears to

my eyes. There were so many prayers I had forgotten about that God had been faithful to answer. Prayers for big and small things, prayers for people, and prayers for myself. Vulnerable prayers, discouraged prayers, expectant prayers, and grateful prayers.

There were answers in these journals, too. I found answers to prayers I hadn't even voiced. I realized as I flipped through the pages that several of the gifts God had given me were things *he knew* I needed, but *I didn't know* I did.

Some of the answers looked different from how I thought they should look. Some answers haven't come yet. I still don't understand God's plan in these, but I guess don't have to. What I do understand is that I can come to him just as I am—with my questions, my disappointments, my confusion, and my hurt.

And then I can switch it up.

Because I trust **who he is** and **what he has done**. I can begin to praise him and remember all the good, all the surprises, all the unexpected ways he has answered my prayers for all these years.

He never stops loving us or listening to us. He is a God of miracles and surprises, and he is always working everything together for good.

He is holy, he is great, and *he can work wonders*.

He will help us find our hope again.

———————

Dear Jesus, thank you that I can be real with you. In my hopelessness, please help me focus on your holiness and greatness. I will hope in you, my wonder-working God. Amen.

REFLECT

In your journal, write **Psalm 77:14** in your own words.

What does this promise reveal to you about how God works?

What wonders of God can you praise him for today?

REMEMBER

In your journal, write the key word (or a different word) that you want to focus on in this verse. How will it help you hold on to this promise?

Draw an image to remind you that God can work wonders.

Promises for When You Feel

Insignificant

God Will ANSWER Us When We Call

Key word **answer** *(verb)*: to speak or write
in reply; to act in response to

*At that time, when you call, the LORD will answer;
when you cry out, he will say, "Here I am."*
Isaiah 58:9

Please pick up, please pick up!

The engine light was flashing on my dashboard. I was on my way home from work, and it was starting to get dark. I kept calling my husband's number, but there was no answer. I pulled over to the side of the busy road to figure out what to do. I continued to call him as I read the manual, searched on my phone for what to do when an engine light is flashing in an eighteen-year-old car, and texted a couple of my friends for moral support.

I was starting to feel scared, alone, and frustrated by the whole situation. Feelings of insignificance teased through my heart and mind. Even though I am completely confident in my husband's love for me, I was starting to wonder if he would even notice that I was unusually late getting home. Would he realize he should check on me?

It wasn't long before he called, concerned and apologetic for not hearing his phone while he was mowing the lawn. He talked me through my tentative drive home, ready to come get me at the first sign of trouble. I was instantly reassured by his caring response.

We all need help sometimes. We might find ourselves in a broken-down car, a broken-down body, a broken-down relationship, or a broken-down spirit.

And we desperately want someone to answer our call.

That's what we can count on with Jesus. He promises that when we call on him, he will answer.

He is available all day and night—constantly watching over us, always thinking about us and listening for our call. We never have to worry that

he might not hear us or that he might not answer. We can be completely confident that he will.

What makes this promise even more meaningful are the words he answers with. Jesus reassures us that when we cry out, he will say, "Here I am."

"Here I am."

I'm right here with you in your brokenness and need. I'm right here giving you the peace and hope of my Spirit. I'm right here holding you close in your panic and your grief. I'm right here taking care of you because you matter more than anything to me.

We get to be loved and listened to by the God of the universe. Even if we don't see or hear an answer right away. Even when the answer is not the one we wanted. Even when we feel like no one is listening. God is.

God is the only one who is never too busy for us. He is the only one who can give us exactly what we need. He is the only one who never loses his phone.

He will always pick up.

Dear Jesus, you are so constant and faithful. I love knowing that you always hear my cries for help. Thank you for answering me every time I call. Amen.

REFLECT

In your journal, write **Isaiah 58:9** in your own words.

What does this promise reveal to you about God's character?

What can you ask Jesus to answer for you today?

REMEMBER

In your journal, write the key word (or a different word) you want to focus on in this verse. How will it help you hold on to this promise?

Draw an image to remind you that God will answer you when you call.

God CHOSE Us

Key word **chose** *(verb)*: to select freely after
consideration, to decide on, to have a preference for

*For he chose us in him, before the foundation of the
world, to be holy and blameless in love before him.*
Ephesians 1:4

It was finally time to get the puppy we had wanted for so long. Our boys
were old enough to take some responsibility, our new house had a yard, and
we had all agreed on a nonshedding, hypoallergenic breed. When we went
to meet the new litter of Cavachons, we wanted to take them all home.

But little Koko—the female runt of the litter—was the one we chose.
She is such a good dog—sweet, loyal, and eager to please. But even if she
weren't, we were committed to keeping her and loving her. The moment we
chose her, she was given a special place in our family. She belongs with us.

Some of us have felt for most of our lives like we've never been chosen
by anyone. For anything.

We don't belong, we tell ourselves.

We're not good enough, pretty enough, smart enough, strong enough.

We don't deserve to be chosen.

But then we read this promise.

God chose us.

In Jesus. Before the foundation of the world. Before we even knew
who God was.

He knew us and he chose us.

He committed to keeping us and loving us no matter what. He made
us holy and blameless in his love. He named us as heirs with Jesus and gave
us a place in his family forever.

Paul wrote this letter to encourage those of us who still can't believe it
sometimes.

For those of us who feel like we might not qualify.

For those of us who get into things we shouldn't and make messes God has to clean up.
For those of us who wonder if God is disappointed that he brought us home.

This promise is about God's heart for us.

It is not about whether we deserve it, because we don't. None of us could possibly be worthy of this kind of unconditional love.

This choosing happened before we could do anything good or bad, before we could possibly earn his love, and before we could do anything to lose it. There is no checklist of qualifications attached to this promise. No criteria to meet or approval required. He sees us as holy and blameless because of Jesus's sacrifice for us. We are already in. Or, as one commentator puts it: "Believers are chosen by God, and they are chosen before they *have done* anything or *have been* anything for God."[16]

God picked you and God picked me because he wants us to be in his family forever.

We are chosen, and we belong with him.

Dear Jesus, sometimes I wonder why you chose me, but I am so glad you did. Please help me remember that I can't possibly earn or lose your love. Thank you for making me yours. Amen.

REFLECT

In your journal, write **Ephesians 1:4** in your own words.

How might you explain this Scripture promise to a child who is feeling *insignificant*?

What does it mean to you to be chosen by God?

REMEMBER

In your journal, write the key word (or a different word) you want to focus on in this verse. How will it help you hold on to this promise?

Draw an image to remind you that you have been chosen to be in God's family.

We Are Not **FORGOTTEN** by Jesus

Key word **forgotten** *(adj)*: disregarded,
ignored, neglected, overlooked

*Aren't five sparrows sold for two pennies? Yet not one of them
is forgotten in God's sight. Indeed, the hairs of your head are all
counted. Don't be afraid; you are worth more than many sparrows.*
Luke 12:6–7

READ

Do I matter?

This question makes its way into hearts too often it seems. I remember sitting with a devastated friend who had been betrayed by some of the closest people in her life. Self-serving choices they had made left her feeling misunderstood and alone. Disregarded. Left. Forgotten.

In her pain she kept repeating, *"I just want to matter. I just want to matter."*

Jesus hears that cry from every one of our hearts.

That's why he tells us about the sparrows.

I read this verse and picture these fragile, tiny sparrows darting around in the brush. Five of them together were worth only a small amount of money in Jesus's time. I don't know what they would cost today, but the important point is that it would not be much. Then or now, two pennies means pretty close to nothing.

Jesus knew when he spoke these words that we would struggle with feelings of worthlessness in this life. He knew people would break our hearts. He knew everywhere on the earth we could possibly turn would be laden with pressure to measure up, fit in, be noticed, and prove we have value.

And he knew that striving to do these things—to prove our worth—would often take us to dark, empty places. Lonely places that reinforce the lie that we are worth pretty close to nothing. That maybe we don't really matter.

But when we find ourselves in these places, Jesus wants us to remember that he has never forgotten us. And he never, ever will.

Because some of the most healing words in the English language mean the *opposite* of forgotten: **remembered, cherished, treasured,** and **attended to**.

Jesus our great high priest **remembers** us as he intercedes for us before our Father.

Jesus our true friend **cherishes** us—delighting in who he has made us to be as we grow closer to him.

Jesus our Savior **treasures** us so much that he died on the cross in our place.

And Jesus our faithful Shepherd **attends to** us—tenderly and fiercely taking care of his precious lambs.

We are never forgotten by Jesus because *we **matter**—**more than anything**—**to him***.

Dear Jesus, thank you for never forgetting me. When I feel small and insignificant and worthless, you remind me that I matter. You remember me, you cherish me, you treasure me, and you attend to me because I am worth everything to you. Amen.

REFLECT

In your journal, write **Luke 12:6–7** in your own words.

Look up these verses in a few other Bible translations or paraphrases (https://www.biblehub.org and https://www.blueletterbible.org are two online resources you can use to do this). Write what you notice.

If you were a little bird perched on Jesus's shoulder, what kind of bird would you be? What do you think Jesus might say to you?

REMEMBER

In your journal, write the key word (or a different word) you want to focus on in these verses. How will it help you hold on to this promise?

Draw an image to remind you that Jesus will never forget you.

God INSCRIBES Us on the
Palms of His Hands

Key word **inscribes** *(verb)*: to write, engrave, or
print as a lasting record; to enter on a list

Look, I have inscribed you on the palms of my hands.
Isaiah 49:16

READ

One of my favorite podcasters asks a great question of her guests at the end
of each show. She asks if they have any tattoos and, if so, their significance.
If they don't have any, she asks what kind of tattoo they would choose if
they *had* to get one.

I love this part of the conversation because I believe the answer to that
question takes us right to the heart and soul of someone.

What represents meaning and value to this person?

*What matters enough to see and think about every day for the rest of his or
her life?*

I love to know about other people's tattoos, but I didn't have one of
my own until a few years ago. It was too hard for me to decide what to get.
Suddenly it became clear while I was working through some pretty rough
anxiety. I was learning about how God cares for me as his precious child,
and I happened upon a favorite photo. It is an old black-and-white taken
by my grandpa of me floating in an inner tube in the saltwater bay at our
family cabin. My five-year-old self was enjoying a warm summer day with
not a care in the world. I was in my happiest place.

My inner-tube tattoo reminds me. When I look at it, I can take a deep
breath and remember that God holds me like that. I can float above the
stress and fear because I belong to him. I am his precious child.

So precious to him, in fact, that he has my name inscribed on the palm
of his hand. Yours is there, too. Out of all the wondrous things he created,
we are the ones he values the most. We are the ones he has set his heart on.
We are the ones he thinks about every moment of every day.

He promises he will never forget us.

Sometimes we might wonder if he has. When circumstances are hard to understand and God seems far away, we might cry like the Israelites did in verse 14:

> "The Lord has abandoned me; the Lord has forgotten me!"

But his tender answer comes next:

> "Can a woman forget her nursing child,
> or lack compassion for the child of her womb?
> Even if these forget,
> yet I will not forget you.
> Look, I have inscribed you on the palms of my hands."
> (Isa. 49:15–16)

Even when we feel unnoticed, even when our prayers seem to go unanswered, even when nothing we do seems to matter; we can remember that God has written our names on the palm of his hand. He never stops caring about us.

If he ever really had to choose a tattoo, he would choose your name and mine.

That's how important we are to him.

*Dear Jesus, thank you for inscribing my name
on your nail-scarred hands. I am so honored and
grateful to matter so much to you. Please help me
remember that you never forget me. Amen.*

REFLECT

In your journal, write **Isaiah 49:16** in your own words.

As you think about this promise, list some things you can be grateful for.

Imagine Jesus looking at his hand and reading your name. How does that make you feel?

REMEMBER

In your journal, write the key word (or a different word) you want to focus on in this verse. How will it help you hold on to this promise?

Draw an image to remind you that your name is inscribed on the palm of God's hand.

God Calls Us by NAME

Key word **name** *(noun)*: the distinctive designation of a person; the words by which a person is regularly known

"I have called you by your name; you are mine."
Isaiah 43:1

READ

Names fascinate me. I love learning who or what someone is named for. I appreciate unique names and creative spellings, and I marvel at how some people have names that really fit them. As a teacher, I have known quite a few children whose names matched their personalities, like Rowdy, Jewel, Patience, and Gabby. I have also known kids like Emmanuel, Princess, and Angel whose names and personalities could not have seemed more different.

Because of my role as a specialist teacher, I teach hundreds of children rather than just one classroom. Each year, the other specialists and I make a huge effort to learn our students' names correctly and remember them. Sometimes we make up little nicknames for them to make them giggle. It's so important to us to make this early connection to help them feel known and secure.

I look in the Gospels and find that Jesus did this all the time. As he talked with people and called them by name, he showed them genuine honor and care. It seems like it didn't take long at all for people to feel familiar and safe in his presence. They could relax and be themselves because he made clear that he already knew them, accepted them, and loved them.

> "**Zacchaeus,** hurry and come down because today it is necessary for me to stay at your house." (Luke 19:5)
> "**Martha,** Martha, you are worried and upset about many things." (Luke 10:41)
> "You are **Simon,** son of John. You will be called **Cephas**" (which is translated "Peter"). (John 1:42)
> And to James the son of Zebedee, and to his brother John, he gave the name "**Boanerges**" (that is, "Sons of Thunder"). (Mark 3:17)

Jesus knew Zacchaeus, Martha, Peter, James, and John before they knew him. He knew Zacchaeus's heart. He knew what Martha needed to hear. He knew that Peter would live up to the name *Cephas*, whose famous statement about Jesus's identity would be the bedrock of the early church.[17] And he knew the stormy personalities of James and John well enough to give them the nickname "Sons of Thunder."

I love to imagine Jesus calling my name out of a crowd and inviting himself to dinner. It would be brave of him to risk having to eat my cooking, but I bet he would know enough to come on a night when we order takeout.

It calms my heart to picture him saying, *"Susie, Susie, you are worried and upset about so many things"* because he actually understands what those things are and deeply cares about me.

It makes me smile to think of Jesus giving me a new name that hints of my place in his kingdom or calling me by a nickname he made up especially for me.

He knows each one of us like that. He knows us like he knew the people he lived with on the earth. He knows our *thoughts, our fears, our personalities, our gifts, our struggles, and our needs.*

He knows us by name, and we belong to him.

Dear Jesus, you know me better than I know myself. I love that you know my name, but you also know my heart. Thank you that I can feel familiar, accepted, and known with you. Amen.

REFLECT

In your journal, write **Isaiah 43:1** in your own words.

List some emotion words that mean the opposite of *insignificant*. Circle one or two you would like to feel instead.

What do you think Jesus would call you? Your formal name? A nickname? Explain why.

REMEMBER

In your journal, write the key word (or a different word) you want to focus on in this verse. How will it help you hold on to this promise?

Draw an image to remind you that God calls you by name.

God's Thoughts about Us
OUTNUMBER the Sand

Key word **outnumber** *(verb)*: to exceed in number

God, how precious your thoughts are to me; how vast their sum is! If I counted them, they would outnumber the grains of sand.
Psalm 139:17–18

READ

Math was not my favorite subject in school, but I did okay. I actually enjoyed learning to solve math facts and equations until too many letters started showing up in the problems.

Numbers belong in math problems, but somewhere along the course of my life they started creeping into my self-esteem. I started using them to compare myself to others. I started needing them to help me figure out if and where I fit in.

> *Is my test score higher or lower than his?*
> *Do I weigh more or less than her?*
> *Is our income above or below theirs?*
> *Where did I rank on the last staff evaluation form?*
> *Likes, followers, reviews—why don't I have as many as she does?*
> *What is my overall number in life, I wonder?*

For those of us who struggle with comparison, what we are desperate to know is what—if anything—we are worth.

This promise is for us: *God's thoughts about us are precious. Their sum is vast. If we counted them, they would* **outnumber** *the grains of sand.*

As fun as that is to think about, it's way too much for my limited brain to figure out. I like to try, though. Almost every time I walk on the beach, I wonder how many grains of sand are under my feet, under the water, all over the world, in a handful. It's impossible for us to count or even estimate that number.

Maybe that's the point.

Maybe God used something so difficult to count because he doesn't want us to keep worrying about or focusing on the numbers.

Psalm 139 tells us that he carefully, intricately designed each one of us. Comparing ourselves with anyone else would make as much sense as comparing apples and oranges.

It tells us God's math is different from ours. The value he places on us is not something we can measure with scales or figures or scores. He doesn't have a system that ranks us as better or worse than anyone else. He doesn't use the greater-than or less-than symbol that we like to use.

It tells us he delights in thinking about us. Protecting us. Growing us. Redeeming our mistakes and healing our hearts. Helping us find our unique purpose in this adventurous life with him. Revealing his unconditional love to us in surprisingly personal ways.

It tells us he cares about us infinitely more than we can understand.

We are totally outnumbered by his love.

Dear Jesus, you know how much I want to count in this world. Please help me trust the way you value me. Thank you for every grain of sand that helps me remember how much you love me. Amen.

REFLECT

In your journal, write **Psalm 139:17–18** in your own words.

What does this promise reveal to you about how God works?

What (or whom) are you comparing yourself to? Can you let Jesus show you how much you are worth to him?

REMEMBER

In your journal, write the key word (or a different word) you want to focus on in these verses. How will it help you hold on to this promise?

Draw an image to remind you that God's thoughts about you outnumber the sand.

Jesus SEES Us

Key word **sees** *(verb)*: to perceive by the
eye, to be aware of, recognize

*Jesus turned and saw her. "Have courage, daughter," he said. "Your
faith has saved you." And the woman was made well at that moment.*
Matthew 9:22

I think we can all sometimes relate to this poor woman. Living in a human
body often means struggling with embarrassing problems or limiting
health conditions. Bleeding was an especially restricting issue during Bible
times. Women who were bleeding were considered to be *unclean*. During
her menstrual cycle, a woman was not allowed into the temple. The place
where everyone gathered was off-limits to her. What seems even worse to
me is that Jewish law forbade her from even touching another person while
she was bleeding.

For the poor woman in this story, this had been her life for twelve
years. Twelve years of bleeding. Twelve years of not being allowed in the
temple. Twelve years of not being able to touch anyone. Twelve years of
being called *unclean*.

Being isolated is brutal. It takes such a toll on our hearts and souls.
We all need physical contact and social connection. I try to imagine life
without it.

What if I were the only one who had to follow these rules?

*What if I had an incurable health issue that kept me from my family and
friends for years?*

The hopelessness would be too much. My heart breaks when I think
of this woman feeling so dismissed and insignificant, in addition to being
physically weak and alone. The people in her life had gotten used to her
not being around.

Was she going to be forgotten? Not by Jesus.

Matthew tells us Jesus turned and *saw her*. The Greek word that helps
us understand this kind of seeing means he **beheld** her. It means that he

was **aware of her situation, he considered what she was experiencing**, and **he understood her.**[18]

This brave woman fought her discouragement and fear when she decided to reach out and touch the robe of Jesus from behind. She thought she would make a quiet, unnoticed, last-chance attempt to be physically healed, but Jesus knew she needed much more than that. When Jesus felt his healing power go out from him, he stopped and asked, "Who touched me?" She must have been terrified. Being called out was not part of her plan.

But Jesus had a better one.

He healed her instantly, miraculously, completely.

He spoke to her tenderly and compassionately, calling her daughter.

He acknowledged her, encouraged her, and affirmed her worth.

He declared in front of a large crowd that she was no longer unclean.

Jesus, in his tender, surprising way, told her that her faith had healed her. He gave her credit for daring to take a chance on him.

He loves us like that, too. He notices us when we feel invisible, unworthy, or unwelcome. We can reach out to him and trust him to respond when we are desperate for a touch of healing or an affirmation of our worth.

He promises to see us.

Dear Jesus, thank you for seeing me. I believe you
notice me even when no one else seems to. I will reach
out my hand to find life and love in you. Amen.

REFLECT

In your journal, write **Matthew 9:22** in your own words.

Do you have any questions for Jesus about this promise?

What can you reach out to Jesus for today?

REMEMBER

In your journal, write the key word (or a different word) you want to focus on in this verse. How will it help you hold on to this promise?

Draw an image to remind you that Jesus sees you.

Promises for When You Feel

Lonely

God ENCIRCLES Us

Key word **encircle** *(verb)*: to form a circle around; surround

You have encircled me; you have placed your hand on me.
Psalm 139:5

READ

It's hard to imagine being *encircled* when we feel alone. In fact, loneliness often feels exactly the opposite—like everyone is as far away as they could possibly be. Even if we have people in the same room with us, we feel terribly vulnerable and exposed. Especially when we are experiencing loneliness plus.

Loneliness plus illness.

Loneliness plus pain.

Loneliness plus anger.

Loneliness plus grief.

Not many people know how to come around us when we are in those places. And most of them would probably rather not.

Except for Jesus.

He promises to encircle us.

Not to constrain us or restrict us, but to keep us safe.

Not to force us to be close to him, but because he wants to be close to us.

Not to shrink our world, but to open our hearts and minds to the adventure of life with him.

But I wonder if maybe what we need to know even more than the fact that we are surrounded on all sides by our loving and protective Father God is that he *places his hand on us*. Not only does he create a border of safety and love around us, but he reaches out his hand and *touches us.* I love the way Matthew Henry describes this in his commentary on Psalm 139:

> Perhaps it is an allusion to the physician's laying his hand upon the patient to feel how his pulse beats or what temper he is in. God knows us as we know not only what we see, but what we feel and have our hands upon.[19]

Jesus gets us. He puts his hand on us and knows us in ways no one else ever could. He understands and has so much compassion for what we are going through.

Recently I experienced this promise in a real way. I was not alone, but the fear of being alone in the future had me shaken. People I depend on were changing, aging, or moving away. I was worrying (*panicking* actually) about life without them, and suddenly I felt God come close. The way he wrapped his arms around me was almost tangible. My heart settled down as his hands seemed to rest on my shoulders.

A God hug when I needed it most.

Sometimes we notice, and sometimes we don't, but he is always doing this for us. Surrounding and enclosing us in his love. His circle is the perfect size for us no matter where we are or why we are lonely. We will never be alone when we are encircled by him.

Dear Jesus, thank you for going ahead of me and behind me. When I am lonely, help me remember that you never leave me alone. I will always belong in your circle of love. Amen.

REFLECT

In your journal, write **Psalm 139:5** in your own words.

What does this promise reveal to you about God's character?

What loneliness or loneliness *plus* can you bring to Jesus right now?

REMEMBER

In your journal, write the key word (or a different word) you want to focus on in this verse. How will it help you hold on to this promise?

Draw an image to remind you that God is encircling you today.

Jesus Makes His HOME with Us

Key word **home** *(noun)*: a place of residence, a familiar or usual setting

Jesus answered, "If anyone loves me, he will keep my word. My father will love him, and we will come to him and make our home with him."
John 14:23

"There's no place like home."

I can still hear Judy Garland's voice as she clicks her ruby-slippered heels together in *The Wizard of Oz*. The iconic movie that started out in black-and-white then turned to color partway through lodged a permanent place in my heart when I was a child. All the excitement and adventure of Dorothy's trip down the yellow brick road to the Emerald City paled in comparison to the relief of seeing her wake up in her own bed in her Kansas farmhouse surrounded by all who loved her.

Several years and residences later, I still agree with Dorothy. When I climb into my own bed after being away, I say it every time.

There's no place like home.

Is it the four walls and a roof that give us protection and warmth?

Is it the familiarity of the furniture and décor we have chosen to fill the space?

Is it the sharing of dishes, bathrooms, and Wi-Fi with people we love?

Is it the comfort of knowing our way around the community we live in?

Home is all those things, yet still there is something about it we can't put into words.

Maybe that's what Jesus was talking about here. In this verse, he was preparing his disciples for what was ahead. He would soon be leaving them to go to his Father in heaven, and he didn't want them to feel like they were being abandoned.

He gave them this promise: "My father will love him, and we will come to him and make our home with him."

The Greek word for "home" that Jesus uses means *staying.*[20] The **act** of staying or the **place** of staying. I think he meant both. He is committing to *staying (verb)* in our *staying (noun).*

He promises us that when we open our hearts to him, he will move in for good.

God the Father, God the Son, and God the Spirit will come and live with us, in us. All of us who love him and keep his word get this offer. That comfortable feeling of being home—protected, relaxed, and known—will settle permanently into our hearts because Jesus will be there forever.

When we feel like we don't have a place to belong, we can remember that we live with Jesus.

When we feel like we are wandering by ourselves in an unfamiliar place, we can remember that we live with Jesus.

When we feel like no one cares what we are going through, we can remember that we live with Jesus.

We can come home to God the Father and Jesus his Son and have everything we need.

We will never be alone.

We will always be right where we need to be.

There truly is no place like home.

Dear Jesus, I need you to be my safe place, my comfort, and my support. Please help me love you by keeping your word as you make your home in my heart. Thank you for staying. Amen.

REFLECT

In your journal, write **John 14:23** in your own words.

How might you explain this Scripture promise to a child who is feeling *lonely*?

How can you let Jesus make himself at home in you today?

REMEMBER

In your journal, write the key word (or a different word) you want to focus on in this verse. How will it help you hold on to this promise?

Draw an image to remind you Jesus makes his home with you.

Christ Is IN Us

Key word **in** *(preposition)*: a function word to indicate inclusion, location, or position

God wanted to make known . . . the glorious wealth of
this mystery, which is Christ in you, the hope of glory.
Colossians 1:27

READ

Sometimes it is hard to imagine that. Christ is really IN us?

The Greek word used here for "in" is *en*, which denotes a fixed position in place, time, or state.[21]

Wow. God places Jesus inside us forever. He is fixed there in place, time, and state, and that is what gives us hope.

Why us, though? We can think of all kinds of reasons we might not be considered worthy to be included in God's glory. Paul is writing this letter with this promise to people who might have the same question. The Gentiles were not the children of Abraham, not the chosen people of Israel, not Jewish. How are they being included now in his great plan?

As one thinker put it, "God had designed to grant the Gentiles the same privileges with the Jews, and make them his people who were not his people."[22]

To grant them (us) the same privileges with the Jews.

To make them (us) his people who were not his people.

It is such a mystery—all God does, why he chose us, how he works. But he wants to let us in on it. Our backgrounds, our religious experience, our titles—they don't matter one bit to him. If we ask Jesus into our hearts, we get to be part of his glory. He wants more than anything to make us his people. And he does that by moving into our hearts. And staying there.

By living in us, Jesus keeps us *going*:

> *Filling us with his peace and strength for hard times.*
> *Giving us his love and patience in difficult relationships.*
> *Restoring our joy even in the depths of grief.*

And by living in us, Jesus keeps us *growing*:

Sanctifying our hearts as we learn more about his.
Energizing us with his invitation to follow him in a life of
adventurous love.
Renewing us each moment in his grace-filled presence.

The hope of this glory is what keeps us going and what keeps us growing. This glory is not limited by time or place or even by our imagination. It is far above and beyond anything we can think of, and yet it is in us.

In me. In you. In our ordinariness. When Christ is in us, ***his glory shows up in our regular lives.***

Because he is IN us, we get to know him deeply and be known by him.

And we get to look forward to becoming more like him as he faithfully finishes the work he began in our hearts.

He is fixed there.

———————

Dear Jesus, thank you with all my heart that you are
in me. I am humbled and thrilled that you would share
your glory with me. Please help me experience and
share this mystery as I go throughout my day. Amen.

REFLECT

In your journal, write **Colossians 1:27** in your own words.

Look up this verse in a few other Bible translations or paraphrases (https://www.biblehub.org and https://www.blueletterbible.org are two online resources you can use to do this). Write what you notice.

What is the hardest part of your day? How might this portion of your day change if you believed Jesus was truly IN you while you walked through it?

REMEMBER

In your journal, write the key word (or a different word) you want to focus on in this verse. How will it help you hold on to this promise?

Draw an image to remind you that Christ is in you.

Jesus Really KNOWS Us

Key word **know** (verb): to have an understanding of; to recognize, to be acquainted or familiar with

"I am the good shepherd. I know my own, and my own know me, just as the Father knows me, and I know the Father."
John 10:14–15

READ

Some of us have lots of friends, coworkers, and family—even a best friend or a loving spouse—and still feel lonely.

The echoes of loneliness are bad enough when we are physically alone. When we live by ourselves, miss someone, or long for a partner or a friend, life can feel empty and hollow. But when we are in relationships and hanging out with people, we expect the loneliness to be gone.

If it remains, we end up feeling the worst kind of lonely.

We feel like there is no one in the whole world who truly knows us.

But Jesus says that he does.

Jesus tells us that we are his own, and he knows us. He knows us like the Father knows him and like he knows the Father.

How can we grasp that?

He tries to help us by using the metaphor of the good shepherd. And we *kind of* get it, even though most of us don't really know much about taking care of sheep.

James K. Wallace, author of *The Basque Sheepherder and the Shepherd Psalm* wrote about how shepherds provide food, water, protection, and rest for their sheep. His interview with a shepherd, Ferando D'Alfonso, helps us understand more about some of the unique and personal ways the shepherds show care.

These are some of my favorites:

"During the day, however, a sheep may leave its place and go to the shepherd. Whereupon the shepherd stretches out his hand as the sheep approaches with expectant eyes and mild little baas. The shepherd rubs its nose and ears, scratches its chin, whispers affectionately in its ears."[23]

D'Alfonso notes that "at every sheepfold, there is a big earthen bowl of olive oil and a large jar of water. As the sheep come in for the night they are led to a gate. . . . As each sheep passes, he quickly examines it for briers in the eyes, snags in the cheek, or weeping of the eyes from dust or scratches." If any such sheep are discovered, they are then pulled out of line and cared for—its wounds washed and anointed with the oil.[24]

We get to have this with Jesus.

Unlimited moments of communion with him—anytime we need reassurance or some special attention.

His careful examination of us for things that might cause us harm.

His water and oil prepared and ready to wash and heal us with his gentle touch.

The Greek word for ***know*** that Jesus uses here in John 10 means "to understand, to perceive, to feel, be aware of."[25]

This promise assures us that Jesus is aware of our needs and can always perceive exactly how we feel. He understands us and knows us completely.

We are never alone or unknown when we belong to him.

Dear Jesus, you are my good Shepherd. I come to you in my loneliness and trust you to take care of me. Thank you that even when I feel totally alone, you know me better than anyone ever could. Amen.

REFLECT

In your journal, write **John 10:14** in your own words.

As you think about this promise, list some things you can be grateful for.

When Jesus examines your heart, what lonely places does he know to tend to?

REMEMBER

In your journal, write the key word (or a different word) you want to focus on in this verse. How will it help you hold on to this promise?

Draw an image to remind you that Jesus really knows you.

God Gives Us a Place NEAR Him

Key word **near** *(adj)*: nearby, close at hand, by the side of

The Lord said, "Here is a place near me."
Exodus 33:21

I wonder if Jesus ever felt lonely.

He certainly had crowds of people around him much of the time and a close group of friends for the last few years of his life. We read that he had to make an effort to get away by himself to pray.

But did he experience that aching, empty feeling inside as he realized that even in the midst of all these people, no one understood him?

Does he know how we feel when we just need someone to come close? To "get" us?

When we learn about the people Jesus sought out, it seems like he understood the loneliness they felt:

> The despised tax collector that had to climb a tree to get a glimpse of him (Luke 19:1–10),
> The woman who went for water alone at the hottest time of day (John 4:1–30),
> The man with leprosy that people walked away from in disgust (Matt. 8:2–4),
> and so many more.

And in the Old Testament, more lonely ones:

> Hagar—the pregnant servant girl of Sarah, rejected and running away (Gen. 16:7–10),
> Naomi—the bitter, grieving widow with no one to take care of her (Ruth 1:11–13),
> Moses—confused and hiding from his past (Exod. 3:1–10).

Moses—the one this promise in Exodus was originally spoken to. What struggles of identity and purpose he must have wrestled with. How alone he must have felt at times as he tried to lead the Israelites through the wilderness.

147

And God understood. He knew what Moses needed.

He said to him, **"Here is a place near me."**

And in the next breath he said, **"You are to stand on the rock, and when my glory passes by, I will put you in the crevice of the rock and cover you with my hand until I have passed by"** (Exod. 33:21–22).

God was getting ready to reveal his power and presence to Moses in a significant way. He invited Moses to put himself in a secure and protected place where he could get the most of God as his Spirit came close. A place *near him*.

When Moses returned from this mountaintop visit with God, his face was literally shining. God had come exceptionally close, revealing his commandments and renewing his covenant of everlasting love for his chosen people.

His chosen people. You and me.

Jesus still invites us to sit next to him.

The "rock" we can put ourselves on might be the chair in the waiting room, the seat of our car, the desk at work, or the side of our bed. He knows our insecurities, our heartaches, our darkest secrets, and our worst fears. He also knows exactly how we like our coffee or tea, our favorite songs, and the things that make us laugh. And he wants to give us everything: redemption, hope, freedom, purpose, guidance, forgiveness, unconditional love, and lasting peace.

He wants to give us himself.

———————

Dear Jesus, you are my most faithful friend. I trust that in my loneliest times, you come closer than ever. Thank you for always making a place for me near you. Amen.

REFLECT

In your journal, write **Exodus 33:21** in your own words.

List some emotion words that mean the opposite of *lonely*. Circle one or two that you would like to feel instead.

Where can you picture Jesus sitting beside you right now?

REMEMBER

In your journal, write the key word (or a different word) you want to focus on in this verse. How will it help you hold on to this promise?

Draw an image to remind you that God has a place for you right beside him.

Jesus Will Be with Us
WHEREVER We Go

Key word **wherever** *(conjunction)*: at, in,
or to all places; in any circumstance

*Do not be afraid or discouraged, for the L*ORD
your God is with you wherever you go.
Joshua 1:9

This promise was spoken to Joshua at a critical time. Moses had recently died, and Joshua was left on his own. As the new leader of God's people hundreds of thousands of Israelites were looking to him for direction and reassurance. I imagine that Joshua felt *afraid and discouraged* for sure, and most likely he was dealing with a lot of grief and loneliness as well.

Why did Moses have to die now? His lifelong mentor—the only person that could possibly understand the position he was in—was gone.

But God reminded Joshua in this moment that he would be with him. *Wherever* he went.

And he was. In observable and mysterious ways, in big and small ways, in challenging and comforting ways, God showed up as Joshua led his people into Canaan.

And guess what?

He promises to be with us wherever we go, too.

In **all the places** and in **any circumstance** we find ourselves in.

So, when we walk out of church, God doesn't just stay there and wait to see us next Sunday? And when we close our Bibles and bring our prayer time to a close, he doesn't just hang out in that room until next time?

I'm being silly, but sometimes I think we live like this.

We forget that he promises to be with us always—not just in the times and places that seem more "spiritual."

Does this mean he comes with us into the grocery store? That he sits with us in the appointments we are worried about? That he is with us during our long days at work and home?

Does it mean he is with us when we have difficult conversations? That he takes our hands and walks with us into new situations? That he sits right beside our beds when we can't sleep?

Yes, 100 percent of the time.

A teacher friend of mine recently shared that she was trying to imagine Jesus sitting in the passenger seat of her car as she drove to school. She was struggling with a difficult group of students, and she really wanted to experience God's presence and help as she worked with them. She believed this promise that he would be with her in her classroom all day long. After a particularly tough day, she reflected with a sense of humor, "I think I accidentally left Jesus in the car."

But he comes in with us no matter what, doesn't he?

That is what is so reassuring about God's commitment to us.

Even when we forget to invite him, he is with us.

Even when we are too distracted to notice, he is with us.

Even when something we are doing fails miserably, he is with us.

Even when the day feels ordinary and mundane, he is with us.

He won't ever just wait in the car.

Dear Jesus, I invite you in to every part of my day today.
Wherever I go, I trust you to be there, too. Please help
me feel you with me in the sweet, the stressful, and the
ordinary moments. Your presence makes me brave. Amen.

REFLECT

In your journal, write **Joshua 1:9** in your own words.

What does this promise reveal to you about how God works?

What environment in your life would be most transformed if you believed Jesus was with you in it?

REMEMBER

In your journal, write the key word (or a different word) you want to focus on in this verse. How will it help you hold on to this promise?

Draw an image to remind you that God is going with you today.

Promises for When You Feel

Lost

We Can **ENTER** God's Rest

Key word **enter** *(verb)*: to go into or upon and
take possession; to participate and share in

For the person who has entered his rest has rested
from his own works, just as God did from his. Let
us then, make every effort to enter that rest.
Hebrews 4:10–11

READ

We try to do all these things for Jesus. Serving others, going to church, sharing his love, studying his word, praying daily—aren't we supposed to be working hard at these?

We know God sees and honors our human attempts to do things for him. But we are reminded, too, that the Creator of the universe doesn't depend on our work to accomplish his.

So we stand on the shore of this sometimes-hard-to-understand life of faith and wonder what exactly we are supposed to do.

When I was growing up, our families spent almost every warm summer day swimming together at our grandparents' beach cabin. We splashed and raced and floated and dove for shells or pennies in the salt water of the bay and in their sparkling in-ground pool. On the days the kids would act sheepish about wading into the water, my mom and her sisters would say we should get "ducked." This was their funny term for going into the water all the way up to their necks. (Any deeper and, well, their hair would get wet.) My cousins and siblings would giggle as we heard our moms ask each other: *"Did you get ducked yet?"* or *"Are you going to get ducked?"*

They didn't ever have to ask me.

Being in the water was my happy place. I felt energized, weightless, creative, and free. My grandpa would tease me that I was part fish because I was often the first one in and the last one out, reluctant and disappointed to have to dry off and head home.

Maybe that's what it is supposed to be like when we live for Jesus.

When we are in the water, everything just feels different. Our bodies are surrounded by swirls of soft, temperate, soothing liquid. We are buoyant,

supported, part of something much larger than ourselves. We are fully immersed in something incredibly powerful yet peaceful at the same time.

So maybe this faith life is as easy as "getting ducked," wading all the way into what he is already doing.

> *Maybe it is simply accepting his invitation to participate and share in the amazing work of his Spirit on this earth.*
>
> *Maybe instead of being bound and weighed down by expectations and things we feel responsible for, he is asking us to stop sometimes and soak in his faithfulness.*
>
> *Maybe instead of working so hard to check off all the things we think we are supposed to do, he wants us to playfully jump in and be surprised by his gifts of hope, grace, and joy.*
>
> *Maybe instead of relying on our own ideas and efforts, he wants us to let go and float. We can lean into the waves of his overwhelming love and power when our strength is gone.*

Because of his death and resurrection, we can rest from our own works. Let's immerse ourselves completely in him.

Dear Jesus, I realize my human efforts accomplish nothing without you. Please help me rest from trying to figure it all out on my own. Thank you for inviting me to enter your rest. Amen.

REFLECT

In your journal, write **Hebrews 4:10–11** in your own words.

What does this promise reveal to you about God's character?

What might be holding you back from entering the rest Jesus is offering you?

REMEMBER

In your journal, write the key word (or a different word) you want to focus on in these verses. How will it help you hold on to this promise?

Draw an image to remind you that you can enter into God's plan by resting in him today.

God Has Good PLANS for Us

Key word **plans** *(noun)*: an orderly arrangement
of parts of an overall objective; goal, purpose

*"For I know the plans I have for you"—this is the
LORD's declaration—"plans for your well-being, not
for disaster, to give you a future and a hope."*
Jeremiah 29:11

Recently we watched our niece walk across the stage, receive a diploma, move her tassel, and celebrate with friends and family. The emotion and significance of the ceremony of graduation brought tears to my eyes. The pomp and circumstance get me every time.

A dear friend of mine will retire this year from her lifelong career as an educator. More tears of joy and sadness. Every June, for graduates and retirees, the years of predictable bell schedules, learning objectives, the predictable school calendar and organized activities have come to an abrupt end. It's bittersweet.

And it can be scary, this huge step into life after school. "What are you going to do next?" is the question asked by most. Even if the answer is more education, a career, military service, volunteering, or travel, so much is unknown.

Whether change is expected or not, it can make us feel so uneasy and out of control. We pray for direction and clarity, but sometimes we don't get it right away. We know God is faithful to hear us, but we get anxious when we can't hear him.

This school, or that one, or something different?

Apply here or there or somewhere else?

Make the move or stay put?

Continue the relationship or not?

Reply with a yes or a no?

God, what is my next step here?

The people of Israel were probably wondering this same thing when they were captives in Babylon. They were unsettled. They were in an

unfamiliar, uncomfortable place. They were getting advice from people with self-serving interests. And they were probably discouraged, wondering what God's plan could possibly be.

But in the middle of this confusing and difficult time, God told the Israelites to *settle in*. He told them to build houses, start families, plant gardens. He told them to work and pray for the peace and prosperity of the place they were in. Why? Because he had a plan.

He was going to rescue and restore them in his perfect timing. He had not forgotten them, not for a moment. His plan was for their "well-being, not for disaster." Even though they didn't see it yet, he reassured them that they would have "a future and a hope."

I want to be able to do that, too. It's so hard for me to settle in and trust him when I don't know what is next. I want to work and pray for and live well in the place I am in, knowing God is faithful and good.

This promise assures us that in our waiting, God is working. When we step out into something new whether by choice or by circumstance, we can trust him to take care of us. While we live in the not-yet, we can live in this hope.

His plans for us are good.

Dear Jesus, thank you for being with me in this
place of uncertainty. Please help me find security in
you—not in my emotions, my time line, or my goals.
I look forward to your good plans for me. Amen.

REFLECT

In your journal, write **Jeremiah 29:11** in your own words.

How might you explain this Scripture promise to a child who is feeling *lost*?

While you are trusting God with your "not-yet," what would it look like to settle into the "here and now"?

REMEMBER

In your journal, write the key word (or a different word) you want to focus on in this verse. How will it help you hold on to this promise?

Draw an image to remind you that God has good plans for you.

God Makes Our Steps SECURE

Key word **secure** *(adjective):* free from
danger; safe, steady, protected

*He brought me up from a desolate pit, out of the muddy
clay, and set my feet on a rock, making my steps secure.*
Psalm 40:2

Yesterday's hike started out great.

The air felt fresh and cool after the rain, and the trail was quiet. The energy of the forest seemed to put a spring in my step. I felt like I could walk forever—that is, until I started down the slope toward the creek bed. Here, the once solid path became almost unrecognizable. The recent storms had turned the area into a muddy mess. My rhythmic, effortless walk suddenly became treacherous. I kept stopping and starting, searching before each step for a rock or a piece of wood to place my foot on.

Several slips and slides and mud sloshes later, I made it to the other side of the creek. The trail gradually climbed back to a solid place. I could relax and enjoy the hike again now that I didn't have to think about where to place my feet with each step. My steps felt secure.

Last week started out great, too.

I had taken care of several things on the weekend and made some decisions I felt good about. Everybody in my family was finally healthy after some winter illnesses and struggles. Some upcoming changes at work looked positive. Things felt settled for the first time in a while.

Until everything went downhill. A terrifying phone call. A traumatic last-minute flight. Budget cuts unexpectedly and drastically altering my job. A basement flood. A complicated miscommunication.

I started to slip into the pit of despair. My mind and heart were racing, and I kept trying to pray.

God, I feel really stuck in here, and I'm starting to panic a bit. I can't see which way to go. I need you to steady my feet and hold my hand. Please help me find my footing again.

This promise helps us remember God does that for us. He brings us up out of the pit when we don't have the strength. He sets our feet on a rock when we don't even see one. He steadies our steps when the path we are on is challenging and unpredictable.

Our footing is his truth and his character.

He is all-knowing.

He is all-powerful.

He is our good Shepherd that promises to walk with us through the worst times of our lives. Protecting us. Taking care of us. Loving us with his life.

We can stand on God's faithfulness.

We all find ourselves in slippery, murky places. Many of us are stressed and frustrated and having a hard time standing strong today. Some of us don't know what our next steps are going to look like, and some of us don't like the path we are on.

But we know the One who can hold us every step of the way.

We are safe and secure with him.

———————

Dear Jesus, please hold my feet, my hands, and my heart steady. I feel so lost as I try to find my way out of this muddy pit on my own. Thank you for being my good Shepherd and my solid Rock. Amen.

REFLECT

In your journal, write **Psalm 40:2** in your own words.

Look up this verse in a few other Bible translations or paraphrases (https://www.biblehub.org and https://www.blueletterbible.org are two online resources you can use to do this). Write what you notice.

What challenging place do you need Jesus to walk you through today?

REMEMBER

In your journal, write the key word (or a different word) you want to focus on in this verse. How will it help you hold on to this promise?

Draw an image to remind you that God makes your steps secure.

God Will SHOW Us the Way to Go

Key word **show** *(verb):* to point out, to direct attention to; to make known

I will instruct you and show you the way to go;
with my eye on you, I will give counsel.
Psalm 32:8

I used to worry about driving to new places because I didn't want to get lost. That changed when three little letters came into my world. GPS is amazing. It helps me find my way to any location, even when I don't know what I'm looking for. And the best part? No matter how far away I get, it is programmed to lead me back home.

Sometimes I wish we could have a GPS for our lives. We could type in the goals we want to accomplish, and a confident, computerized voice would take us there. She would let us know ahead of time which lane to get in and where to exit. She would automatically reroute us if we took a wrong turn. She would even tell us our estimated time of arrival.

But real life is way more complicated than that. When we set out to accomplish something or get somewhere, we don't usually hear step-by-step directions. There are multiple ways to go, and we can't always trust our own sense of direction or the voices of others.

We need God to show us the way, and he promises that he will.

How does he do it? Certainly not from a satellite preprogrammed with streets and addresses connected to our phones.

God shows us where to go *with his eye on us. He will give counsel.*

He cares about what we do. He gives us direction and guidance as he sees everything that is happening in our lives. He instructs us through his Word, through circumstances of all kinds, and through people we trust. Sometimes he surprises us with a new and unexpected path.

He knows what is best for us, but he doesn't always make it easy.

I have been asking him recently for clear directions in my next steps at work. Things are changing at school and home, and I need to know.

Should I take a new teaching position? Part-time or full-time? Leave education and do something completely different? What is the best route for the next few years, God?

I want to hear something like, *"Get in the right lane. In two miles, exit onto your next adventure."* Or, *"In 500 feet, stay in this position. Your destination will be on your left."*

But all I am hearing is, *"Trust me."*

Trust me even when the road is not clearly marked.

Trust my wisdom and timing in revealing things to you.

Trust me to lead you with my faithful love.

> With your faithful love, you will lead the people you have redeemed; you will guide them to your holy dwelling with your strength. (Exod. 15:13)

We can trust the way he leads us. Even if we go the wrong way, even if we get lost, we can feel safe because his eyes are on us.

And he will always show us the way home.

———————

Dear Jesus, I am so thankful for your eyes upon me. You will show me the best way to go, and I want to trust you with every twist and turn in the road. You are my way home. Amen.

REFLECT

In your journal, write **Psalm 32:8** in your own words.

As you think about this promise, list some things you can be grateful for.

In what area of life do you tend to forget to ask God's instruction, direction, or counsel? Why?

REMEMBER

In your journal, write the key word (or a different word) you want to focus on in this verse. How will it help you hold on to this promise?

Draw an image to remind you that God will show you the way.

God Will Make a WAY

Key word **way** *(noun)*: a passage cleared
for travel, a route, an opening

*Look, I am about to do something new; even now it
is coming. Do you not see it? Indeed, I will make a
way in the wilderness, rivers in the desert.*
Isaiah 43:19

"Do you not see it?" Neither do I sometimes.

We can't always see or understand what God is doing, especially when we are stuck in the wilderness. Sometimes it seems like we will never find our way out. Wandering through long and difficult places can drain our energy and steal our hope. Places like Cancer. Addiction. Infertility. Struggling with too much work to do or not enough. Depression. Divorce.

Sometimes the wilderness doesn't have a name, but we just feel like we are in one. We feel depleted and empty. We know that we are in deep, that things look dark, and we don't know which path to take. We need to believe that God is making a way out.

This promise encourages us that he is.

When we read about the Israelites' time in the wilderness, we see that God showed up in so many faithful ways. And it helps to know that just as God was with the Israelites for those forty trying years, he is with us. He knows the ways of the wilderness much better than we do. He knows exactly where we are and how we feel when we are there. And he knows how to lead us through and lead us out in his timing.

That's another hard part. Trusting him with the timing. The Israelites didn't know when they would finally get to the other side of their wilderness, and we don't either. We might be in it for longer than we might think. So, what can we do?

We can mark times we have seen God's faithfulness in where we've been.

How has God provided for us in the past?

What places of refreshment has God shown us along the way?
What do we know to be true about how he loves and takes care of us?

We can look for signs of his faithfulness ahead.

What might God be teaching us in this challenging time?
Where can we see his power and love showing up?
What good could God bring out of this struggle?

God led the Israelites with a cloud by day and a fire by night. He gave them leaders—Moses and then Joshua—to guide and govern them with wisdom. He gave them daily manna from the sky and brought water from rocks. He faithfully led them in his timing to the promised land of Canaan where goodness overflowed.

He never failed them or left them, and he won't fail or leave us either. He is with us every step of our wilderness journey, and he is always making a way.

Even when we can't see it.

Dear Jesus, will you come close in my wilderness places today? I believe you are doing something new and that you will lead me through. Thank you for making a way for me. Amen.

REFLECT

In your journal, write **Isaiah 43:19** in your own words.

List some emotion words that mean the opposite of *lost*. Circle one or two you would like to feel instead.

Through what circumstance do you need God to make a way?

REMEMBER

In your journal, write the key word (or a different word) you want to focus on in this verse. How will it help you hold on to this promise?

Draw an image to remind you that God will make a way for you.

We Are God's
WORKMANSHIP

Key word **workmanship** *(noun)*: something effected,
made, or produced; the art or skill of a workman

*For we are his workmanship, created in Christ Jesus for good
works, which God prepared ahead of time for us to do.*
Ephesians 2:10

One of the best emails I receive each week is from Carolyn. When I see *Poems for You* as the subject line, I smile. I know her message will contain some brilliantly crafted words to encourage me and point me to Jesus. Poetry is one of the incredible gifts God gave Carolyn. Every Monday, she shares her poems faithfully and generously with her readers, then wraps up her email with: ***YOU ARE GOD'S POEM Ephesians 2:10.***

Carolyn must have known what I just discovered. The Greek word for "workmanship" is *poiema* in this verse, and it means *poem* or *poetry*.[26] We really are his poem!

Joni Eareckson Tada is another inspirational person who knows this. She was only seventeen when she was paralyzed in a tragic diving accident. For over forty years, she has been in a wheelchair serving Jesus with all her heart. Some of the many gifts he has given her are the ability to write, speak, and sing about him. She is an incredible advocate for the rights of people with disabilities, and she is also an artist who paints beautiful pictures with a paintbrush between her teeth.

Joni describes herself as God's "*poiema*" in her book *A Place of Healing*.

She writes, "[God] has a plan and purpose for my time on earth. He is the Master Artist or Sculptor, and He is the One Who chooses the tools He will use to perfect His **workmanship**."[27]

God promises that we are his workmanship, which means so many unique and beautiful things, some of which we haven't even discovered yet.

In my own little circle of friends, I am fascinated by God's infinite creativity. Some are overflowing with genuine warmth and hospitality,

some have incredible leadership skills, some are amazingly generous and thoughtful, and others have admirable creative talents.

I could go on and on about the people in my life. The way God has gifted his people is one of the things I love the most. Seeing how he brings good and glory through those he created is wildly mysterious and comforting at the same time. Mysterious because we don't always understand the process. Comforting because God knows what he is doing. His workmanship is perfection. He makes us using the best tools, the highest quality products, and the most intricate detail. He puts us together for the purpose of doing good works for him. He knows what they are, and he has prepared us for them.

He will give us everything we need.

Dear Jesus, thank you for making me your poem.
It comforts me to know that you created me
specifically for the good works you have prepared
for me to do. Help me trust your gifts. Amen.

REFLECT

In your journal, write **Ephesians 2:10** in your own words.

What does this promise reveal to you about how God works?

If you haven't primarily seen yourself as God's workmanship, what *have* you seen yourself as? What about your life might change if you viewed yourself the way God does, as a poem or piece of art he created himself?

REMEMBER

In your journal, write the key word (or a different word) you want to focus on in this verse. How will it help you hold on to this promise?

Draw an image to remind you that you are God's workmanship.

Promises for When You Feel

You Feel

Oppressed

God Is All **AROUND** Us

Key word **around** *(preposition):* on all
sides of; so as to encircle or enclose

*So the LORD opened the servant's eyes, and he saw that the mountain
was covered with horses and chariots of fire all around Elisha.*
2 Kings 6:17

The second book of Kings contains the story of the faithful prophet Elisha,
the king of Syria and his army, and Elisha's servant Gehazi.

In short, the king of Syria was plotting against Israel. God's prophet
Elisha knew all the details and kept warning the king of Israel of the Syrian
army's plans and locations. The Syrian king became enraged with Elisha
for thwarting his plans and determined to capture him.

One night, the angry king sent his army to find Elisha. Huge num-
bers of Syrian horses and chariots positioned themselves all around Elisha's
camp preparing to attack. In the early morning, when Elisha's servant
Gehazi stepped out of his tent, he was terrified by what he saw.

"What are we to do?" (v. 15), Gehazi asked Elisha.

Elisha's answer surprised him:

> "Don't be afraid, for those who are with us outnumber
> those who are with them." (v. 16)

All the servant could see were the enemy troops surrounding the city.
What was his master talking about?

Elisha prayed for Gehazi.

> "LORD, please open his eyes and let him see." (v. 17)

All of a sudden, Gehazi could see so much more. His eyes were opened
to a vast army covering the mountains above the city. God's invisible army
became visible. Gehazi saw that the horses and chariots of fire standing
ready to defend Elisha far outnumbered the Syrians.

God made his power, peace, and protection clear to Elisha and his
servant, and he makes these things clear to us, if we only ask for God to

open our eyes to the fact that they are already there, all around us. And once we see these things at work in our life, we cannot unsee them. Or as one commentator would put it, "It sure makes a difference on our whole outlook on life. Lord, open our eyes that we might see the truth. That we might not just see the obvious physical things, but that we might see the spiritual realities."[28]

When we feel like we are being pursued by problems and pressures, when we think we have been sneak-attacked, when we feel surrounded by the evil lies of the enemy, we can ask God to help us. We can remember what Elisha said and did.

We can say to ourselves: **"Don't be afraid, for those who are with [you] outnumber those who are with them"** (v. 16).

God's angels outnumber the fears that surround our hearts.

God's angels outnumber the lies we've believed.

God's angels outnumber the shameful thoughts that haunt us.

God's angels outnumber the evil words and deeds that take aim at our souls.

And we can pray, *"Lord, please open our eyes and let us see."*

We can believe it even when we can't see it because we can believe *him*. He is *all around* us *all the time*.

Dear Jesus, I need to know you are here. Please open my eyes to see your powerful presence all around me, even in my oppression and fear. Thank you for surrounding me with your power, peace, and protection. Amen.

REFLECT

In your journal, write **2 Kings 6:17** in your own words.

What does this promise reveal to you about God's character?

Around what circumstance do you need spiritual eyes to see God's powerful presence?

REMEMBER

In your journal, write the key word (or a different word) you want to focus on in this verse. How will it help you hold on to this promise?

Draw an image to remind you God is all around you.

We Are More Than
CONQUERORS

Key word **conqueror** *(noun)*: one that defeats
an enemy or opponent; winner, victor

No, in all these things we are more than
conquerors through him who loved us.
Romans 8:37

My friend Halee clings to this promise.

Her story of fear, heartbreak, and shame-inducing trauma is a powerful example of how Jesus can conquer the things that threaten to destroy us. As a life coach and Bible teacher, Halee helps others experience this victory every day.

But she doesn't glamorize it. She shares with us honestly:

> This isn't just any kind of conquering—it is a super, hyped-up, beyond-our-imagination kind of conquering. It's not a "someday we will conquer"—it is a "right now" kind of conquering. But I sometimes look in the mirror, seeing only brokenness, pain . . . so much suffering, and I think, *What am I missing? This looks nothing like victory to me.*

When Halee was only twelve, she was emotionally and sexually abused by an older teen. When the abuse resulted in pregnancy two years later, her mother decided on abortion. During that same time, her parents separated, and her closest friend died in a car accident. The resulting grief and confusion left her reeling.

Fast-forward twenty years. Halee and her husband were leading Christ-centered recovery groups after these same groups were a catalyst to healing from her own trauma. She was also a successful chemical engineer with a happy family, looking forward to the birth of their second son.

Tragically, labor and delivery spawned shock and tears as their baby was stillborn. Shortly after she recovered from giving birth, a large tumor

in her abdomen required immediate surgery to remove. The effects of seven hours of anesthesia combined with the fog of grief made it impossible for her to work safely. She resigned her position and took a less desirable job. During this time of adjustment, Halee's suffering was exacerbated when her mom died unexpectedly. She began to fear losing everyone she loved.

Even though she still has hard, hard days, Halee tells her story with humility, honesty, and deep gratitude to Jesus. She reminds us that following Jesus does not entitle us to a problem-free life. We get hurt by others. We lose people we love. We get sick. We have frustrations at work. We have difficult relationships. We feel depressed and defeated.

But this promise gives us hope: "We are more than conquerors through him who loved us."

Halee shares this with her clients, her church, and her community. She tells how Jesus's comfort wraps around her broken heart, how his peace washes over her fear, and how his love has redeemed her life. If you meet Halee, you will see how his joy fills her empty places and bubbles over into the most contagious laugh.

She says it so well:

> It is not our own wisdom or might, it's not even Jesus's ability to destroy the enemy. . . . It is his love that makes us more than conquerors.

Dear Jesus, you know what it means to suffer. Thank you for giving your life to win the victory for me. I trust your great love to conquer the hardest things in life. Amen.

REFLECT

In your journal, write **Romans 8:37** in your own words.

How might you explain this Scripture promise to a child who is feeling *oppressed*?

What parts of your story do you need Jesus to help you conquer?

REMEMBER

In your journal, write the key word (or a different word) you want to focus on in this verse. How will it help you hold on to this promise?

Draw an image to remind you that you are more than a conqueror through Jesus.

God Will FIGHT for Us

Key word **fight** *(verb):* to engage in battle,
wage war, defend, protect, uphold

The LORD will fight for you.
Exodus 14:14

Some of the books and movies we love most are stories of overcoming. The victim is awarded justice. The underdog wins the game. The kid growing up in the hardest circumstances becomes a success.

We are inspired when the least likely ones not only *survive*, but they *prevail*. They get the recognition, the victory, the reward.

God must like these stories, too, because the Bible is full of them. Most of the miracles Jesus did were for the outcast and the vulnerable. Most of the battles in the Old Testament were decisively won by God's smaller, less-equipped armies. The stories of Joseph, Esther, Daniel, and so many others in oppressive situations give us hope.

Joseph was wrongly accused and imprisoned, and God fought for him. He gifted him with eventual release, a position of leadership, and the restoration of his family.

Esther risked her life to approach the king, and God fought for her. He softened the heart of the king to grant her request to save her people.

Daniel's faithful obedience landed him in a den of lions. God fought for him by closing the mouths of the lions and miraculously sparing his life.

And Moses.

God made him the main character in one of the greatest victory stories ever told. Of all the extraordinary things God did in and through Moses, the parting of the Red Sea is where we find this incredible promise.

> "Don't be afraid. Stand firm and see the LORD's salvation that he will accomplish for you today; for the Egyptians you see today, you will never see again. The LORD will fight for you, and you must be quiet." (Exod. 14:13–14)

When Moses said this, the Israelites were surrounded on all sides by impossibility. The mighty Egyptian army was closing in on them, and there seemed to be no way out or back. They were preparing to die. But Moses believed God would keep his promise. Even though he didn't know exactly how God was going to save them, he trusted that he would.

We know how this story ends. God miraculously parted the Red Sea, and the Israelites walked safely through the towering walls of water to freedom. When the Egyptian army tried to follow them, the thunderous sea collapsed. The enemies drowned, and God's people won.

Our battles are different today, but our God is the same.

When we are surrounded with our own impossibilities, God is right there with us. He loves us fiercely. He engages in the fight for our hearts—defending, protecting, and saving us. No matter what kind of enemy is pressing in, we can trust him to give us the victory.

Our lives will tell stories of overcoming addiction, betrayal, disease, heartbreak, shame, and fear.

God will win the battle for our hearts and lives forever.

He will never stop fighting for us.

Dear Jesus, thank you for promising to fight for me.
I need your help with so many impossible things. I
will trust you to win the battle for me today. Amen.

REFLECT

In your journal, write **Exodus 14:14** in your own words.

Look up this verse in a few other Bible translations or paraphrases (https://www.biblehub.org and https://www.blueletterbible.org are two online resources you can use to do this). Write what you notice.

What battle are you facing today that you need God to fight for you?

REMEMBER

In your journal, write the key word (or a different word) you want to focus on in this verse. How will it help you hold on to this promise?

Draw an image to remind you that God will fight for you.

The Spirit of the Lord Brings
FREEDOM

Key word **free** *(adjective)*: not restricted,
obstructed, or impeded; no longer confined

Now the Lord is the Spirit, and where the
Spirit of the Lord is, there is freedom.
2 Corinthians 3:17

READ

If you have been to Disneyland in California, you might understand why it is called the "Happiest Place on Earth" and the "Magic Kingdom."

I've been dreaming about going back. My memories of fun Disney visits range from my first experience as a five-year-old all the way to our most recent trip with our college-aged sons. There are things I count on to feel the same every time: the rising anticipation as we step through the turnstiles, the upbeat music pumping through the speakers on Main Street, the cool air and familiar sounds of the rides, and the delicious warm smells of cinnamon-sugar churros and buttery popcorn wafting up from old-fashioned carts.

Change is also a constant at Disneyland, and that is part of the fun. New "lands" and attractions are added, old rides are renovated, and systems for organizing lines and managing crowds evolve with technology.

Some of us remember that Disney attraction tickets were sold in books in the early years, and rides were categorized by their popularity. Each book contained a few tickets for each type of ride. I remember my mom trying to organize the tickets in the morning and making a careful plan to use the E tickets sparingly. Those were for the best attractions—the ones everyone wanted to do the most. Once the tickets were gone, we were done going on rides for the day.

Some stress came along with this rationing, this limiting, this feeling of not enough. The worry about running out of E tickets loomed all day. What a huge difference it made when Disneyland did away with the ticket

books and made all the rides unlimited for everyone who paid the one-time fee to enter the park. Such freedom!

Maybe this kind of freedom is what this promise in 2 Corinthians is about.

When God sent Jesus, he did away with limits. He sent his Son so that we could approach him personally with repentant hearts instead of through burnt offerings and high priests. He paid a one-time price for us to fully experience a grace- and mercy-filled relationship with him. He brought us freedom from the pressure of trying to earn his love and forgiveness.

Sometimes I think we respond with a ticket-book mentality to God. All those ***rules***. All our ***sins***. His laws are so hard to follow perfectly, and we mistakenly think we have only a limited number of chances.

What if we mess up too many times? What if we use up all our good tickets?

Jesus came to help us understand that the old rules have been replaced with a new way of experiencing God. He sent his Spirit to guide us every step of the way through this kingdom life. When we enter his freedom and love, he gives each one of us a unique, fulfilling, adventurous relationship with him.

And it will never come to an end.

Dear Jesus, thank you for sending your Spirit of freedom. You already paid the highest price for me to richly experience your power and love. Help me live in response to your unlimited love. Amen.

REFLECT

In your journal, write **2 Corinthians 3:17** in your own words.

As you think about this promise, list some things you can be grateful for.

What can you let God's Spirit give you freedom from today?

REMEMBER

In your journal, write the key word (or a different word) you want to focus on in this verse. How will it help you hold on to this promise?

Draw an image to remind you that the Spirit of the Lord brings freedom.

God Will **LISTEN** to Us

Key word **listen** *(verb)*: to hear something
with thoughtful attention

You will call to me and come and pray to me, and I will listen to you.
Jeremiah 29:12

READ

When I was in elementary school, one of my favorite activities in physical education was playing with the parachute. As a teacher, I still get excited about it. When I drag the enormous, bright-colored circle of fun out for the kids, there are squeals and cheers and smiles all around.

But in the crazy excitement, it gets awfully loud in the gym. There are important directions to be given before each new game, so I teach the kids to get into a "listening position." We have to practice this a few times. Toes on the parachute, hands at their sides, and voices off. It takes a lot of work to get restless little ones to *really* listen. My voice and my energy are completely gone at the end of a parachute day.

Sometimes it takes a lot of work to get anyone to really listen, doesn't it?

We don't want to have to work that hard when our hearts are already worn out.

Jesus tells us we don't have to. He cares so much about what we want to say, and he promises to hear us.

The Israelites Jeremiah was writing to needed to know this. They were captives in Babylon—unsettled, uncomfortable, and unsure of what was ahead. They were far away from home and wondering if God was even paying attention.

They were in the middle of seventy years of *"those days."*

"Those days" when our hearts are extra heavy, when we feel unusually worried, confused, and misunderstood.

"Those days" when we want to be heard, but everything else is so loud around us.

Maybe it seems like *those days* are *most* days, and no one ever has the time or energy or attention span to hear about it. We might start to wonder if our struggles are too unimportant for anyone to care about—especially

God. Can we honestly believe he stops to listen to our every prayer? Can we trust him to hear us above all the noise?

This promise assures us that we can.

Jesus is always in a listening position. He is alert for our cry. He knows exactly what is going on, and he deeply cares. He is ready with real comfort and lasting peace.

Whenever we open our hearts and begin to talk to him, we can count on his full attention. Every time.

We don't have to worry that we are bothering him.

We don't have to make an appointment.

We don't have to beg or apologize or wait our turn for him to hear us.

His ears are always tuned to the cries of our hearts.

*Dear Jesus, thank you that I never have to work
hard to get you to hear me. Even on my hardest,
loudest, lowest days, you promise to hear my
prayers. Thank you for always listening. Amen.*

REFLECT

In your journal, write **Jeremiah 29:12** in your own words.

List some emotion words that mean the opposite of *oppressed*. Circle one or two you would like to feel instead.

What do you want Jesus to hear you say today?

REMEMBER

In your journal, write the key word (or a different word) you want to focus on in this verse. How will it help you hold on to this promise?

Draw an image to remind you that God is listening to you.

God **RAISES** Us Up

Key word **raise** *(verb)*: to help to rise to
a standing position; to lift up

The Lord helps all who fall; he raises up all who are oppressed.
Psalm 145:14

Sometimes it feels like life is beating us up. It doesn't take much to tip the scales of everyday stress into debilitating *dis*tress. It happens when we least expect it. Hard things start pummeling us one after another, and pretty soon we can't seem to get our feet under us or catch our breath. All the beating up starts to beat us down.

It's such a helpless feeling to be down in this place. The things that oppress us are heavy. They pile on top of us and make us physically exhausted, emotionally ready to give up, and spiritually vulnerable.

Some heavy things are true and real. Things happen to us and to the people we love that are difficult to cope with whether we expected them or not. Bad accidents, selfish people, budget cuts, medical issues, and parenting challenges can seem to pull the rug out from underneath us.

*Other heavy things are **not true**, and they are **not real**.* Unfounded worries rob us of our sleep and our peace. Misinformation leads us into controversy and confusion. Destructive lies we believe about ourselves, about others, and even about God keep us bound up tight. They push us down even further.

God sees us—his children who have fallen down hard and can't get up on our own. He knows we need help, and he bends down to scoop us up into his loving and powerful arms.

> God raised up the Lord and will also raise us up by his power. (1 Cor. 6:14)

His power is so much higher than any other power. No matter how far down we are, he can reach us. No matter the weight of what we are buried under, he is stronger. No matter how long we have believed the lies, he can break us free. He can raise us up.

When life is weighing heavy on us, the next verse in Psalms 145 helps us know what to do.

All eyes look to you. (v. 15)

From our deepest, darkest places, we can look up to Jesus. His rising on that first Easter morning defeated the darkness. His rising broke through the weight of sin and death. His rising brought us truth, forgiveness, victory, and peace.

Because of his power to **rise**, we have the hope of eternal life with him.

Because of his power to **raise**, we have everything we need for the hardest times of this life.

He will help us when we fall, and *he will raise us up.*

We just need to look up.

Dear Jesus, I trust you to lift me up when I fall.
Help me look to you when I am feeling beaten
down. I want to rise with you. Amen.

REFLECT

In your journal, write **Psalm 145:14** in your own words.

What does this promise reveal to you about how God works?

What can you let Jesus raise you up from?

REMEMBER

In your journal, write the key word (or a different word) you want to focus on in this verse. How will it help you hold on to this promise?

Draw an image to remind you that God raises you up when you are oppressed.

Promises for When You Feel

You Feel

Overwhelmed

Jesus Holds ALL Things Together

Key word **all** *(adj)*: the whole amount, quantity, or extent of; entire, total

He is before all things, and by him all things hold together.
Colossians 1:17

He's got the whole world in his hands.

Remember that simple little song? We sang it as children in Sunday School, and I would picture God's strong hands cradling the blue and green planet we call home. It was so comforting to picture him holding everything and everyone.

But our childlike faith can get shaken pretty easily by things we see on the news, in our communities, and in our own fragile lives.

Are you really holding the *whole* world, Jesus?

Are you really holding *all things* together?

Even though we have made a mess of this world you've created, we really want to believe you are.

Paul reminds us that Jesus is the center of everything as he writes from prison:

> He is before all things,
> and by him all things hold together.
> He is also the head of the body, the church;
> he is the beginning,
> the firstborn from the dead,
> so that he might come to have
> first place in everything.
> For God was pleased to have
> all his fullness dwell in him,
> and through him to reconcile
> everything to himself,
> whether things on earth or things in heaven,
> by making peace
> through his blood, shed on the cross. (Col. 1:17–20)

He holds all of time and space.

He holds all of creation, all of the resurrection.

He holds everything we can see and everything we can't.

He holds every kind of power.

He holds the entire church—the collective body of believers—in him.

He holds all the fullness of God.

And in this place he holds in the center of it all, what do we learn that he wants to do?

He wants to reconcile everything to himself.

He wants to bring us to himself and give us his peace.

> By nature of His unique position as the firstborn of creation, Jesus connects everything: us to each other, us to creation, and (most importantly) us to God. He brings the broken pieces of our fallen world together again.[29]

He created us, he rules us, and he loves us. No matter what we see or feel or experience, we can trust the merciful and mighty One who died to save us. He holds all the power and authority that has ever been and ever will be. He is holding everything together, including you and me.

We can still find comfort in this simple song because it's true.

He's got the whole world in his hands.

Dear Jesus, you are the center of everything. Thank you for being all-powerful, all-knowing, and full of love as you rule this world. I trust you to hold everything together—including me. Amen.

REFLECT

In your journal, write **Colossians 1:17** in your own words.

What does this promise reveal to you about God's character?

What can you let Jesus hold together for you right now?

REMEMBER

In your journal, write the key word (or a different word) you want to focus on in this verse. How will it help you hold on to this promise?

Draw an image to remind you that Jesus holds all things together.

Nothing Is **IMPOSSIBLE** for God

Key word **impossible** *(adjective)*: incapable of being solved or accomplished

The LORD of Armies says this: "Though it may seem impossible to the remnant of this people in those days, should it also seem impossible to me?"
Zechariah 8:6

A lot is going on in the book of Zechariah. The major problem is that the temple had been destroyed, and God's people were losing heart as they were trying to rebuild it. The new walls had been partially constructed, but they were overwhelmed by what they still had left to do. They needed some real help.

Too much pressure.

Feelings of inadequacy and discouragement.

Wondering if God can or will intervene.

We can relate. We are overwhelmed, too. Our hearts are heavy. And we wonder the same thing: *Can* God help us? *Will* he?

When God asked his people if anything is impossible for him, he answered his own question this way in verses 7 and 8:

> "I will save my people from the land of the east and the land of the west. I will bring them back to live in Jerusalem. They will be my people, and I will be their faithful and righteous God."

The people Zechariah was speaking to needed to know this. Their new temple and the city of Jerusalem would be complete and full of joy one day. Even though it appeared to be too hard and too much, they could be sure he would do what he said.

And we can be sure of this, too. God can still do the impossible. We just have to trust that he can and he will.

I don't always do that first. I have lots of other ways I like to try to deal with my overwhelm.

My default response goes like this: I lose sleep thinking about it, muster up every ounce of my own strength, and Google all the ways to get that partially built wall finished. After a while, I realize it is too much for me to handle on my own.

I forget that we cannot "rebuild the temple" without God.

> "Not by strength or by might, but by my Spirit," says the
> LORD of Armies. (Zech. 4:6)

It's not our own strength we must rely on. It's the strong Spirit of God—the same Spirit who worked in creation as he hovered over the waters (Gen. 1:2), who opened and closed the Red Sea for God's people (Exod. 15:8, 10), who gave life to dead bones (Ezek. 37:1–14).[30] And, of course, the same Spirit who has filled the heart of every Christian across the globe.

When we are worried about someone, anxious about something, or feeling inadequate and defeated, we can remember all these impossible things God has done using his *own* strength, including the rebuilding of the temple.

Everything we are stressed about, hoping for, and struggling with can be entrusted to him. We can exchange our anxiety and fear for his faithful and generous power to rebuild our problems into something good.

Nothing is impossible for him.

Dear Jesus, thank you for never being overwhelmed.
Please remind me when I can't handle it all, you can
and you will. I bring my worries and struggles to you
and trust that you can do the impossible. Amen.

REFLECT

In your journal, write **Zechariah 8:6** in your own words.

How might you explain this Scripture promise to a child who is feeling *overwhelmed*?

What impossible thing are you asking God for?

REMEMBER

In your journal, write the key word (or a different word) you want to focus on in this verse. How will it help you hold on to this promise?

Draw an image to remind you that God can do the impossible.

minimalminimalminimalminimalminimalminimalminimalminimalminimalminimalminimalminimalminimal

minimalminimalminimalminimalminimalminimalminimalminimalminimalminimalminimalminimalminimalminimalminimminimal

My stress was increasing by the hour. I was trying to pray. For answers, for peace, for my son, for my dad, and for myself, but my brain felt like it was blocked. I needed to connect with God more than ever, but I couldn't seem to get out of my own head.

Sometimes we are just too overwhelmed to pray.

But God says he's got us even then. He reminds us that others are praying for us, and so is he.

He promises to intercede.

The *Holman Bible Dictionary* describes it this way:

> The Bible reveals that intercession is performed by the Holy Spirit, Christ, and Christians. Romans 8:26–27 shows that the Holy Spirit works to sustain the burdened believer, to intercede to carry, even inexpressible prayers to God.[31]

Inexpressible prayers.

The Spirit carries the prayers we don't know how to pray to God for us. Prayers for things only he knows we need. Prayers we can't explain but he can.

He is the one who prays for us, and he is the one who answers.

We can rest in his gentle care.

Dear Jesus, my heart is overwhelmed, and the
words won't come. Thank you that your Spirit is
interceding for me right at this moment. Help me
trust you with all the things I need. Amen.

REFLECT

In your journal, write **Romans 8:26** in your own words.

Look up this verse in a few other Bible translations or paraphrases (https://www.biblehub.org and https://www.blueletterbible.org are two online resources you can use to do this). Write what you notice.

What can you trust the Holy Spirit to intercede for you about right now?

REMEMBER

In your journal, write the key word (or a different word) you want to focus on in this verse. How will it help you hold on to this promise?

Draw an image to remind you that the Holy Spirit is interceding for you right at this moment.

God Will RENEW Our Strength

Key word **renew** *(verb)*: to make like new; restore to freshness, vigor, or perfection

But those who trust in the LORD will renew their strength;
they will soar on wings like eagles; they will run and
not become weary, they will walk and not faint.
Isaiah 40:31

Trusting God in the waiting is so hard sometimes.

Waiting for God to answer our prayers, waiting for direction, waiting for test results, waiting for healing or help. Times of waiting can become breeding grounds for anxiety and cynicism if we are struggling to trust.

Some of us have been praying and waiting for what seems like forever. Sometimes we get to the point where the relief of any answer, good or bad, would be better than the agony of waiting.

Why does he seem to take so long sometimes?

We don't always get to understand God's timing or his reasons. But maybe it will help us to know that in the waiting he promises renewal and strength.

Isaiah tells us that when we wait on God,

He will renew our strength.

God miraculously renews our strength. He doesn't simply give us a little boost once in a while, and he doesn't help us weakly limp through the day or week or year. He infuses his limitless strength into us, making our mind, body, and spirit new. When we wait on him and believe this promise, he will do the work of restoring us to freshness, vigor, and perfection.

We will soar on wings like eagles.

After just a few minutes of Googling, I was reminded that God created eagles with amazing seven-foot wingspans and the ability to fly carrying heavy prey. But I was curious to know more about how they are able to soar on even the windiest of days.

Turns out, the secret is in the feathers. The way they are separated causes air to flow over and under them, forming little colliding whirlpools

that create lift.[32] Because of this miraculous design, the huge, powerful wings of an eagle can soar through the strongest winds without much effort on the eagle's part at all.

Colliding whirlpools. Forces swirling and crashing at the same time. God designed eagles' wings to help them use this energy to rise above. When forces in our lives seem to push in on us from all directions, he will help us rise above our stress and worry, too.

God promises:

- *That we will be given that same miraculous ability to soar, even in the toughest storms and in the most painful places of waiting.*
- *That we will be given the strength we need to keep putting one foot in front of the other.*
- *That we will be held up by him when we feel like we've got nothing left. We will walk and not faint.*

The stronger the storm, the higher we can rise with Jesus. The longer we wait, the more we get to be renewed by him.

Dear Jesus, thank you for your promise to renew my strength as I wait on you. I need you to lift and carry me in this difficult storm. Help me trust that you are going to answer me in a powerful way. Amen.

REFLECT

In your journal, write **Isaiah 40:31** in your own words.

As you think about this promise, list some things you can be grateful for.

Where do you need Jesus to renew your strength and help you soar through today?

REMEMBER

In your journal, write the key word (or a different word) you want to focus on in this verse. How will it help you hold on to this promise?

Draw an image to remind you that God will renew your strength.

Jesus Gives Us REST

Key word **rest** *(noun)*: peace of mind
or spirit; quiet, stillness, repose

*"Come to me, all of you who are weary and
burdened, and I will give you rest."*
Matthew 11:28

Rest is a complicated word for some of us. I wish it were as simple as a slow morning, a spa day, a quiet weekend, or a sweet nap surrounded by cozy pillows and warm blankets. But I'm pretty sure Jesus wasn't talking about sleep, even though almost everyone I know struggles to get enough. We are tired in all kinds of ways.

After several years of medical practice and research, one doctor discovered that the rest we need is not just physical. In the book, *Sacred Rest,*[33] we find that mental, emotional, spiritual, social, sensory, and creative types of rest are just as important as physical rest. We also find a question that, if we take it seriously, may convince us that we are meant to rest even when we don't think we have time:

> What if rest is in itself a vital activity required to tend to the garden of our lives? . . . What if rest is the hands of the gardener pulling up the weeds threatening to edge out beauty?[34]

Maybe that is what Jesus is promising to help us with.

> Take my yoke upon you and learn from me, because I am lowly and humble in heart, and you will find rest for your souls. For my yoke is easy and my burden is light. (Matt. 11:29–30)

I believe Jesus knows the pressure we feel as we try to do everything we are supposed to do and that life feels awfully heavy sometimes.

He surprises us here by turning the whole idea of a yoke on its head. He uses this symbol of something worn by animals or humans being forced to work and invites us to put one on.

But the yoke *he* has for us is not a bulky one. Not a forced one. Not a lonely one.

"Take my yoke upon you and learn from me."

He offers to partner with us, to work beside us and share our burdens. There is something he will teach us here in this hard ground we are struggling through.

"Because I am lowly and humble in heart, and you will find rest for your souls."

He is gentle. He understands. He is moved by compassion for us.

"For my yoke is easy and my burden is light."

Jesus isn't a taskmaster forcing us to do a bunch of hard things or add to our list of obligations. He offers to shoulder the load with us, giving our desperate souls a deep breath.

"Come to me."

He knows what weighs us down. He knows all the reasons we are worn out.

He wants us to trust him with the gardens of our souls. If we let him, he will help us weed out the unnecessary and give us the kind of real rest we need.

*Dear Jesus, thank you for offering to share my
yoke. I surrender my load to you. Please help me
rest in the beauty of your love today. Amen.*

REFLECT

In your journal, write **Matthew 11:28** in your own words.

List some emotion words that mean the opposite of *overwhelmed*. Circle one or two that you would like to feel instead.

What do you need real rest from right now?

REMEMBER

In your journal, write the key word (or a different word) you want to focus on in this verse. How will it help you hold on to this promise?

Draw an image to remind you that Jesus gives you rest.

God Will STRENGTHEN Us

Key word **strengthen** *(verb)*: to make stronger,
to increase the ability of; to fortify, to boost

I am able to do all things through him who strengthens me.
Philippians 4:13

We are all facing hard things.

Things we get ourselves into and things that result from the choices of others. Things that are part of this human, temporal life and things that are part of our spiritual discipline. Things that are on the calendar and things that will crash in without any warning. And everything in between.

So many people I know and love are dealing with all kinds of *really* hard things. Struggling with depression, trying to navigate life changes they didn't see coming, battling addictions, fighting cancer, reeling from grief.

Sometimes it's tempting to "grit our teeth" and try to just make it through each day in our own strength. Our stubborn, self-reliant, mustered-up strength.

How often I try this and end up in a downward spiral, feeling worse than I did before. My good intentions and self-help plans last about as long as my morning coffee buzz. I run out of motivation and stamina pretty quickly.

Is there a better way to get through these difficult situations, these long weeks, these awful feelings?

Because of Jesus there is.

In place of this burdensome, exhausting kind of self-strength, he tells us he will give us his kind of strength.

Paul prays for this kind of strength in his letter to the Colossians. He prays that they (and we) would be:

> strengthened with all power, according to his glorious might, so that you may have great endurance and patience; joyfully giving thanks to the Father, who has

enabled you to share in the saints' inheritance in the light. (Col. 1:11–12)

Jesus promises to strengthen us.

Because we belong to him, we are constantly being fortified, boosted, and made stronger by his Spirit at work inside us.

With all the power according to his glorious might.

No matter what we are going through or how weak we feel, we have unlimited access to his infinite power and extraordinary might.

We will have great endurance and patience,

Endurance and patience—two things we need the most help with as we try to handle hard things in a way that glorifies him and loves people.

And we will be filled with joy as we thank God for enabling us to share in his inheritance in the light.

There is so much joy in belonging to Jesus. As we rely on him in the middle of our longest, toughest days, he will bring us bright and beautiful gifts. Encouraging words. A knowing smile. A breath of peace. A burst of energy. A creative idea. A new opportunity. A listening ear. A just-right song. A beautiful sky.

He knows exactly what we need.

And he promises that we can do hard things—*all things*—through him.

*Dear Jesus, I can't handle this on my own. I need
your strength to do all things. Thank you for
giving me your power and glory, your patience
and endurance, your light and joy. Amen.*

REFLECT

In your journal, write **Philippians 4:13** in your own words.

What does this promise reveal to you about how God works?

How can you approach your overwhelming situation with Jesus's strength?

REMEMBER

In your journal, write the key word (or a different word) you want to focus on in this verse. How will it help you hold on to this promise?

Draw an image to remind you that Jesus will strengthen you.

Promises for When You Are

Sick or in Pain

God Has a New BUILDING for Us

Key word **building** *(noun)*: a usually walled and roofed structure built for permanent use; dwelling, shelter

For we know that if our earthly tent we live in is destroyed, we have a building from God, an eternal dwelling in the heavens.
2 Corinthians 5:1

READ

Camping is a favorite activity for many of us in the Pacific Northwest. There are campgrounds everywhere—in the evergreen forests; near lakes, rivers, and oceans; and in the mountains. For my husband and me, our choice spot in the San Juan Islands had a little bit of all of these. We loved being surrounded by trees, water, and elevation in the state park that felt like our second home. We were not the most experienced or well-supplied camping couple, but we had a decent tent and could cook hot dogs and beans over a fire. When we started our family, we couldn't wait to share the experience with our young son.

Camping turned out to be less than relaxing with a toddler who didn't want to go to sleep. I think we spent more time in the car driving around with him than we did in our tent. By the time our second baby was on the way, we had figured out how to rent a house on the island instead. This was long before there were user-friendly vacation rental companies, long before making reservations online was even a thing. But once we found out how much we loved staying in a local home or cabin, we never went back to staying in a tent.

I still think tent camping sounds fun. But here was how my pregnant self decided on a house instead all those years ago.

> *Tent:* hard ground, vulnerable, uncomfortable, too hot/cold, claustrophobic
> *House:* soft bed, locked doors, cozy furniture, controlled temperature, plenty of space

They are completely different experiences. This promise tells us that God has a different experience for us, too. Paul is explaining to the Corinthians that our human bodies are like tents. Other translations of this verse use the word *tabernacle,* which means a cloth hut or a temporary residence.

How encouraging this illustration must have been to those who were suffering with painful conditions, debilitating illnesses, and the constant physical strain of life. Paul included. He needed to know that he would not have to remain in his limited, weak, tired body forever. His faith was strengthened as he looked forward to one day moving into the new home God was building for him.

God has a building for each one of us. Our weak and uncomfortable bodies that are vulnerable to injury and disease are not made to last. These tents we are staying in will come down, and God will welcome us to our eternal place with him. These new buildings will not only be comfortable and safe, but they will be better than anything we can even imagine. Mansions with rooms like no one has ever seen or lived in before.

That's the kind of home God is building for us.

Dear Jesus, thank you for my earthly tent—even
the parts that are sick and in pain. I need your
healing presence and the hope of a new body when
I feel like this. Thank you that you have a new
building for me to dwell in forever. Amen.

REFLECT

In your journal, write **2 Corinthians 5:1** in your own words.

What does this promise reveal to you about God's character?

Describe the home you imagine God building for you.

REMEMBER

In your journal, write the key word (or a different word) you want to focus on in this verse. How will it help you hold on to this promise?

Draw an image to remind you that God has a new building for you that will last forever.

Jesus CARRIES Our Pain

Key word **carries** *(verb)*: to wear or have on one's person; to sustain the weight or burden of

Yet he himself bore our sicknesses, and he carried our pains.
Isaiah 53:4

"You need to call your kids and your husband," the doctors told Kristi as she was being wheeled down the hall toward the operating room. *"We're not sure what we are going to find."* She tears up as she shares with me how it felt to make those agonizing calls.

Her husband was at a conference across the country, and her three kids were at sports practices that morning. She had driven herself to the emergency room with a burning pain in her chest, thinking maybe she had a blood clot in her lungs. Never did this athletic, vibrant, energetic mom think something could be wrong with her heart.

Kristi was awake as they found the blockage and started to place a stent. She heard the doctor suddenly stop the procedure and guide the surgical team in delicately easing the stent back out. He miraculously recognized the problem as a tear in the wall of her artery rather than a standard blockage. Going any further with the stent could have ruptured the weakened artery and taken her life.

She was diagnosed that day with a rare condition called SCAD (Spontaneous Coronary Artery Dissection). Knowing it could happen again without warning brings anxiety and worry for sure, but Kristi doesn't live in fear. The peace and joy she radiates to everyone in her life is deep and real. It comes from a faith-filled place of knowing who holds her heart.

Jesus does.

He carried her through the dangerous procedure to diagnose her heart condition and the uncertain days in the ICU that followed.

He carried her through cardiac rehab while parenting teenagers during the COVID-19 pandemic.

He is carrying her now through the losses and changes of launching kids and caring for aging parents.

He will continue to carry her through every single day for the rest of her life.

Kristi's verse:

> Trust in the Lord with all your heart,
> And lean not on your own understanding;
> In all your ways acknowledge Him,
> And he shall direct your paths. (Prov. 3:5–6 NKJV)

She knows what it means to trust in him with ALL her heart when things are hard to understand. She knows that even if she lost everything and everyone she cared about, she would still be held by Jesus. She knows that he gets it. While he lived on this earth, Jesus experienced sickness, rejection, conflict, grief, abandonment, and extreme physical pain.

"Yet he himself bore our sicknesses, and he carried our pains."

This promise is Jesus saying, in essence:

> *"I'll hold this for you."*
> *"I know how sick you feel."*
> *"I understand how much this hurts."*
> *"I've got you."*

We can trust him with all our hearts.

*Dear Jesus, thank you for understanding what
I am going through. Please take and hold this
pain, this sickness, this trouble I'm suffering.
I need you to carry me through. Amen.*

REFLECT

In your journal, write **Isaiah 53:4** in your own words.

How might you explain this Scripture promise to a child who is feeling *sick or in pain*?

What do you find most encouraging about Jesus carrying your pain and sickness for you right now?

REMEMBER

In your journal, write the key word (or a different word) you want to focus on in this verse. How will it help you hold on to this promise?

Draw an image to remind you that Jesus carries your pain.

God Is ENTHRONED Forever

Key word **enthroned** *(adjective)*: to be seated in a place of authority or influence; assigned supreme virtue or value

But you, LORD, are enthroned forever; your
fame endures to all generations.
Psalm 102:12

This psalm starts out so rough. One commentator titles it this way: "A Prayer of One Whose Life Is Falling to Pieces, and Who Lets God Know Just How Bad It Is."[35]

Eleven verses of raw frustration and real questions from a heart that is worn out. Sickness and depression have taken over. The psalmist's appetite is gone, he can't sleep, and he feels like death. Everything is going wrong, and it seems like he is being attacked by everyone around him.

Worst of all, God seems to be in on this whole thing.

I think we can all relate sometimes to this venting, this questioning, this disillusionment with God and life and everything going wrong at once. In verses 10–11, he says he feels like God has picked him up and thrown him aside and that he is withering away like grass.

Whew. That might just be the worst feeling ever. But here at his lowest point, the psalmist states this promise:

> **But you, LORD, are enthroned forever; your fame endures to all generations.**

The famous preacher Charles Spurgeon says this about the dramatic change from verse 11 to verse 12: "Now the writer's mind is turned away from his personal and relative troubles to the true source of all consolation, namely, the Lord himself, and his gracious purposes towards his own people. . . . The sovereignty of God in all things is an unfailing ground for consolation; he rules and reigns whatever happens, and therefore all is well."[36]

Enthroned

He is fully powerful. Completely in control. The Creator and Finisher of all things. The God who holds us reigns over every aspect of life and death.

Even when the results are not good. Even when the phone call doesn't come. Even when we lose someone we love. Even when things don't seem to be getting better. Even when our worst fears are coming true.

Forever

God is still on the throne. No matter what bad things are happening around us, God is sovereign forever and ever.

When we are trudging through the hardest stuff of life, it's hard to think about anything else. But if we can find the strength to look up and remember that he is still on his throne, things start to get a bit brighter. Hope rises. Peace and joy lift our hearts.

But You, Lord

What a turnaround when we look to him.

From what we feel to *what we know to be true.*

From what we see to *whom we trust.*

From focusing on ourselves to *keeping our eyes on our God who loves us.*

Because God is on the throne, we can be sure all will be well. Forever.

Dear Jesus, you know the discouragement I am struggling with. Please help me look to YOU in the middle of my confusion and stress. Even when I feel like my life is falling to pieces, I will trust that you are enthroned forever. Amen.

REFLECT

In your journal, write **Psalms 102:12** in your own words.

Look up this verse in a few other Bible translations or paraphrases (https://www.biblehub.org and https://www.blueletterbible.org are two online resources you can use to do this). Write what you notice.

What kind of turnaround might you experience if you could get a glimpse of Jesus on his eternal throne?

REMEMBER

In your journal, write the keyword (or a different word) that you want to focus on in this verse. How will it help you hold on to this promise?

Draw an image to remind you that Jesus is enthroned forever.

God **HEALS** Us

Key word **heal** *(verb)*: to restore to a healthy condition, to make sound or whole, to make well again

For I am the LORD *who heals you.*
Exodus 15:26

READ

Sometimes living with chronic illness and pain can feel like a cruel maze with no way out. We spend precious time and energy searching for answers and help that are difficult to find. We wait hours, days, weeks, and months for results, appointments, and next steps. We chase after hints of hope trying to find relief. Sometimes we make progress, and we feel so encouraged. Other times, after waiting and hoping and praying, we run into a wall that forces us to go back and try a different path. It's excruciating in so many ways.

My friend Andrea knows all about the challenges of living with debilitating illness and pain. For the past twenty years, she has suffered with multiple diagnoses including complex regional pain syndrome and aggressive non-Hodgkin's lymphoma. Every time I talk to Andrea or read her words, I feel so much hope. I hope that she feels better. I hope she gets more time with her family, and I hope for a miracle cure for the diseases ravaging her body. But a deeper hope comes from knowing Andrea's peaceful and joyful perspective on what it really means to be healed.

In her book, *Incurable Faith*, she writes about the hope of healing in her devotion titled: "Hope for More":

> God placed the desire for wholeness and healing within us to point us toward wholeness in Christ and true healing that lasts for eternity. Your desire for healing can lead you to greater faith as you discover the true hope of an eternal perspective. God gives us far more than this world can offer. He can miraculously heal us, and we pray for this, but eternal healing is our only assured hope.

Salvation promises bodily restoration, resurrection, and eternal life in heaven. One day we will be fully healed, and until that time, God "has given us everything we need for a godly life through our knowledge of him" (2 Pet. 1:3).[37]

Andrea knows that true healing means wholeness in Christ. She encourages us that as we wait for his healing, he will give us everything we need to live a godly, faith-filled life. She helps us remember that while we wait, we can draw closer to our Great Physician who promises to heal us.

Even when pain and illness seem to overwhelm our bodies and minds, we can trust the one who created our bodies to take the best care of us. We can grow in faith as we lean into his strength and help. We can look up to him who sees everything from a much higher perspective. He knows the way through the confusing and disheartening maze, and he will lead us out.

With his faithful love and in his perfect timing, Jesus will make us whole.

Dear Jesus, I come to you in my pain and suffering.
Please help me to share your eternal perspective
and hope. Thank you for your promise to heal
me and give me wholeness in you. Amen.

REFLECT

In your journal, write **Exodus 15:26** in your own words.

As you think about this promise, list some things you can be grateful for.

What does true healing mean to you?

REMEMBER

In your journal, write the key word (or a different word) you want to focus on in this verse. How will it help you hold on to this promise?

Draw an image to remind you that God is your eternal healer.

God Is Our **PORTION** Forever

Key word **portion** *(noun)*: a part or share of something; allotment, inheritance

My flesh and my heart may fail, but God is the strength of my heart, my portion forever.
Psalm 73:26

My husband grew up in a family that had lots of love and little money. He and his twin brother knew all about portions. They had to share almost everything—a bedroom, the used bike their dad brought home, their high school yearbook, and the meager amount of food their family could afford. So much about this was challenging for these extremely active and competitive boys. Dessert was the source of the most heated arguments until their mom came up with a brilliant plan. One twin would carefully divide the homemade pudding or pie, and the other would get to choose their portion first. Problem solved.

When the psalmist calls God his "portion forever," he is referring to something much more significant than an after-dinner treat. A portion to someone living in the Old Testament times was ***everything***. For most of the Israelites, a portion was an inheritance of land representing identity and security. To have God as their portion meant their infinitely loving, all-powerful, present-everywhere God was taking care of them. He gave them a purpose, he provided for them consistently and faithfully, and he brought them peace and protection.

What more could they possibly need?

And what more could we possibly need?

Nothing really, we think, until our hearts, our minds, or our bodies start to fail. Then we start to imagine all kinds of things we might need. We get scared, depressed, and overwhelmed. We naturally long for relief and dwell on what we are lacking. We silently wonder:

> *Why is this my lot in life?*
> *Where is my share of health and strength and comfort?*
> *Who is serving up the dessert right now? This doesn't seem fair.*

No, sometimes it really doesn't.

Yet Jesus offers ALL of himself to each one of us, no matter what we are facing right now. He promises to be our ***portion***.

I love what John Gill writes in his commentary about the security of having God as our portion:

> My portion for ever; both in life and at death, and to all eternity; this is a very large portion indeed; such who have it inherit all things; yea, it is immense and inconceivable; it is a soul satisfying one, and is safe and secure; it can never be taken away, nor can it be spent; it will last always[38]

So here is what we can be sure will be infinitely available to us if Jesus is our portion:

- *An overflowing amount of everything we need—so much that we can't even imagine it all.*
- *His loving presence in life, in death, and for all eternity.*
- *A soul that is satisfied and content.*
- *The safety and security of knowing God's gifts to us can never be taken away or spent; they will last forever.*

Let's load up our plates!

Dear Jesus, you know what I need. Sometimes I focus on what I am lacking, what I wish I could have. Please help me remember that you are my portion forever and I am completely taken care of. Amen.

REFLECT

In your journal, write **Psalm 73:26** in your own words.

List some emotion words that mean the opposite of sick or in pain. Circle one or two that you would like to feel instead.

What specific area of your illness or pain can you bring to Jesus right now?

REMEMBER

In your journal, write the key word (or a different word) you want to focus on in this verse. How will it help you hold on to this promise?

Draw an image to remind you that Jesus is your portion today.

God's Grace Is SUFFICIENT for Us

Key word **sufficient** *(adjective)*: adequate, reasonable; enough to meet the needs of a situation

But he said to me, "My grace is sufficient for you, for my power is perfected in weakness."
2 Corinthians 12:9

READ

Our little guy was sick. We were in a hotel room getting ready for a big day at Disneyland when his tummy started feeling bad. "Fix it!" he pleaded with me. He was starting to cry. He wanted to feel better, to get the bad feeling over with and go have fun.

Don't we all want God to "fix it" sometimes?

When we feel sick or suffer with pain, it starts to consume our thoughts and emotions. All we want is relief. *Please God, take it away. I can't go through this any longer. I just want to feel better and go on with my day.*

Paul wanted that, too.

He writes to the Corinthians here about having "a thorn in [his] flesh" (v. 7). I'm so curious about this. I wish I knew what he was struggling with, but it probably doesn't matter. We can assume that it must have been something painful, embarrassing, or limiting. He was being afflicted in a physical way that made him feel or appear weak.

Three times Paul asked God to take it away—*to "fix it"*—but God did not.

Instead, God told Paul that his grace is sufficient and his power is perfected in weakness.

That same grace and power are for us, too. When we ask God to make us well and he doesn't, we can remember this promise:

His "grace is sufficient."

Even when healing doesn't come. Even when it still hurts badly. Even when we can't get out of bed. He will be right there with us, comforting us and giving us what we really need. He will give us all of his love and care and attention.

His "power is perfected in weakness."

Our human bodies and minds are amazingly complex. So many systems work together miraculously most of the time, yet we are simultaneously vulnerable to a host of threats. These fragile clay pots that hold our souls can easily crack in this dangerous world.

God reassures us here that the places where we feel the most broken and weak are sacred. Just because we suffer with illness or pain doesn't mean he isn't answering. He is always working. He hears our prayers and fills us with his Spirit to do things we could never do on our own. Perfectly. Powerfully. Profoundly.

Our Disneyland day turned out to be a special memory. The tummy ache went away, and our toddler's smile returned. But even if his sickness had caused us to stay in the hotel room that day, our son would have had everything he needed. We would have been right there with him in his sickness and pain. We would have taken care of him and comforted him. We would have given him fluids, medicine, rest, reassurance—anything and everything he could have possibly needed.

This promise reminds us.

We *are* enough and we *have* enough, not *because* of us but because *he is enough* for us.

———————

Dear Jesus, thank you for being close and taking care of me. I trust you to meet all my needs even in this pain and sickness. Please be close to me and work powerfully through my weakness. Amen.

REFLECT

In your journal, write **2 Corinthians 12:9** in your own words.

What does this promise reveal to you about how God works?

What area of weakness can you trust God's grace to be sufficient for?

REMEMBER

In your journal, write the key word (or a different word) you want to focus on in this verse. How will it help you hold on to this promise?

Draw an image to remind you that God's grace is sufficient for you today.

Promises for When You Feel

Tempted

We Will Receive the CROWN of Life

Key word **crown** *(noun)*: a decorative band or wreath worn about the head as a symbol of victory or a mark of honor; a reward

Blessed is the one who endures trials, because when he has stood the test he will receive the crown of life that God has promised to those who love him. No one undergoing a trial should say, "I am being tempted by God," since God is not tempted by evil, and he himself doesn't tempt anyone.
James 1:12–13

READ

The opportunity to win something can be so motivating. We spend money, share our email addresses, and play silly games for a chance to win a prize. If our name is drawn or our number called, we feel so lucky.

Other prizes are earned by hard work and sacrifice. Many people devote their lives to competitions that measure skill and performance—hoping to be rewarded with a medal, trophy, or title.

It's a bit confusing, then, when James talks about going through trials and temptations and God's promise of the crown of life.

Are we going to be lucky if we get one?

Or should we be working hard to earn one?

The answer to both of these questions can be **yes** *and* **no**.

Yes, we will be fortunate to have a crown placed on our head by the giver of life.

No, this is not a random selection kind of prize. God promises that everyone who loves him will get one.

Yes, we should have our eyes on this prize. We should be making every effort to work toward it. The crown is something we should want to win.

No, it is not a competition. We can never deserve it or earn it based on our performance or skill.

So, how do we "stand the test"?

We focus on the crown of life.

We can be sure that trials allowed by our loving Father are meant to strengthen our faith and move us closer to receiving this prize. We can also be sure that temptations from the enemy are intended to weaken our faith and keep us from getting one.

Like James, Peter writes to encourage us during these trials by reminding us of what is on the other side of them:

> You are being guarded by God's power through faith for a salvation that is ready to be revealed in the last time. You rejoice in this, even though now for a short time, if necessary, you suffer grief in various trials so that the proven character of your faith —more valuable than gold which, though perishable, is refined by fire—may result in praise, glory, and honor at the revelation of Jesus Christ. (1 Pet. 1:5–7)

Jesus wants us to win—to experience the victory of life with him now and forever.

He is with us in our trials and temptations. He guards us and helps us as our faith is being strengthened. He is not going to give up on us if we aren't the fastest or strongest or luckiest. He is not going to reject us when we fall if we come to him with repentant hearts.

He has a crown of life—and love—waiting for every one of us.

Dear Jesus, please guard me and help me fight this temptation. I want to obey you and come through this with a stronger faith. Thank you for saving a crown for me in heaven. Amen.

REFLECT

In your journal, write **James 1:12–13** in your own words.

What does this promise reveal to you about God's character?

What trial or temptation are you facing today?

REMEMBER

In your journal, write the key word (or a different word) you want to focus on in this verse. How will it help you hold on to this promise?

Draw an image to remind you that Jesus has the crown of life waiting for you.

God Will **DO** It

Key word **do** *(verb)*: to bring to pass,
to carry out; accomplish

Now may the God of peace himself sanctify you completely.
And may your whole spirit, soul, and body be kept
sound and blameless at the coming of our Lord Jesus
Christ. He who calls you is faithful; he will do it.
1 Thessalonians 5:23–24

One of the hardest things for many of us to do is exercise. Even with all the classes, machines, personal trainers, and workout apps available to us, getting and staying in shape requires our time and energy. Working out is not something we can have someone else take care of for us. To become strong, flexible, and increase our cardiorespiratory endurance, we have to move our *own* muscles.

Physical fitness takes self-discipline, motivation, and effort.

Sometimes we approach our spiritual "fitness" the same way. We think the results depend on us. We try to motivate ourselves to work hard. We pressure ourselves to reach goals. We even create nice little routines of doing things we think will get us into good Christian "shape."

Are we trying to do the impossible and sanctify ourselves?

I'm so thankful for this promise that gives us a breather and reminds us of an important truth.

Becoming "fit" in God's eyes is **not** something we are ultimately in charge of. Our well-intentioned efforts can bring good change and real growth, but not sanctification. While it does require our cooperation, at the end of the day, the transformative work of becoming holy and set apart is something *he does for us*, not something we do for him on our own.

When we take a few moments to drink all this in, it refreshes and strengthens us in so many ways.

"The God of Peace"

God is not harsh and demanding. His peaceful Spirit gently inspires and teaches us.

"Sanctifies [Us] Completely."

He will finish the work. We will be 100 percent set apart for him.

He keeps our spirit, soul, and body sound and blameless and makes us ready for the coming of Jesus.

Every part of us will be in perfect condition to meet Jesus.

The God who called us **"is faithful, and he will do it."**

The Amplified Bible describes it this way: "[He will fulfill His call by making you holy, guarding you, watching over you, and protecting you as His own.]"

Living the way he wants us to is not a float down a lazy river, but it's also not a CrossFit competition. I think of it more like a hike designed personally for us by God. The path he leads us on will have nice level places, plenty of rocky spots, some steep switchbacks for sure, and indescribably beautiful viewpoints. We will be tempted to take dangerous shortcuts. We might trip and fall, but he will help us get back up and keep going. We will be profoundly challenged, and we will be greatly rewarded. We will have sore, tired muscles, but we will have stronger hearts and lifted spirits as we walk with him.

Our sanctification is *his* work. All we have to do is take the next step and trust him along the way.

He will do it.

Dear Jesus, please help me keep going the way you want me to. I am tempted to wander off right now, and I need you to hold my hand. Thank you that you are in charge of sanctifying me, and you will do it. Amen.

REFLECT

In your journal, write **1 Thessalonians 5:23–24** in your own words.

How would you explain this Scripture promise to a young child who is feeling tempted?

What area of temptation and weakness do you need Jesus to work on with you?

REMEMBER

In your journal, write the key word (or a different word) you want to focus on in these verses. How will it help you hold on to this promise?

Draw an image to remind you that you God is faithful and he will do it.

Jesus FILLS All Things

Key word **fills** *(verb)*: to occupy the
whole of, to satisfy, to complete

And he subjected everything under his feet and appointed
him as head over everything for the church, which is his body,
the fullness of the one who fills all things in every way.
Ephesians 1:22–23

READ

I see the appointment written on the calendar, and I sigh. Dentist appointment again already? I know dental care is important, and I truly am grateful for mine. The office is bright and welcoming, and the friendly, knowledgeable staff makes the gum poking and teeth scraping *mostly* bearable.

But still, sitting in a dentist's chair is not something most of us enjoy. And if a dreaded cavity is found, we know the next appointment is going to be worse. Needles, drills, and something that feels like a miniature crowbar are required to fix this problem inside our mouth.

As tempting as it might be to just ignore a small hole in a tooth, we can't. Cavities left alone only get larger with infection and worsening pain to come. They need a *filling*. A specific kind of material to occupy the whole of a cavity, to satisfy and complete it so that no empty places remain.

We know all of this, of course, but we still wonder: *Can't we just stick some gum in there and hope it holds?*

I wonder if that is what we often try to do with the holes in our hearts. It is so easy and tempting to turn to quick fixes or unhealthy options when we are in pain.

Do we try to ignore it and pretend it doesn't hurt?

Do we try to numb the pain with something else like food, shopping, alcohol, busyness, or binging on the next show in our entertainment queue?

Do we try to fix it ourselves with some kind of self-help plan we found on social media?

This promise reminds us that we have such better care available than that.

We have Jesus.

In this first chapter of Ephesians, Paul reminds us of what that means for us:

> *He has chosen us to be his (v. 4).*
> *He has adopted us as sons (v. 5).*
> *He has redeemed us through his blood (v. 7).*
> *He has poured out his grace on us with all wisdom and understanding (v. 8).*
> *He has made known to us the mystery of his will (v. 9).*
> *He has sealed us with the promise of his Spirit (v. 13).*

The incredible power Jesus has is far above every ruler and authority, stronger than all power and dominion, and more important than every title given now and forever.

He is the only one who can heal us. He knows every painful cavity in our hearts, and he has all the power and compassion needed to fill them. When we turn to him instead of giving in to temptations, we will be completely taken care of.

No appointment (or novocaine shots) required.

Dear Jesus, you know how to fix the hole in my heart. Please help me run to you alone instead of turning to the many temptations that offer me false satisfaction. Thank you for all the ways you fill me with your love and power. Amen.

REFLECT

In your journal, write **Ephesians 1:22–23** in your own words.

Look up this verse in a few other Bible translations or paraphrases (https://www.biblehub.org and https://www.blueletterbible.org are two online resources you can use to do this). Write what you notice.

What do you often turn to instead of asking Jesus to fill the holes in your heart?

REMEMBER

In your journal, write the key word (or a different word) you want to focus on in these verses. How will it help you hold on to this promise?

Draw an image to remind you that Jesus fills all things.

The Devil Will **FLEE**

Key word **flee** *(verb)*: to run away from danger, to hurry toward a place of security; to bolt

Therefore, submit to God. Resist the devil, and he will flee from you. Draw near to God, and he will draw near to you.
James 4:7–8

READ

There is a constant battle for our hearts and souls every moment of every day. Cartoonists depict it as a devil on one shoulder and an angel on the other, both trying to persuade us to listen to them.

Our enemy is always looking for a fight, as Peter tells us here: "Your adversary the devil is prowling around like a roaring lion, looking for anyone he can devour" (1 Pet. 5:8).

But we know and believe that Jesus has already defeated the devil soundly and will continue to fight for us.

So, who is going to win this time? We really want it to be Jesus. We want to hear him and obey him and experience his victory.

But sometimes the enemy is awfully loud. In his efforts to get between us and Jesus, he doubles down and turns up the volume. He manipulates with evil tricks and lies that mess with our minds and test our faith. It can feel like the temptation to give in is too strong, and making the right choice seems almost impossible.

What can we do? How do we keep this hateful, deceitful enemy from taking us down?

We can remember this promise. God can win this battle. He has all the power, wisdom, love, and truth needed to get the enemy out of our ear and away from us.

James tells us what to do:

1. "Resist the devil, and he will flee from you."

Or, as one paraphrase puts it: "Yell a loud *no* to the Devil and watch him make himself scarce."[39] We can do that. Even toddlers know how to yell no. We can stop the lies and the confusion with one word.

2. "Draw near to God, and he will draw near to you."

Again, paraphrased: "Say a quiet *yes* to God and he'll be there in no time."[40]

We can do that, too. We can say a quiet yes to God and expect him to come and help. Sometimes, all I can say is the name, *"Jesus,"* and that's enough.

A Christian thinker named Trevin Wax has dedicated his career to ministry—including teaching God's Word in the local church, writing books about important theological matters, being a missionary in Romania for a portion of his life, and teaching in seminaries (which are the training grounds for future pastors!). One of his phrases about the most important mark of a Christian helps us here, too.

Based on the Bible's entire message about the defining mark of a follower of God, Trevin encourages us to *"turn away and turn toward."*[41]

Turn away from the temptation or the sinful choices and turn toward Jesus. Turn away from the enemy and his lies and turn toward Jesus.

When we turn toward Jesus, the enemy bolts. When he hears us yell *no,* he runs away as fast as he can. He knows he has already lost.

And Jesus wins.

Dear Jesus, I'm having such a hard time with temptation right now. Please help me resist the devil and submit to you. Thank you for coming close when I whisper your name. Amen.

REFLECT

In your journal, write **James 4:7** in your own words.

As you think about this promise, list some things you can be grateful for.

What do you need to yell a loud no about to the enemy right now?

REMEMBER

In your journal, write the key word (or a different word) you want to focus on in this verse. How will it help you hold on to this promise?

Draw an image to remind you that the enemy will flee when you turn to Jesus.

God Will **PROVIDE** a Way Out

Key word **provide** *(verb)*: to make something available;
to supply something for sustenance or support

But God is faithful; he will not allow you to be tempted
beyond what you are able, but with the temptation he will
also provide the way out so that you may be able to bear it.
1 Corinthians 10:13

READ

So many stories in the Bible remind us that God is our provider.

In the Old Testament, we read about how he provided descendants for Abraham and Sarah, food, guidance, and protection for the Israelites, redemption for Joseph, a family for Ruth, victory for David, and favor for Esther.

In the New Testament, we read about how he provided food for the five thousand, wine for the wedding guests, healing for the sick, blind, and paralyzed, freedom for those who were bound by the law, and the hope of eternal life.

There are thousands more stories of how God took care of his people by promising and providing a Messiah. God gave everybody everything when he gave us Jesus.

In the book of Genesis, Abraham was given a way out of a heart-wrenching situation. God had asked him to sacrifice his son, and Abraham obeyed. He went up into the mountains with the wood, the fire supplies, and young Isaac. When Isaac asked where the lamb for the sacrifice was, Abraham told him God would provide. When a ram really did come out of nowhere at the exact moment to spare his son,

> Abraham named that place The LORD Will Provide, so today it is said, "It will be provided on the LORD's mountain." (Gen. 22:14)

The Lord will provide. ***Jehovah-jireh.***

The Hebrew word *jireh* means more than provide. It also means "to see, perceive, and consider."[42]

It helps so much to know God sees us. He perceives and considers what we are struggling with.

Even when our struggle is with temptation.

We all get tempted. Every day we run into things that we know we shouldn't do or say or think about. God sees the temptations we face, and he promises to provide a way out.

We need to trust this promise. Turning away from our temptations can be hard, especially the ones no one knows about. So many things we are tempted by are personal and private. Sometimes the only One that knows we are struggling is God.

Luckily for us, the One who knows us best knows the best way to get us out. We just need to ask him.

He might give us a Scripture to read or recite, a photo to remind us, a friend to hold us accountable, a song to pierce our heart, or another of his holy interruptions. It might be a quick redirection or a long process of healthy discipline, or both. But no matter how he does it, we can trust his promise to provide everything we need.

Even when it appears to us that we are trapped in our temptation, we are not. God sees us, God will answer us, and God will give us a way out.

Dear Jesus, I confess that I am tempted by things that are not good for me or others. Please help me turn to you, and to your people, in my temptations so that I do not have to bear them alone. Thank you for promising to provide a way out. Amen.

REFLECT

In your journal, write **1 Corinthians 10:13** in your own words.

List some emotion words that mean the opposite of *tempted*. Circle one or two you would like to feel instead.

List some temptations you need a way out of.

REMEMBER

In your journal, write the key word (or a different word) you want to focus on in this verse. How will it help you hold on to this promise?

Draw an image to remind you that God will provide a way out.

We Are **UNDER** Grace

Key word **grace** *(noun)*: mercy, pardon,
approval; special favor

For sin will not rule over you, because you are
not under the law but under grace.
Romans 6:14

The Pacific Northwest has a rainy reputation. Gray, drippy days are the norm. We have rain jackets, hats, and waterproof shoes, canopies to stand under when we watch our kids play sports, and some of us even carry umbrellas. That's a stretch for me though. I refuse to use one unless there is a convincing reason I shouldn't get wet. Most of the time, I honestly don't even know where my umbrella is.

I will admit, though, that while watching my boys play baseball in the early spring, there were definitely days when I wished I did. As I gratefully stood under a more prepared person's protective umbrella, I realized how much better it felt to be covered. The rain was really coming down, yet we were not getting wet. The umbrella blocked the drops and allowed us to relax and enjoy the game.

Protected. Covered. Free. That's how we can live under the grace of God.

Grace is a hard concept for us sometimes. We need it so desperately. This undeserved favor, this complete forgiveness of our sin, this loving welcome into the open arms of Jesus.

This generous gift of God—pure and simple and free—is supposed to be anything but hard to receive, yet we find ways. We try to earn it. We try to understand it. We try to explain it.

We feel drips of *why? Why does God offer us this covering when we don't deserve it?*

And we feel drops of *how? How can he possibly want to give us grace when we keep struggling with the same stuff?*

Sin continues to try and keep us in this place of unworthiness. Drip, drop, drip, drop, drip drop. *But Jesus reminds us that grace doesn't have to be earned, understood, or explained.* It is free, undeserved. A ***gift***.

Ahhh. But some of us don't do well with those. If we are given something, we have a hard time accepting it. We scramble. Something in return—quick! A gift for them, a note of thanks, a favor. We can barely handle it. But that isn't why people give us gifts, is it? To make us run around and try to earn them?

And it certainly isn't the reason God does. The only thing God wants us to do with his precious gifts is to humbly receive them. He holds up his wide umbrella of grace and welcomes us in.

God will keep us covered when the desire to sin is strong. God will keep us covered when we start to believe the lies of the enemy. God will keep us covered when we fail again and again. Even when the temptations to doubt and disobey never seem to let up, we can take refuge with him.

He will keep us under grace.

Dear Jesus, I humbly ask for your forgiveness and your help. The temptation to sin is strong right now, and I need your empowerment. Please keep me safe and protected under your umbrella of grace. Amen.

REFLECT

In your journal, write **Romans 6:14** in your own words.

What does this promise reveal to you about how God works?

What can you bring under the umbrella of Jesus's grace right now?

REMEMBER

In your journal, write the key word (or a different word) you want to focus on in this verse. How will it help you hold on to this promise?

Draw an image to remind you that you are under grace.

Promises for When You Feel

Unlovable

We **BELONG** to Jesus

Key word **belong** (*verb*): to be attached or
bound; to be a member of, to fit in

You belong to Christ.
1 Corinthians 3:23

So many people around me are running on fumes trying to meet too many
needs, too many deadlines, too many expectations. They greet me with
tired eyes and stressed-out sighs, and my heart sighs, too.

It seems like much of our stress comes from *belonging. Or trying to.*
Our families need us, our workplaces depend on us, our friends and social
groups look for our responses, and our community counts on us. Good and
important things pull us in different directions and sap our energy.

We love our people. We value being part of most of these groups, but
sometimes we get resentful and weary. And deep down we secretly fear
what might happen if we can't keep it up. If we don't perform well, if we let
down, if we don't give them what they need, will they just let us go? Where
will we *belong* if we fail? Who will want us then?

Jesus will.

> "Do not fear, for I have redeemed you; I have called you
> by your name; you are mine." (Isa. 43:1, emphasis added)

He calls us by name. He has redeemed us. He tells us we don't have
to be afraid. We are his forever, and that is not something we can earn or
something we can lose. He has already done everything that really needs to
be done. This price for us was paid in full a long time ago. We don't have
to *do* a bunch of things. We don't have to *prove* ourselves. We don't have to
strive to keep our place.

He promises that we will always belong. Even when we feel like we
don't.

When we neglect to do or say the right thing.

*When we completely forget about the appointment, the field trip, the
meeting.*

When we react harshly and hurt someone we love.

When we have to choose between two or more important events knowing someone will be disappointed.

When it happens. When we experience the heartbreaking devastation of being abandoned by a boss, a friend, a parent, or a spouse.

He has so much compassion for us. He knows how much our hearts need to feel like we belong somewhere, to something, and to someone. Because we belong to him, he will hold us and help us even when no one will.

We matter so much to him that he gave his own life for ours.

Ann Voskamp's beautiful words help us understand how personal his sacrifice was. She writes that when Jesus hung on the cross,

> He shed his blood to make you his blood. You get to never be abandoned because he abandoned everything to be with you, and his atonement on the cross was for at-one-ment with you.[43]

At one with Jesus.

We belong forever to the One who loves us most.

———————

Dear Jesus, you lived and died so that I could be part of your family. Please help me live like I belong to you. Thank you. I am yours forever. Amen.

REFLECT

In your journal, write **1 Corinthians 3:23** in your own words.

What does this promise reveal to you about God's character?

How can you live like you belong to Jesus today?

REMEMBER

In your journal, write the key word (or a different word) you want to focus on in this verse. How will it help you hold on to this promise?

Draw an image to remind you that you belong to Jesus.

God's Love ENDURES Forever

Key word **endures** *(verb)*: to remain firm under
suffering or misfortune without yielding; to continue

*Give thanks to the L*ORD *for he is good; his
faithful love endures forever.*
Psalm 118:1

READ

The first days with our newborn son were a blend of joy and exhaustion,
learning and love. But the first night at home was pretty rough. I remember
walking and bouncing in the dark for hours trying to console my screaming
baby. My eyes were heavy and my body ached, but whenever I tried to sit
or lie down for even a moment, he cried harder. He didn't want Daddy, he
didn't want milk, he didn't need his diaper changed. I didn't know what he
needed or how to console him. The only thing I could do was hold him in
my arms and keep moving.

It took almost all of my energy and most of my patience, but the
strength of my love for this tiny son of mine kept me going. Nothing was
going to keep me from caring for him.

As parents, spouses, and adult children of aging parents, we sometimes
have to love in ways that aren't easy. We deal with tantrums, moods, and
annoying habits. We repeat things more times than we should ever have to.
We clean up things we never thought we could. We listen longer than our
tired bodies want to listen.

We endure hard things because we love our people.

And Jesus loves us even better and stronger than that.

He promises his love endures forever. No amount of neediness could
ever keep him from taking care of us.

I will admit there have been more than a few times in my life that I
thought God might want to give up on me. My neediness and imperfec-
tions make me wonder if I am worth the trouble.

I stopped going to church in college after years of going regularly. I was
burned out, questioning my faith, disillusioned by hypocrisy. What does it
mean to be a Christian? Is this really what I believe?

But he didn't give up on me just because I was asking questions.

I started my teaching career, feeling guilty that maybe I hadn't chosen the right path. Surely God was disappointed that I wasn't a missionary somewhere across the world or employed by a church or outreach organization.

But he didn't give up on me just because I wasn't working in what I thought of as "ministry."

When my doctor prescribed medication and therapy for my anxiety disorder, I sobbed in her office. What is wrong with me? God must be so disappointed, so ashamed of my weakness.

But he didn't give up on me just because I needed help.

Now I know it.

His love for us remains firm. The stressful things we go through and the complicated decisions we make don't surprise him or wear him out.

Even when we are at our most unlovable, his love remains strong.

Even when we won't stop crying, he will hold us close.

Even when we feel like quitting, he does not.

"His faithful love endures forever."

Dear Jesus, you are so faithful and so good to me.
Please help me live in your constant love. I want to
love people the way you do—no matter what. Amen.

REFLECT

In your journal, write **Psalm 118:1** in your own words.

How might you explain this Scripture promise to a child who is feeling *unlovable*?

What "thing"—a worry, a choice, a sin, or a weakness—is so strong in your life right now that you assume Jesus's love cannot endure it? How does it feel to know his love is far more durable than that thing?

REMEMBER

In your journal, write the key word (or a different word) you want to focus on in this verse. How will it help you hold on to this promise?

Draw an image to remind you that God's love endures forever.

God Has Made Us HEIRS

Key word **heir** *(noun)*: a son or daughter; descendant

*And because you are sons, God sent the Spirit of his Son into
our hearts, crying, "**Abba**, Father!" So you are no longer a slave
but a son, and if a son, then God has made you an heir.*
Galatians 4:6–7, emphasis added

God loves us so much that he calls us his children. He has adopted us into
his family, and we are brothers and sisters of Jesus. He put his Spirit into
our hearts to assure this.

He even lets us call him "Abba, Father," which is as familiar as calling
him "Daddy."

That might sound kind of weird to people that don't know him well.
Depending on our relationship with our earthly fathers or lack of one, it
might seem uncomfortable or disrespectful or impossible to believe.

Even if we have a healthy, loving relationship with a father or father
figure in our lives, it can be hard to make sense of this incredible relation-
ship God promises us. Our emotions and experiences can influence in good
or bad ways what it means to be his child.

Paul uses a legal example here that might help us understand a bit better.

In this part of his letter to the Galatians, he takes us from the role of
slave to *son* to *heir*. He tells us that we are no longer slaves, but we are God's
children. Then he says that because we are God's children, he has made us
his heirs.

What does that really mean for us?

My husband and I recently updated our will. We have two adult sons
that we have named as beneficiaries of everything we own. We kid them
about the disappointment ahead. With two schoolteachers for parents,
there won't be much of an inheritance coming to them when we die.

It is a serious thing, though, to name someone in a will. A will is a legal
document, binding and lasting. Nothing and no one can change what is writ-
ten there. Everything that is designated for the beneficiaries is guaranteed to
be given. There is no question that our boys will get what we leave to them.

That is so reassuring. And we can be even more sure about the inheritance we will have as children of our loving Father God. Because we are in his family and named as his heirs, we have so much more than we can imagine coming our way.

Peter writes that we can look forward to "an inheritance that is imperishable, undefiled, and unfading, kept in heaven for you" (1 Pet. 1:4).

Now and forever, we have:

> *His constant attention and help,*
> *His comfort and caring for our pain,*
> *His protection from our enemies and temptations,*
> *Forgiveness and freedom from sin,*
> *Healing and hope when we are sick,*
> *Indescribable peace and joy,*
> *Unconditional love and grace,*
> *The glory of his presence,*
> *And a place right beside him.*

As his children and his heirs, he promises that we won't be disappointed. We will inherit the earth one day (Matt. 5:5), and the world will be perfect. We will have everything we need from our loving Father forever.

> *Dear Jesus, your inheritance is more than I*
> *could ever hope for. Please remind me when I*
> *forget that I am your child and your heir. Thank*
> *you for letting me call you Daddy. Amen.*

REFLECT

In your journal, write **Galatians 4:6–7** in your own words.

Look up this verse in a few other Bible translations or paraphrases (https://www.biblehub.org and https://www.blueletterbible.org are two online resources you can use to do this). Write what you notice.

What do you need your Father to give you right now?

REMEMBER

In your journal, write the key word (or a different word) you want to focus on in these verses. How will it help you hold on to this promise?

Draw an image to remind you that God has made us his heirs.

God Will **RUN** to Us

Key word **run** *(verb)*: to go faster than a walk; to go rapidly or hurriedly

But while the son was still a long way off, his father saw him and was filled with compassion. He ran, threw his arms around his neck, and kissed him.
Luke 15:20

When we read the story of the prodigal son, most of us can relate to one brother or the other: the younger one who didn't play by the rules and went his own way, or the older one who dutifully, responsibly lived on the estate and worked the fields.

One defiant and disrespectful, and the other resentful and proud. Both self-serving, as all of us are a lot of the time. But no matter which of the sons we identify with, we can be so incredibly grateful that we have the same Father they did.

A father that looked often for his wayward son. I imagine that several times a day he would go to a place on his property where he could see the farthest and scour the landscape—just in case. Watching for any sign of him, waiting hopefully, never giving up.

A father that saw his son coming home when he was still a "long way off" and ran to him. With a pounding heart and complete forgiveness, this ecstatic father ran to meet his son. He didn't stand there with arms crossed, waiting for an apology. He didn't list all the ways his son had hurt him and caused him grief. He practically tackled him—hugging and kissing him as he welcomed him home.

A father that wrapped his dirty son in the finest robe, placed a ring on his finger, and prepared a generous celebration feast in his honor. A father who held nothing back as he instantly restored his son to his place in the family.

A father that tended to the stinging heart of his other son, too. He made sure his faithful older son knew he was understood, appreciated, still so important to him. He invited him out of the fields and into the party, to take a rest from his labors. He reassured him that all the

celebrating of his brother's return would take nothing away from the relationship they shared.

This is the kind of Father we have, no matter what kind of kid we are. This is how deeply our God cares about us, how well he knows us, how quick he is to forgive, and how extravagant he is in his love toward us.

Charles Spurgeon describes it this way:

> We read that the father "ran." The compassion of God is followed by swift movements. He is slow to anger, but He is quick to bless. He does not take any time to consider how He shall show His love to penitent prodigals—that was all done long ago in the Eternal Covenant. He has no need to prepare for their return to Him—that was all done on Calvary. God comes flying in the greatness of His compassion to help every poor penitent soul.[44]

I love to picture this. God comes flying in the greatness of his compassion. No matter where we have been, what we have done, or how hurtful our choices have been.

He will run to us.

Dear Jesus, I am so sorry for everything I've done to hurt you. It is amazing to me that even at my worst, you run to me. Thank you for your unconditional love. Amen.

REFLECT

In your journal, write **Luke 15:20** in your own words.

As you think about this promise, list some things you can be grateful for.

Which of the two brothers do you relate to in this story? How does that affect your understanding of God's Father heart for you?

REMEMBER

In your journal, write the key word (or a different word) you want to focus on in this verse. How will it help you hold on to this promise?

Draw an image to remind you that God will run to you.

Nothing Can **SEPARATE** Us from God's Love

Key word **separate** *(verb)*: to set or keep apart; to disconnect, to sever

For I am persuaded that neither death nor life, nor angels nor rulers, nor things present nor things to come, nor powers, nor height nor depth, nor any other created thing will be able to separate us from the love of God that is in Christ Jesus our Lord.
Romans 8:38–39

READ

Nothing? I can think of several things that are *trying* to get between me and God's love today.

I am worried about people I love.

I'm distracted by a busy calendar and a long to-do list.

I'm struggling with self-doubt and a lot of pressure to perform well.

I am overwhelmed by the evil and heartbreak happening all over the world.

I have made selfish, sinful choices already this morning.

I don't feel like praying.

I'm just plain TIRED.

There.

Those are some things that are trying to get between me and God's love. I bet you have some, too. "Today" things and "tomorrow" things. Thinkable things and unthinkable things. And all the rest.

But Paul says in this powerful verse that *nothing* can separate us from God's love.

Nothing we are worried about.

Nothing that has happened or will happen.

Nothing we have to do.

Nothing we are feeling.

Nothing we have done.

Nothing physical, mental, emotional, or spiritual.

Not. One. Thing.

Because God's love doesn't work that way.

These things that seem to get in the space between us and Jesus are not barriers to him. Nothing we experience is strong enough or big enough to prevent his love from reaching us.

Because he isn't on the other side of them.

He is ***inside*** of us.

That's the way he embraces us. From the inside. He fills us with his Spirit and wraps his love tightly around our hearts. This love he has for us is closer than any other thing in our lives.

A few verses earlier in Romans 8, Paul writes: "Who can separate us from the love of Christ? Can affliction or distress or persecution or famine or nakedness or danger or sword. . . . No, in all these things we are more than conquerors through him who loved us" (vv. 35, 37).

Jesus is inside our hearts. He lives there, he works there, ***he loves there.*** His unconditional, never-ending love endures more than we can imagine.

And he will make sure that absolutely nothing will disconnect us from this powerful, perfect love he has for us.

Dear Jesus, thank you for dying on the cross to
make sure nothing can get between us. I will rest
in knowing that your love is inside me and is
stronger than anything else in my life. Amen.

REFLECT

In your journal, write **Romans 8:38–39** in your own words.

List some emotion words that mean the opposite of unlovable. Circle one or two that you would like to feel instead.

What things are you tempted to believe separate you from Jesus's love for you?

REMEMBER

In your journal, write the key word (or a different word) you want to focus on in these verses. How will it help you hold on to this promise?

Draw an image to remind you that nothing can get between you and God's love.

God Has **SET** His Heart on Us

Key word **set** *(verb)*: to direct with fixed
attention; to put securely in place

The Lord *had his heart set on you and chose you, not because*
you were more numerous than all peoples, for you were the
fewest of all peoples. But because the Lord *loved you.*
Deuteronomy 7:7–8

My heart was set on Bob Crosby.

I wanted nothing more than to be with him. I counted the days until our wedding, hoping that nothing would interrupt our plans. I couldn't wait to spend the rest of our lives together. My heart, my attention were fixed on him.

Fast-forward to over thirty years later, and I am so grateful to be married to him. He's still the love of my life and my best friend.

When we set our hearts on someone, we think about them all the time. We want to be with them. We don't want anything to come between us.

This promise tells us that God feels that way about us. His heart is set on us.

The Hebrew word for "set" is *hasaq*.[45] It means to cling, join, love, and delight in.

In a much higher and holier way than we can ever love another, God loves us. He delights in us. He desires that we cling to him and be joined together with him forever.

Moses gave the people of Israel this promise from God as they were about to cross the Jordan River into the long-awaited land of Canaan. It seems like they might have had a hard time understanding why he chose them.

If they had been a larger or more valiant people, God's selection might have possibly made sense. Large numbers meant strength, security, reputation, and confidence—especially during times of battle. If they were stronger, they might have had something that would benefit God. But this little group of people was the smallest of all the surrounding nations. They were

worn out from forty years of surviving in the wilderness. They didn't have much to offer.

Just before God was going to give them overwhelming blessings in this new and bountiful land, he wanted them to know why. It wasn't because they had earned it. It wasn't because he needed their strength or abilities. *It was simply because he loved them. And he loves us this way too.*

But those of us who feel unworthy of love still wonder what we could possibly have to offer him. Our minds start to race. Why would he choose us? We don't measure up. We make a lot of mistakes. We are not very strong, and we tend to give up when things get tough. Surely, he can find people who will bring more talent, more strength, and more results.

When we compare ourselves with others, our numbers don't look very good. But Jesus promises the numbers don't matter. He doesn't choose us because we have something he wants or needs. He chose us for no other reason than to pour upon us his merciful, extravagant, and unmerited love.

When we feel like the smallest, the weakest, or the least desirable, we can remember that Jesus's attention is fixed securely on us. We are locked in his love.

His has set his heart on us.

———

Dear Jesus, thank you for setting your heart on me. When I feel unlovable and unworthy, please help me trust your unconditional love. You are all the love I need. Amen.

REFLECT

In your journal, write **Deuteronomy 7:7–8** in your own words.

What does this promise reveal to you about how God works?

What do you find most encouraging about God's setting his heart on you?

REMEMBER

In your journal, write the key word (or a different word) you want to focus on in these verses. How will it help you hold on to this promise?

Draw an image to remind you that God has set his heart on you.

Quick Reference Guide

Promises for When You Feel AFRAID

God will HOLD on to us.
"Do not fear, for I am with you; do not be afraid, for I am your God. I will strengthen you; I will help you; I will hold on to you with my righteous right hand." (Isa. 41:10)

Jesus REACHES out his hand to us.
But when he saw the strength of the wind, he was afraid, and beginning to sink he cried out, "Lord, save me!" Immediately Jesus reached out his hand, caught hold of him. (Matt. 14:30–31)

God is our REFUGE.
God is our refuge and our strength, a helper who is always found in times of trouble. (Ps. 46:1)

We are protected in God's SHADOW.
The one who lives under the protection of the Most High dwells in the shadow of the Almighty. (Ps. 91:1)

The SPIRIT of fear is not from God.
For God has not given us a spirit of fear, but one of power, love, and sound judgment. (2 Tim. 1:7)

God is our STRONGHOLD.
The LORD is the stronghold of my life—whom should I dread? (Ps. 27:1)

God is WITH us.
"Do not fear, for I am with you." (Isa. 43:5)

Promises for When You Feel ANXIOUS

Jesus stands AMONG us.
Jesus came, stood among them, and said to them, "Peace be with you." (John 20:19)

Jesus CARES about us.
Casting all your cares on him, because he cares about you. (1 Pet. 5:7)

Jesus is the First and the LAST.
"Don't be afraid. I am the First and the Last." (Rev. 1:17)

Jesus gives us his PEACE.
"Peace I leave with you. My peace I give to you. I do not give to you as the world gives. Don't let your heart be troubled or fearful." (John 14:27)

Jesus is our SHEPHERD.
The LORD is my shepherd, I have everything I need. (Ps. 23:1 GNT)

Jesus SINGS over us.
The LORD your God is among you, a warrior who saves. He will rejoice over you with gladness. He will be quiet in his love. He will delight in you with singing. (Zeph. 3:17)

The peace of God SURPASSES understanding.
And the peace of God, which surpasses all understanding, will guard your hearts and minds in Christ Jesus. (Phil. 4:7)

Promises for When You Feel ASHAMED

We can APPROACH God's throne with boldness.
Therefore, let us approach the throne of grace with boldness, so that we may receive mercy and find grace to help us in time of need. (Heb. 4:16)

Jesus does not CONDEMN us.
"Neither do I condemn you," said Jesus. "Go, and from now on do not sin anymore." (John 8:11)

Jesus gives us a DOUBLE portion.
Instead of your shame you will receive a double portion, and instead of disgrace you will rejoice in your inheritance. And so you will inherit a double portion in your land, and everlasting joy will be yours. (Isa. 61:7 NIV)

God is FOR us.
If God is for us, who is against us? He did not even spare his own Son but gave him up for us all. How will he not also with him grant us everything? (Rom. 8:31–32)

God's heart is GREATER than ours.
This is how we will know that we belong to the truth and will reassure our hearts before him whenever our hearts condemn us; for God is greater than our hearts, and he knows all things. (1 John 3:19–20)

God's mercies are NEW every morning.
Because of the LORD's faithful love we do not perish, for his mercies never end. They are new every morning; great is your faithfulness! (Lam. 3:22–23)

Promises for When You Feel DISCOURAGED

Jesus came to give us life in ABUNDANCE.
A thief comes only to steal and kill and destroy. I have come so that they may have life and have it in abundance. (John 10:10)

God will deliver us AGAIN.
We have put our hope in him that he will deliver us again. (2 Cor. 1:10)

Jesus is the BREAD of life.
"I am the bread of life," Jesus told them. "No one who comes to me will ever be hungry, and no one who believes in me will ever be thirsty again." (John 6:35)

God works all things together for GOOD.
We know that all things work together for the good of those who love God, who are called according to his purpose. (Rom. 8:28)

God's ways are HIGHER than ours.
"For as heaven is higher than earth, so my ways are higher than your ways, and my thoughts than your thoughts." (Isa. 55:9)

Jesus stays the SAME.
Jesus Christ is the same yesterday, today, and forever. (Heb. 13:8)

Promises for When You Are DOUBTING

Jesus is with us ALWAYS.
When they saw him, they worshiped, but some doubted. Jesus came near and said to them, "All authority has been given to me in heaven and on earth. Go, therefore, and make disciples of all nations. . . . And remember, I am with you always, to the end of the age." (Matt. 28:17–20)

We can BELIEVE Jesus.
Because you have seen me, you have believed. Blessed are those who have not seen and yet believe. (John 20:29)

God shows us CLEARLY who he is.
For his invisible attributes, that is, his eternal power and divine nature, have been clearly seen since the creation of the world, being understood through what he has made. As a result, people are without excuse. (Rom. 1:20)

We can ENTRUST ourselves to Jesus.
So then, let those who suffer according to God's will entrust themselves to a faithful Creator while doing what is good. (1 Pet. 4:19)

We will know FULLY.
For now we see only a reflection as in a mirror, but then face to face. Now I know in part, but then I will know fully, as I am fully known. (1 Cor. 13:12)

What is UNSEEN is eternal.
So we do not focus on what is seen, but on what is unseen. For what is seen is temporary, but what is unseen is eternal. (2 Cor. 4:18)

Promises for When You Need FORGIVENESS

Jesus presents us without BLEMISH.
Now to him who is able to protect you from stumbling and to make you stand in the presence of his glory, without blemish and with great joy. (Jude 24)

We are JUSTIFIED through Jesus.
Everyone who believes is justified through him. (Acts 13:39)

God REMOVES our transgressions far from us.
As far as the east is from the west, so far has he removed our transgressions from us. (Ps. 103:12)

Jesus came to SAVE us.
For God did not send his Son into the world to condemn the world, but to save the world through him. (John 3:17)

God SETTLES the matter of our sins.
"Come, let's settle this," says the LORD. "Though your sins are scarlet, they will be as white as snow; though they are crimson red, they will be like wool." (Isa. 1:18)

God HURLS our iniquities into the depths of the sea.
You will again have compassion on us; you will tread our sins underfoot and hurl all our iniquities into the depths of the sea. (Mic. 7:19 NIV)

Jesus is our ADVOCATE.
But if anyone does sin, we have an advocate with the Father—Jesus Christ the righteous one. He himself is the atoning sacrifice for our sins. (1 John 2:1–2)

Promises for When You Feel HEARTBROKEN

Jesus BANDAGES our wounds.
He heals the brokenhearted and bandages their wounds. (Ps. 147:3)

God gives us COMFORT.
Blessed be the God and Father of our Lord Jesus Christ, the Father of mercies and the God of all comfort. (2 Cor. 1:3)

God saves the CRUSHED in spirit.
The LORD is near the brokenhearted; he saves those crushed in spirit. (Ps. 34:18)

Jesus is LIGHT in our darkness.
The people walking in darkness have seen a great light; a light has dawned on those living in the land of darkness. (Isa. 9:2)

God RECORDS our misery.
You have taken account of my miseries; Put my tears in Your bottle. Are they not in Your book? (Ps. 56:8 NASB)

Jesus WEEPS with us.
Jesus wept. (John 11:35)

Promises for When You Feel HOPELESS

God is ABLE to do more than we ask.
Now to him who is able to do above and beyond all that we ask or think according to the power that works in us. (Eph. 3:20)

Jesus is our ANCHOR.
We have this hope as an anchor for the soul, firm and secure. (Heb. 6:19)

We will see God's GOODNESS.
I am certain that I will see the LORD's goodness in the land of the living. (Ps. 27:13)

God will RESCUE us.
Then they cried out to the LORD in their trouble; he rescued them from their distress. (Ps. 107:6).

God's Word SHINES in our dark places.
We also have the prophetic word strongly confirmed, and you will do well to pay attention to it, as to a lamp shining in a dark place, until the day dawns and the morning star rises in your hearts. (2 Pet. 1:19)

God can work WONDERS.
You are the God who works wonders. (Ps. 77:14)

Promises for When You Feel INSIGNIFICANT

God will ANSWER us when we call.
At that time, when you call, the LORD will answer; when you cry out, he will say, "Here I am." (Isa. 58:9)

God CHOSE us.
For he chose us in him, before the foundation of the world, to be holy and blameless in love before him. (Eph. 1:4)

We are not FORGOTTEN by Jesus.
Aren't five sparrows sold for two pennies? Yet not one of them is forgotten in God's sight. Indeed, the hairs of your head are all counted. Don't be afraid, you are worth more than many sparrows. (Luke 12:6–7)

God INSCRIBES us on the palms of his hands.
Look, I have inscribed you on the palms of my hands. (Isa. 49:16)

God calls us by NAME.
"I have called you by your name; you are mine." (Isa. 43:1)

God's thoughts about us OUTNUMBER the sand.
God, how precious your thoughts are to me; how vast their sum is! If I counted them, they would outnumber the grains of sand. (Ps. 139:17–18)

Jesus SEES us.
Jesus turned and saw her. "Have courage daughter," he said. "Your faith has saved you." And the woman was made well at that moment. (Matt. 9:22)

Promises for When You Feel LONELY

God ENCIRCLES us.
You have encircled me; you have placed your hand on me. (Ps. 139:5)

Jesus makes his HOME with us.
Jesus answered, "If anyone loves me, he will keep my word. My father will love him, and we will come to him and make our home with him." (John 14:23)

Christ is IN us.
God wanted to make known . . . the glorious wealth of this mystery, which is Christ in you, the hope of glory. (Col. 1:27)

Jesus really KNOWS us.
"I am the good shepherd. I know my own, and my own know me, just as the Father knows me, and I know the Father." (John 10:14–15)

God gives us a place NEAR him.
The LORD said, "Here is a place near me." (Exod. 33:21)

Jesus will be with us WHEREVER we go.
Do not be afraid or discouraged, for the LORD your God is with you wherever you go. (Josh. 1:9)

Promises for When You Feel LOST

We can ENTER God's rest.
For the person who has entered his rest has rested from his own works, just as God did from his. Let us then, make every effort to enter that rest. (Heb. 4:10–11)

God has good PLANS for us.
"For I know the plans I have for you"—this is the LORD's declaration—"plans for your well-being, not for disaster, to give you a future and a hope." (Jer. 29:11)

God makes our steps SECURE.
He brought me up from a desolate pit, out of the muddy clay, and set my feet on a rock, making my steps secure. (Ps. 40:2)

God will SHOW us the way to go.
I will instruct you and show you the way to go; with my eye on you, I will give counsel. (Ps. 32:8)

God will make a WAY.
Look, I am about to do something new; even now it is coming. Do you not see it? Indeed, I will make a way in the wilderness, rivers in the desert. (Isa. 43:19)

We are God's WORKMANSHIP.
For we are his workmanship, created in Christ Jesus for good works, which God prepared ahead of time for us to do. (Eph. 2:10)

Promises for When You Feel OPPRESSED

God is all AROUND us.
So the LORD opened the servant's eyes, and he saw that the mountain was covered with horses and chariots of fire all around Elisha. (2 Kings 6:17)

We are more than CONQUERORS.
No, in all these things we are more than conquerors through him who loved us. (Rom. 8:37)

God will FIGHT for us.
The LORD will fight for you. (Exod. 14:14)

The Spirit of the Lord brings FREEDOM.
Now the Lord is the Spirit, and where the Spirit of the Lord is, there is freedom. (2 Cor. 3:17)

God will LISTEN to us.
You will call to me and come and pray to me, and I will listen to you. (Jer. 29:12)

God RAISES us up.
The LORD helps all who fall; he raises up all who are oppressed. (Ps. 145:14)

Promises for When You Feel OVERWHELMED

Jesus holds ALL things together.
He is before all things, and by him all things hold together. (Col. 1:17)

Nothing is IMPOSSIBLE for God.
The LORD of Armies says this: "Though it may seem impossible to the remnant of this people in those days, should it also seem impossible to me?" (Zech. 8:6)

God's Spirit INTERCEDES for us
We do not know what to pray for as we should, but the Spirit himself intercedes for us with inexpressible groanings. (Rom. 8:26)

God will RENEW our strength.
But those who trust in the LORD will renew their strength; they will soar on wings like eagles; they will run and not become weary, they will walk and not faint. (Isa. 40:31)

Jesus gives us REST.
"Come to me, all of you who are weary and burdened, and I will give you rest." (Matt. 11:28)

God will STRENGTHEN us.
I am able to do all things through him who strengthens me. (Phil. 4:13)

Promises for When You Are SICK or IN PAIN

God has a new BUILDING for us.
For we know that if our earthly tent we live in is destroyed, we have a building from God, an eternal dwelling in the heavens. (2 Cor. 5:1)

Jesus CARRIES our pain.
Yet he himself bore our sicknesses, and he carried our pains. (Isa. 53:4)

God is ENTHRONED forever.
But you, LORD, are enthroned forever; your fame endures to all generations. (Ps. 102:12)

God HEALS us.
For I am the Lord who heals you. (Exod. 15:26)

God is our PORTION forever.
My flesh and my heart may fail, but God is the strength of my heart, my portion forever. (Ps. 73:26)

God's grace is SUFFICIENT for us.
But he said to me, "My grace is sufficient for you, for my power is perfected in weakness." (2 Cor. 12:9)

Promises for When You Are TEMPTED

We will receive the CROWN of life.
Blessed is the one who endures trials, because when he has stood the test he will receive the crown of life that God has promised to those who love him. No one undergoing a trial should say, "I am being tempted by God," since God is not tempted by evil, and he himself doesn't tempt anyone. (James 1:12–13)

God will DO it.
Now may the God of peace himself sanctify you completely. And may your whole spirit, soul, and body be kept sound and blameless at the coming of our Lord Jesus Christ. He who calls you is faithful; he will do it. (1 Thess. 5:23–24)

Jesus FILLS all things.
And he subjected everything under his feet and appointed him as head over everything for the church, which is his body, the fullness of the one who fills all things in every way. (Eph. 1:22–23)

The devil will FLEE.
Therefore, submit to God. Resist the devil, and he will flee from you. Draw near to God, and he will draw near to you. (James 4:7–8)

God will PROVIDE a way out.
But God is faithful; he will not allow you to be tempted beyond what you are able, but with the temptation he will also provide the way out so that you may be able to bear it. (1 Cor. 10:13)

We are UNDER grace.
For sin will not rule over you, because you are not under the law but under grace. (Rom. 6:14)

Promises for When You Feel UNLOVABLE

We BELONG to Jesus.
You belong to Christ. (1 Cor. 3:23)

God's love ENDURES forever.
Give thanks to the LORD, for he is good; his faithful love endures forever. (Ps. 118:1)

God has made us HEIRS.
*And because you are sons, God sent the Spirit of his Son into our hearts, crying, "**Abba**, Father!" So you are no longer a slave but a son, and if a son, then God has made you an heir.* (Gal. 4:6–7, emphasis added)

God will RUN to us.
But while the son was still a long way off, his father saw him and was filled with compassion. He ran, threw his arms around his neck, and kissed him. (Luke 15:20)

Nothing can SEPARATE us from God's love.
For I am persuaded that neither death nor life, nor angels nor rulers, nor things present nor things to come, nor powers, nor height nor depth, nor any other created thing will be able to separate us from the love of God that is in Christ Jesus our Lord. (Rom. 8:38–39)

God has SET his heart on us.

The LORD had his heart set on you and chose you, not because you were more numerous than all peoples, for you were the fewest of all peoples. But because the LORD loved you. (Deut. 7:7–8)

Acknowledgments

With all my heart, I want to thank:

My husband Bob and my sons Andy and Ty—You three are the **absolute best** at loving and supporting me. You make me laugh like nobody else can, and you mean the world to me. I love you so much.

My family—Especially my dad Jack, my sisters Amy and Laurie, my brother Scott, and all their spouses and kids. Thank you to all the Sonntags, McBrides, and Crosbys as well. So much of the love we share is because God keeps his promises to us.

My prayer team (past and present)—You have lifted up these words, you have prayed for one another, and you have prayed for me as I write. I truly couldn't have done this without you. Gail Grimston, Gail Antilla, Kathy Dufault, Kelly Reinertsen, Peggy King Anderson, Debbie Hill, Cheryl Boze, Janny Carlson, Kristi Lin, Rachel Snyder, Julia Berggren, Shelly Harpring, Erica Lee, Kiesha Lee, Norma Lee, Caitlyn Rockey, Tassie Green, Amy Grindle, Angela Bettencourt, Tani Stenfjord, Kristin McGee, Lorna Slominski, and Chiron Naab.

My friends who graciously allowed me to share their stories in these devotions—Your vulnerability and openness help us see God at work. Thank you Aly, Andrea, Allyson, Halee, and Kristi.

Angie Baughman—Your Step by Step Bible Study method and Steady On University have deepened my understanding of God's heart and his words. I'm so grateful for the way he put us together in ministry and made us such good friends.

Halee Wood—Thank you for being willing to open your heart to help me with this project. I'm inspired every day by your authentic faith, your generous friendship, and your contagious joy.

Sarah Johnson—Thank you for being excited about every little step of this process, for your detailed, thoughtful editing help, and for cheering me on. I'm lucky to have you as my "top fan" and my "gym sister."

Cindi Whalen—You taught me how to trust Jesus and his promises in the hardest places. Thank you for always holding hope for me and for believing in this book.

Karen Neumair—You are wise and wonderful and the absolutely perfect agent for me. I am so grateful to get to work with you, Tim Beals, and everyone at Credo Communications.

B&H Publishing—Thank you to this incredible team for enriching this project and bringing it to completion. Ashley Gorman, thank you for supporting this project and for all your editorial labor. To Jade and Susan, thank you for all your work on the cover. To Kim, thank you for expertly guiding this book through the production process. And to Ashley V., thank you for your diligence in marketing!"

So many on this writing journey deserve thanks for their guidance and generosity. It is a privilege and a joy to be doing this with you, my friends: Grace Fox, Debbie Macomber, Nancie Carmichael, Andrea Herzer, Jane Daly, Peggy Anderson King, Deb Gruelle, Tonya Kubo, Kathi Lipp, Pam Farrel, Dr. Saundra Dalton Smith, Cynthia Cavanaugh, Laura Christianson, Mabel Ninan, Carolyn Caines, Jenni Elwood, Jody Evans, Cathy Fort Leyland, and all the wonderful people of the Northwest Christian Writers Association. If I left anyone out, please forgive me. I'm grateful for you, too!

My readers—You are on my mind and in my heart with every word I write. Thank you for your kind comments, emails, and notes that encourage my spirit and keep me writing.

And most of all, to Jesus—My load is lightened and my heart is lifted because of who you are and how you love me. Thank you for always keeping your promises.

For every one of God's promises is "Yes" in him.
(2 Cor. 1:20)

Notes

1. All definitions are from the *Merriam-Webster Online Dictionary*, the *Merriam-Webster Online Thesaurus* copyright 2021 by Merriam-Webster Incorporated, and the Word Hippo App © KAT IP PTY LTD.

Exceptions:

greater, fully, fights

These definitions are from the Apple Dictionary and Thesaurus *Oxford Dictionary of English*_Copyright © 2010, 2019 by Oxford University Press. All rights reserved.

crushed

Definition from the *Oxford Languages Oxford University Press 2023 accessed 4/07/23*

justified

Definition from *Strongs Concordance*: "G1344 - dikaioō - Strong's Greek Lexicon (csb)." Blue Letter Bible. Web. 13 Oct, 2023. <https://www.blueletterbible.org/lexicon/g1344/csb/mgnt/0-1/>.

2. W. Phillip Keller, *A Shepherd Looks at Psalm 23* (Grand Rapids: Zondervan, 2007), 33–34.

3. Keller, *A Shepherd Looks at Psalm 23*, 33–34.

4. Sermon #3152, "The Lower Courts," C. H. Spurgeon's Sermons: Metropolitan Tabernacle Pulpit (1909), vol. 55 (Pasadena, TX: Pilgrim Publications, 1979), 325.

5. Lysa TerKeurst, *Finding I Am* (Nashville: Lifeway Press, 2016), 34.

6. David Guzik, "Study Guide for 1 Peter 4," Blue Letter Bible, accessed March 23, 2023, https://www.blueletterbible.org/comm/guzik_david/study -guide/1-peter/1-peter-4.cfm.

7. D. K. Lowery, "1 Corinthians," in J. F. Walvoord and R. B. Zuck, eds., *The Bible Knowledge Commentary: An Exposition of the Scriptures*, vol. 2 (Wheaton, IL: Victor Books, 1985), 536.

8. *Free* is one of the meanings of *justified* as found in *Strong's Concordance* under ***dikaioo*** (G1344), accessed November 20, 2023, https://www.blueletter bible.org/lexicon/g1344/kjv/tr/0-1.

9. "H3198—yāḵaḥ," *Strong's Hebrew Lexicon* (csb), Blue Letter Bible, accessed October 12, 2023, https://www.blueletterbible.org/lexicon/h3198/csb/wlc/0-1.

10. Charles Haddon Spurgeon, *The New Park Street Pulpit*, vols. 1–6 and *The Metropolitan Tabernacle Pulpit*, vols. 7–63 (Pasadena, TX: Pilgrim Publications, 199).

11. "G3870—parakaleō," *Strong's Greek Lexicon* (csb), Blue Letter Bible, accessed October 12, 2023, https://www.blueletterbible.org/lexicon/g3870/csb/mgnt/0-1.

12. "H1793—dakā'," *Strong's Hebrew Lexicon* (csb), Blue Letter Bible, accessed October 12, 2023, https://www.blueletterbible.org/lexicon/h1793/csb/wlc/0-1.

13. K. P. Shah, "Construction, Working and Maintenance of Crushers for Crushing Bulk Materials," accessed November 21, 2023, https://practicalmaintenance.net/wp-content/uploads/Construction-Working-and-Maintenance-of-Crushers-for-Crushing-Bulk-Materials.pdf.

14. "H2895—ṭôḇ," *Strong's Hebrew Lexicon* (kjv), Blue Letter Bible, accessed March 17, 2023, https://www.blueletterbible.org/lexicon/h2895/kjv/wlc/0-1.

15. Ray Konig, "Chart of Old Testament Prophesies Fulfilled by Jesus," about-jesus.org, accessed October 17, 2023, http://www.about-jesus.org/complete-chart-prophecies-jesus.htm.

16. David Guzik, "Study Guide for Ephesians 1," Blue Letter Bible, accessed March 17, 2023, https://www.blueletterbible.org/comm/guzik_david/study-guide/ephesians/ephesians-1.cfm.

17. "And I also say to you that you are Peter, and on this rock I will build my church, and the gates of Hades will not overpower it" (Matt. 16:18).

18. "G3708—horaō," Strong's Greek Lexicon (csb), Blue Letter Bible accessed October 12, 2023, https://www.blueletterbible.org/lexicon/g3708/csb/mgnt/0-1/.

19. "Psalm 139:1–6," Matthew Henry's Commentary, Bible Gateway, accessed November 23, 2023, https://www.biblegateway.com/resources/matthew-henry/Ps.139.1-Ps.139.6.

20. "G3438—monē," *Strong's Greek Lexicon* (csb), Blue Letter Bible, accessed October 12, 2023, https://www.blueletterbible.org/lexicon/g3438/csb/tr/0-1.

21. "G1722—en," *Strong's Greek Lexicon* (csb), Blue Letter Bible, accessed October 13 2023, https://www.blueletterbible.org/lexicon/g1722/csb/mgnt/0-1.

22. Adam Clarke, *Clarke's Commentary: The Holy Bible Containing the Old and New Testaments with a Commentary and Critical Notes*, vol. 6 (Romans-Revelation) (New York: Eaton and Mains, 1832).

23. James Wallace, *The Basque Sheepherder and the Shepherd Psalm,* reprinted in *The National Wool Grower,* December 1949. This article was published in *Reader's Digest* in June 1950 and republished in July 1980. Accessed November 23, 2023, https://www.authorsden.com/visit/viewarticle.asp?id=23099.

24. James Wallace, *The Basque Sheepherder and the Shepherd Psalm.*

25. "G1097—ginōskō," *Strong's Greek Lexicon* (csb), Blue Letter Bible, accessed October 13, 2023, https://www.blueletterbible.org/lexicon/g1097/csb/tr/0-1.

26. W. Vine, "Made (Be)," *Vine's Expository Dictionary of New Testament Words,* Blue Letter Bible, accessed October 13, 2023, https://www.blueletter bible.org/search/Dictionary/viewTopic.cfm.

27. Joni Eareckson Tada, *A Place of Healing: Wrestling with the Mysteries of Suffering, Pain, and God's Sovereignty* (Colorado Springs, CO: David C. Cook, 2015), 67.

28. Chuck Smith, "Verse by Verse Study on 2 Kings 5–8 (C2000)," Blue Letter Bible, accessed March 26, 2023, https://www.blueletterbible.org/Comm/smith_chuck/c2000_2Ki/2Ki_005.cfm.

29. John D. Barry, *Colossians: Being like Jesus,* Not Your Average Bible Study (Bellingham, WA: Lexham Press, 2014), 21.

30. David Guzik, "Study Guide for Zechariah 4," Blue Letter Bible, accessed April 1, 2023, https://www.blueletterbible.org/comm/guzik_david/study-guide/zechariah/zechariah-4.cfm.

31. Trent C. Butler, ed., "Intercession," *Holman Bible Dictionary* (Nashville: B&H Publishing, 1991), accessed November 25, 2023, https://www.studylight.org/dictionaries/eng/hbd/i/intercession.html.

32. Wayne Jackson, "Science and the Eagle's Wings," *Christian Courier,* accessed January 17, 2024, https://christiancourier.com/articles/science-and-the-eagles-wings.

33. Saundra Dalton-Smith, *Sacred Rest: Recover your Life, Renew Your Energy, Restore Your Sanity* (New York: Faith Words, 2017).

34. Dalton-Smith, *Sacred Rest,* 15.

35. Eugene Peterson, heading for Psalm 102, *The Message.*

36. Charles Spurgeon, "Psalm 102," Blue Letter Bible, accessed April 2, 2023, https://www.blueletterbible.org/Comm/spurgeon_charles/tod/ps102.cfm.

37. Andrea Herzer, *Incurable Faith* (Colorado Springs, CO: 2023), 98–99.

38. John Gill, "Psalm 73:26," Blue Letter Bible, accessed November 25, 2023, https://biblehub.com/commentaries/gill/psalms/73.htm.

39. James 4:7 msg.

40. James 4:8 msg.

41. The original wording of this quotation reads that to "turn away from sin, and turn toward a merciful God" is "one of the defining marks of a Christian."

Found in Trevin Wax, "The Mark of Christianity That Is Disappearing from Our Worship," August 27, 2015, https://www.thegospelcoalition.org/blogs/trevin-wax/the-mark-of-christianity-that-is-disappearing-from-our-worship.

42. "Will Provide," ASV, Blue Letter Bible, accessed April 8, 2023, https://www.blueletterbible.org//search/search.cfm?Criteria=%22Will+Provide%22&t=ASV#s=s_primary_0_1.

43. Ann Voskamp, "The Greatest Passion You (or Humanity) Has Ever Known . . . & Why Good Friday Matters," accessed November 26, 2023, https://annvoskamp.com/2023/04/the-greatest-passion-you-or-humanity-has-ever-known-why-good-friday-matters/#more-223121.

44. Charles H. Spurgeon, "Prodigal Love for the Prodigal Son," Spurgeon's Sermons, accessed November 27, 2023, https://ccel.org/ccel/spurgeon/sermons37/sermons37.lv.html.

45. "H2836—ḥāšaq," *Strong's Hebrew Lexicon* (CSB), Blue Letter Bible, accessed October 13, 2023, https://www.blueletterbible.org/lexicon/h2836/csb/wlc/0-1.

Other great devotionals
from B&H

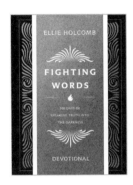